THE CRAFTSMAN'S WAY

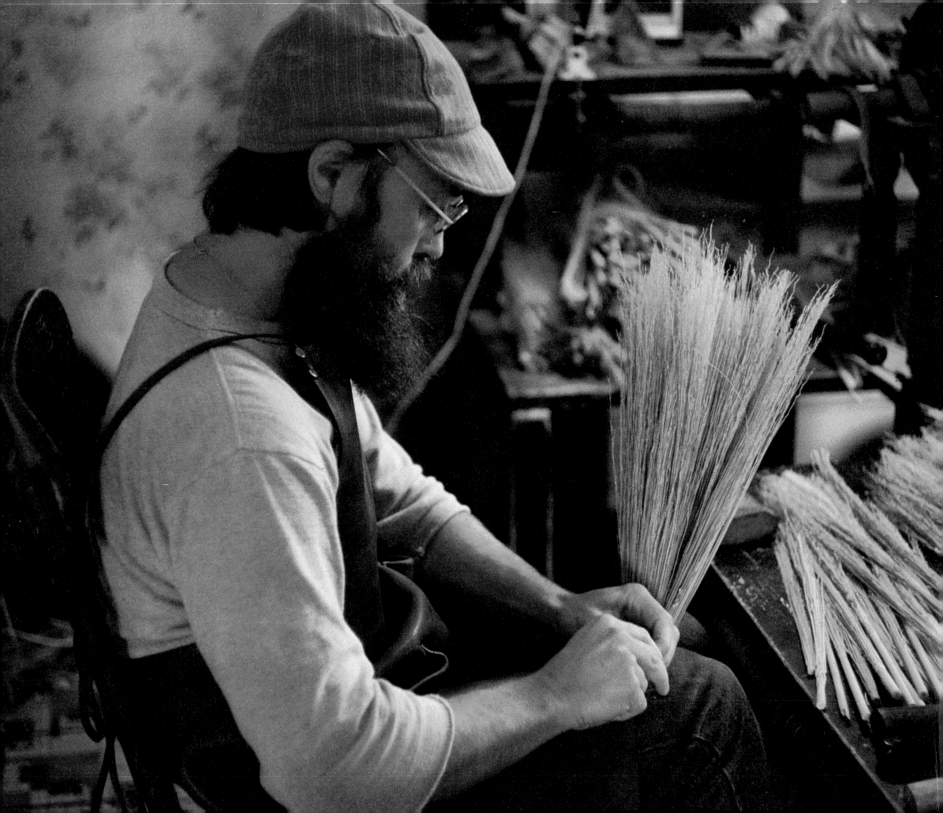

The Craftsman's Way

CANADIAN EXPRESSIONS

Introduction by HART MASSEY

Interviews and photographs by JOHN FLANDERS

UNIVERSITY OF TORONTO PRESS · TORONTO BUFFALO LONDON

© The Massey Foundation 1981
Printed in Canada

ISBN 0-8020-2433-5

Canadian Cataloguing in Publication Data

Main entry under title:
The Craftsman's way

ISBN 0-8020-2433-5

1. Artisans – Canada – Interviews. 2. Handicraft –
Canada. 3. Massey Foundation – Art collections.
1. Flanders, John.

TT26.C72 745.5'092'2 C81-094854-0

This book has been published with
the help of the Massey Foundation
and the block grant programs of
the Canada Council and the Ontario
Arts Council.

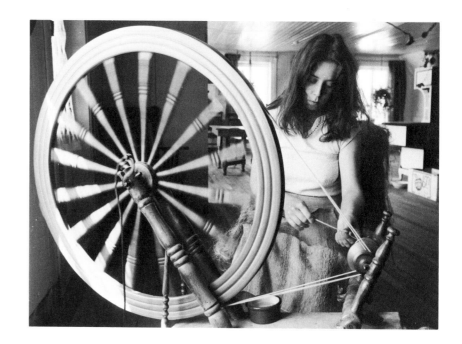

Contents

Introduction 3

The Traditional Crafts 20

Pottery 23

Wood 53

Glass 81

Textiles 99

Basketry, Brooms, Paper, Leather 133

Metal 161

Biographies 191

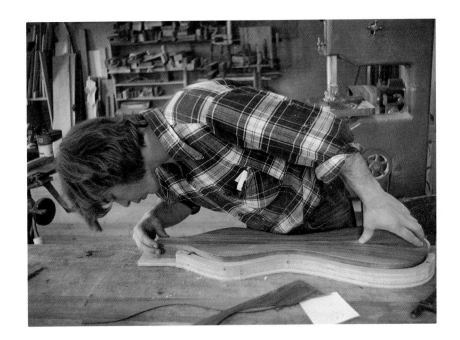

THE CRAFTSMAN'S WAY

What are my ambitions? I want to make a broom that has love in it, and has harmony in it, and can be perceived consciously or unconsciously by others as such. That's what I want to do with brooms. That's a tall order, a very tall order. And to work towards that and the smelling of the lilac blossoms in June are part of it, and work on broom-making and meditation are part of it, and contemplating, meeting many other people, suffering through a lot of things, are important. Everything works into this. Broom-making is the symbol for the whole life really, because obviously I want to do the same in everything else too and I am not there. I am conscious of the goal. It occasionally slips out of my mind but I would say that over the years it has come more to the fore, all the time in my mind and in my heart, because that is just as important, and I am working towards it. I do not see any quick answers. It is a lifetime of work and more. It goes on and on.

Robert Lyons, broommaker

Introduction

A resurgence of interest in the crafts is evident in most countries of the industrialized world. In some of the older European societies where cultural traditions are strong, the contemporary crafts are but the current flowering of something deeply rooted. They are, in fact, part of a continuum stretching back hundreds of years. This tradition was, in most cases, strong enough to survive the impact of the industrial revolution, though gravely weakened in the process. In North America this was hardly the case. The traditional crafts crossed the Atlantic with the early settlers and were vital to their existence here, but it was not long before the machine began to usurp the craftsman's role. In Canada this was especially so because our political beginnings and the foundations of our society lie in quite recent times, during the boisterous years of nineteenth-century industrial growth. As Canada was being born, the traditional crafts, so essential to the pioneers, were already dying. The machine made many more things, faster and cheaper than was previously possible. Some old crafts certainly survived in a few corners of the country but their influence was negligible and we, by and large, entered the twentieth century without a strong craft tradition. The machine had won.

During the first half of this century a change took place in the nature of the crafts and our attitude towards them. Because the machine now supplied the essentials of life and work, the crafts were free to become more expressive of human creativity. They began to occupy almost exclusively a part of the cultural spectrum somewhere between the functional disciplines of the artisan and the aspirations of the artist. They were no longer taken for granted as a necessary part of everyday living but became instead non-essential embellishments of it. They became, with some exceptions, the 'fine crafts' we know today.

In Canada, beset during this time by two world wars and a severe depression, the fine crafts existed but hardly prospered. There were a few professional craftsmen scattered across the country, with some enthusiastic but poorly financed organizations to back them up, but public interest was low. Quebec has always had a stronger craft tradition than many of the other provinces and has done more to encourage the crafts. (It is, nevertheless, surprising to learn from a federal Royal Commission report that in 1950 there were as many as 70,000 hand looms being used in Quebec alone.) It was in Quebec during the early part of this century that the Canadian Handicrafts Guild was born. This guild became a national organization with branches in several provinces. These eventually evolved into the independent provincial craft associations of today and have been joined by many affiliated organizations devoted to particular media. It was in Quebec also that the first training school for craftsmen, L'École du Meuble, was opened in 1937. (Most of the craft schools we know today are very recent developments.)

There was, of course, activity involving crafts in all the provinces, but much of it concerned amateur and hobby craftsmen. They are not to be dismissed, but our focus in this book is on the professional, and a measure of the state of affairs in the crafts prior to 1950 is the number of professional craftsmen earning a living from their crafts at that time. The precise numbers are not known to me but memory, both mine and others', would indicate that there were not many and that the range of media was quite limited. Even a well-informed observer such as John Reeve, the potter, says that he now can name only about six potters (such as the Deichmanns of New Brunswick) who were working in Canada when he was at the Vancouver School of Art in the fifties. He adds: 'It was considered a very, very eccentric thing to do.'* And pottery has always

*Quotations in the introduction are, unless otherwise noted, from interviews carried out by John Flanders. The interviews were long, and only edited portions of them appear here and later in this volume.

3

been the most populous of the craft media. There would, of course, have been other professionals working in textiles, wood, and metal but, again, extremely few. This small band kept the crafts alive during lean times, and one has no wish to belittle their contribution to the crafts movement in this country. It would, however, be a mistake to overestimate the influence of the crafts between 1900 and 1950 on what happened later. In trying to locate the roots of the present explosion of interest one is forced, therefore, to look elsewhere.

We were all influenced, whether we wished to be or not, by the turmoil and change of the 1960s. It was a time that affected both old and young alike, although for the latter it had a special significance. It was really their time. They were the catalyst and it was they who felt its influences most deeply. They were really what it was all about.

This was particularly so for those who grew up in those years. It put an imprint on many of them which they were to carry into adult life and which gave new direction to their lives. It was a time of reassessment. The previous generation's ways of life and thought were examined and found badly wanting. The gross materialism of society was rejected by many of the young who sought more meaning for themselves in simpler styles of life and more fulfilling kinds of work. Old values lost in the pressure of a largely urban population were rediscovered.

Working with the hands in a craft had a new and strong appeal since it offered not only a living but also other and less tangible rewards. The crafts attracted many men and women for these reasons although few, either because of talent or motivation, persevered in them to achieve professional levels of competence. It is, nevertheless, this generation, pursuing this path, which fills out the ranks of professional craftsmen now working in Canada. There are, of course, exceptions; but most Canadian craftsmen conform to this general pattern, and it is largely due to them that the crafts now enjoy such a healthy life in this country.

Since they were weaned in the sixties or, at least, on the ideas of that time, most of these men and women are young and still in their most productive years. Many have not been actively engaged in their craft for much more than ten years and it is rare to find any Canadian craftsmen who have been at it for twenty. It can hardly be said, therefore, that there are many among them who are 'masters' in the old sense. There has not been time for them to reach that level. This should not be a matter of much concern, however, for it will eventually come to pass in the natural course of events. The important thing is that work of a very high order is now being produced, and in sufficient volume across the country to merit serious attention. It would, therefore, seem to be an appropriate time to assess the accomplishments of these professional Canadian craftsmen and to make others aware of what they are doing.

THE
MASSEY FOUNDATION
COLLECTION

For these reasons the Massey Foundation decided in 1975 to make a major national collection of contemporary Canadian crafts. Such a collection, we felt, would not only recognize what was being done but would also be an instrument to endow with needed prestige an important and hitherto neglected part of our cultural life. The fine crafts, in spite of their current high quality, have been largely ignored by the museums and galleries of Canada, and indeed by the federal government itself through agencies such as the Canada Council. In Europe, most countries have major national collections of contemporary crafts. In Japan and Mexico, to name only two others, the crafts are revered and cherished as important aspects of national life. Many national governments, moreover, provide adequate funding to organizations whose purpose is to foster the crafts. None of this has happened in Canada. There is no major collection of contemporary crafts in any national institution, and financial assistance for the

crafts is almost non-existent. Indeed, as two recent briefs to the Federal Cultural Policy Review Committee make very clear, there is no federal government policy in this area. The Royal Canadian Academy brief states that 'the area of applied arts remains virtually without recognition and support.' That of the Canadian Conference of the Arts makes a similar point: 'No art museum in Canada systematically and comprehensively collects, displays or promotes the applied arts of the 20th century – not even the applied arts produced in Canada.' In spite of increasing high achievement in the crafts and increasing public interest, there persists an amazing indifference to them on the part of those institutions, both federal and provincial, whose function it surely should be to foster their development in this country. If this major cultural activity is not supported by Canadian museums and galleries and the various funding agencies, it is small wonder that it does not attract more attention and respect from Canadians as a whole.

The Massey Foundation is keenly aware of this situation and the need to do something about it. Improvement will not happen overnight, but we have felt for some time that this particular collection might be used as one small device to initiate a change of attitude. The collection has now reached a point, both in quality and in size, where it can be fairly said to represent a cross-section of Canadian crafts as they are at this moment. It has, therefore, become necessary to find it an appropriate home. Because of the attitude to the crafts prevalent in the museum world of this country, that has been no easy task. Not only are there very few institutions interested in the crafts of today, but there are hardly any with the appropriate resources to handle a collection of this size. Understandably, there have been frustrations and disappointments during our search. It is especially encouraging therefore that after many months of negotiation, the National Museum of Man has agreed to take the collection under its wing. Considerable

credit for this outcome is due to the director of the museum, Dr William Taylor, and we are grateful to him for his support. This conclusion, reached at last, is appropriate on several counts. The collection is national in scope and should be seen by Canadians in all parts of the country: the Museum of Man has a matching national mandate. It is significant also that a major collection of contemporary Canadian crafts will be lodged for the first time in a major national institution. This may indicate a changing attitude to the crafts and, if so, it is to be much welcomed. But by far the most important aspect of this development is that the Museum of Man has the resources needed to care for such a collection and to display it to the Canadian public through exhibitions and other means. A collection of this kind is of little use unless it is seen, and by as many people as possible. It is the hope of the Massey Foundation that the National Museum of Man will recognize this as an essential part of its new responsibility.

The collection has been made by the Massey Foundation over the past five to six years in travels by its directors several times across the country. It now consists of almost 900 individual objects from all regions of Canada and includes work from all the major craft media. Even though it is now quite sizeable, there is no intention that the collecting process will suddenly end when the objects are in the Museum of Man. To keep the collection alive, we hope to continue making acquisitions as new talent in the crafts reveals itself.

Collecting has been enjoyable but far from easy. Not only must great distances be travelled in this huge and thinly populated land, but within each region the craftsmen themselves are widely dispersed, often living in remote rural locations. The problem for the collector, therefore, is first to discover who is doing good work, then to arrange to be in the right place at the right time to buy it. It is often difficult to do this because one cannot possibly visit every studio or even see every exhibition. So one does the best one can. The collection as it now stands cannot be said, therefore, yet to include the work of every good craftsman in Canada; it represents only the Massey Foundation's best effort to accomplish this in the time available. The logistical difficulties are great but they are not the only ones which have created some important omissions. It has sometimes proved impossible to purchase the work of some major craftsmen. Among others, Bill Reid's name is missing from those represented in the collection. This has certainly not occurred for want of trying. We will, however, continue the work of collecting, for there is much yet to be done.

Just as the good craftsman should ponder the meaning of his work, so should the serious collector consider carefully the purpose and nature of his collection. The Massey Foundation established at the outset therefore some general guidelines to help us in making acquisitions. Above all else, the collection would emphasize high quality; that was to be the prime consideration. It would also, provided this was consistent with maintaining standards, attempt to be representative of the diverse regional and cultural backgrounds of the Canadian people. We intended, furthermore, through the collection to take a position, perhaps a controversial one, concerning the key relationship of the crafts to human use and to attempt to define their special nature, certainly in our own minds and perhaps also in the minds of others.

I have dealt at greater length with this elsewhere but for the time being it is enough to say that there is, these days, a tendency for the crafts to drift in the direction of art, forsaking in the process any link with the functional source of craft or at best only giving it lip service. What results from this approach is often mere form without substance or content, having little meaning. Such work seems to belong in a no-man's land. It is neither successful art nor good honest craft. Much of this confusion of purpose abounds in the world of craft these days, and it has tended to deprive it of the very thing which gives it strength. By stressing in the collection, therefore, the importance of the functional element in craft we are, as collectors, expressing a point of view. Not all will agree with it nor do we expect that it will have much effect on current trends. It may, however, stimulate reflection and discussion on what craft is all about. That alone would be worthwhile.

While it is based on work in the Massey Foundation Collection and some of the craftsmen represented in it, this book is by no means a catalogue of that collection. Of all the objects now in the collection, fewer than one-third are illustrated here. The same is even more true of the craftsmen themselves: because of limitations of space, only a small fraction of them could be given coverage. This small group of craftsmen is, however, representative of all craftsmen in Canada. And probably more than the objects themselves, these men and women are what this book is about.

What Canadian craftsmen represent in their thought and ways of life is probably more important to us than what they produce. While the finished objects may bring pleasure, even joy, the values represented by the makers have perhaps a deeper message. The Massey Foundation decided to obtain, for this reason, a visual and verbal record of some of the craftsmen with work in the collection. We commissioned John Flanders of Ottawa to do this, and

during the summers of 1979 and 1980 he interviewed and photographed nearly eighty craftsmen from Newfoundland to British Columbia. This book has resulted from the material obtained on those journeys and, of course, represents but a small fraction of the total brought back. It is a remarkable record and the Massey Foundation owes much to John Flanders, not only for what he has accomplished but also for his keen interest in this task and the work it entailed over many weeks of travelling from coast to coast.

The basis for the selection of the men and women appearing here is to some extent subjective and perhaps even arbitrary. Those shown are, nevertheless, broadly representative of the crafts as they are in Canada today. Craftsmen from all regions and most of the media are included. We would have liked to give major coverage to many more craftsmen. Some are only represented by photographs of objects they have made. This is not an ideal situation but unavoidable within

the confines of one volume. There is, however, no intention to imply by this the greater importance of one craftsman relative to another. The effort to be representative and balanced, as well as to compress much into a confined space, inevitably resulted in compromise. Our intention, above all, is to give a rounded impression not only of the Massey Foundation Collection but also of the crafts as they are in Canada today.

Somebody told me there was this old fellow down the road and I should go see him … I did and it turned my whole life around. He was my base inspiration. Not so much for his work … as for his excitement. I hadn't known what good ironwork was. He showed me.

John Little, blacksmith

In looking for patterns in childhood and early life to explain where craftsmen come from, one is struck by the diversity of influences from which blossom people who share in later life very similar attitudes. While many craftsmen report early interest in art and making things with their hands, this is by no means universal. Even in the matter of family background and parental attitude one can make no generalizations. The gamut seems to run all the way from culturally rich environments with enthusiastic support in the home to active discouragement of interest in craft or art by parents who placed higher value on vocations more certain to earn a

good living. Some common ground can, however, be found in later years. Nearly all the craftsmen in this book have educational backgrounds setting them apart from the traditional craftsmen of the past. High school or its equivalent seems pretty general. At this point many entered an art or crafts school, but a surprisingly large percentage went to university before tiring finally of the academic life and turning with some evident relief to a craft. Among these craftsmen one can find backgrounds in psychology, sociology, physics, mathematics, architecture, art history, philosophy, and so on. The new wave of interest in the crafts has attracted well-educated people and, as their statements in this book also attest, quite articulate ones.

It is obvious that for many, the way into crafts was by no means a smooth flow from high school through crafts school to workshop. While the desire to work at a craft was presumably latent, it often lay dormant until triggered by some chance happening or encounter which set them off in a new direction. The actual event, of course, would have been insignificant had it not happened at a time when the individual was in some doubt about the path then being pursued and, therefore, susceptible to other influences. A typical example comes from Renée Lavaillante, a Quebec potter who at the time was studying art history in Paris: 'On my way to university, I often walked by a potter's workshop. One day, without really thinking, I went in and asked if I could work there, and that is how it all started. At first it was just one way of getting out of a dead-end street ... so this is what I tried and it worked.' Another potter, David Taylor, from Nova Scotia, became intrigued with ceramics through the pieces of pottery he found while excavating at an archaeological dig in Iran. Others had a lucky encounter with a gifted teacher or an exceptional person. There are many cases of this. Sandra Orr was influenced by Marie Aiken, David Trotter by Daphne Lingwood, and David Orban, having admired some handmade shoes in Colorado, found the maker 200 miles away and stayed to become his apprentice. Some craftsmen, on the other hand, made what appear to be quite precipitate leaps into their craft. Raymond Landry, on the basis only of reading a chapter on metal spinning in a well-known textbook, took the plunge, bought a $2000 lathe and started work. Similarly Suzanne Lanthier and Paul Marineau became weavers. 'We just happened to be looking in the classified ads of *Le Droit* and there was a loom for sale, a used one. So we decided to call the lady and go and see that loom. That's the way we bought it. Then she showed us how to weave.' This approach is, however, not common and must surely be a difficult one, laden with time-consuming frustrations. Still others have eased slowly into something they found at last really suited them. Sandra Brownlee is one of these: 'I've always resisted any kind of routine imposed by other people ... I never consciously went into weaving ... it evolved gradually and naturally. I never went into weaving to earn a living – never thought of that at all; I thought I never could. It just grabbed me.'

Some, having drifted through various levels of education and increasingly disenchanted with the academic life, later moved from job to job until they got close to something that seemed right for them. They knew finally that that was where they belonged. For a rather different reason, Daniel Crichton, then fresh from the academic world, says: 'I started doing crafts or getting into glass because I needed to as a person. I had far too much physical energy to be just sitting behind a desk and thinking all the time.' David Miller, the Saskatoon instrumentmaker, was involved for a time in the theatre in Halifax, where, 'between engagements' and 'moderately broke,' he admired an Appalachian dulcimer in a store window. He couldn't afford to buy it but instead bought a book on making dulcimers. 'I scrounged a bit of material from a friend ...

carved it up mostly with his tools, and turned it into a dulcimer that actually played music – much to my surprise. I decided I would like to try another one, and the thing kind of grew.' John Little, a Nova Scotia blacksmith, literally tripped over his craft. After leaving the master's program in psychology at Dalhousie University he had bought some beautiful seashore land in Nova Scotia and was living there on a shoestring. He says: 'I had an anvil. I ordered it from a company called Brown's in England … and I had to wait six months to get it. Now, I must have had some damn good reason for doing that, but I can't remember any reason. That thing was sitting out there, in my way, and I was tripping over it, so I set it up. It sounds corny as hell, but that's literally how this started.' There is, of course, more to it than that but the story makes a point. The initial switch that turns the mind to new possibilities can be flipped by any manner of thing.

Of all such events described by those in this book, that of Robert Lyons, the Ontario broommaker, is unique. With a university background in commerce and finance as well as sociology, he had been employed for a time at a pioneer village where he became familiar with some of the traditional crafts, including the use of an old broommaking machine. He was able to use it for only one half-day, making, in total, two brooms. But he had also reached a turning point in his life. In his own words: 'One morning about 6 AM I woke up from a dream. In this dream, a very clear voice told me: "You can make a living making brooms." That was it. I woke up and decided to take the dream at its face value.' He is now doing just that and has been making a living at his craft for several years. That takes courage and commitment of an unusual order.

There are many starting points and many paths, but no matter how different they are the decision to become a professional craftsman was, for all those making it, a major one, resulting from their own needs and their own way of thinking about things. Most of these men and women have decided for any number of reasons to pursue a life out of the mainstream of the urban industrialized society in which they live. To do this and to do it successfully requires conviction. To react to the materialistic values of society is one thing; it is quite another to create a new kind of existence on the edge of that society based on different values, and to make it work from both a personal and an economic point of view. Most professional craftsmen have been able to do that. The urge to take this new direction stems from a number of motivations – a wish to be free of society's more pointless demands and pressures, a strong independent spirit which refuses to accept bosses and 9-to-5 hours, a compulsion to work with the hands as well as the mind, a desire in some to be part of a long tradition, and a wish to make things with relevance and beauty for enjoyment by others. All these are important. But many craftsmen articulate an objective of wider scope. This involves the idea of not only finding enjoyment and reward in one's work but integrating that work with daily life so that there is no real separation between them. They shun the schizophrenic thing that is most office and factory workers' daily experience and seek a life in which all aspects of it flow together and become one.

I want to keep in touch with my own values and my own life and, hopefully, grow but not throw myself away on passing things. To work very hard and to open myself as much as I'm able to.

Sandra Brownlee, weaver

To achieve such goals requires a different approach to life, with values and a way of living not shared by society as a whole. It generally requires sacrifices of a material nature. David Trotter knows this: 'There is more to it than running to work every day and making as much money as you can and having all the things you think you need.' Not all craftsmen are poor even in society's terms, and most make a living from their craft adequate for their needs, although it is sometimes supplemented by income from teaching. Yet not one I am aware of could be called affluent in the conventional sense, and a few have existed happily well below the 'poverty line' on annual family budgets of $5000, $2500, or even less. One Nova Scotia craftsman recalls a time when he and his wife lived for four years on $500 a year! (No electricity, no telephone, no plumbing, wood heat). Not many would have the ingenuity to accomplish this or even wish to try, but for those two and many others living on very small incomes there has to be more to life than the cars and TV sets of the consumer society. True wealth can be measured in other ways. While living on $5000 a year, one craftsman can still say: 'By our standards we are rich.'

These may well be extreme cases but they indicate a general willingness on the part of craftsmen to do with fewer material things in return for something else. The 'something else,' of course, is the chance to live their own lives in the way they want. These objectives are well put by Daniel Crichton: 'The independence, the freedom to will a life ... the will to love the stuff you are working with and the people you are connected with and not having the problems of someone who has to work in a factory or in a situation they feel stuck with.' To achieve such aims is not easy and for financial reasons many have decided not to live in cities where costs are high and space limited, but to find inexpensive and often very beautiful places in rural Canada where the pace is slower, living costs are less, and there is space – space for work, space for living, space for bringing up children, and space for growing vegetables.

Not all are able to do this because of teaching or other commitments, but wherever they live most craftsmen create for themselves a special environment in which their values are predominant, where they live their lives by their own rules surrounded by things which are important to them. These are usually comfortable and relaxing places to visit, and the craftsmen themselves are comfortable and relaxed people to be with because most of them live fulfilled, creative, and integrated lives. By and large, they know who they are and what they are and seem sure in that knowledge. Or perhaps, to quote Daniel Crichton again, craftsmen are this way 'because they are not in competition with anyone but themselves. There are still ambitions, there are still egos and there are certainly politics, but at the same time there are an awful lot of good people who have gained a spiritual understanding about themselves and a spiritual approach to the stuff they are working with and the environment they are working in. That sort of meaning is something that's not that easy to come by in today's world. It is to some extent a luxury.'

It is the integration of rewarding work with all the other aspects of life which makes the craftsman different from most other members of society. As Rickey Lair says: 'I wanted my work not to be work but an essential feature for other activities in my life.' And this, of course, is the craftsmen's discovery and their special importance. To be able to work at something one enjoys, to earn a living from it and weave a life for oneself in which all parts are related and in harmony, is, I believe,

BEING A
CRAFTSMAN

the objective of most men and women embarking seriously on a craft. Many have achieved it. Tam Irving is aware of the interaction taking place: 'The values you apply to your craft inevitably overflow into all sorts of other values in one's life.' Wayne Ngan also talks about this. For him everything done in pottery relates to everything else: cooking, building a house, firing a kiln – indeed the whole of life is one process. This is put in other words by David Orban: 'My religion, my philosophy, my trade, and my craft are all wrapped up in a bundle.' There is for these people no fine line to be drawn between working and not working or between the various parts of their lives. Perhaps Paul Epp expresses it best: 'One of the strongest values in what I'm doing now is the integration of many aspects of my life ... I don't feel cut and divided. I don't have to pretend I'm different people at different times. I'm the same person all the time and that I think is very important to human health.'

You work too many hours because once you get into it you don't realize you are tired. It takes you away. It's a different world and it gives me such incredible happiness.

Elsie Blaschke, embroiderer

A sunflower seed and a solar system are the same thing; they are both whole systems. I find it easier to pay attention to the complexities of the smaller than to pay attention to the complexities of the larger. That, as much as anything, is why I'm a craftsman. It's a small discipline but you can put an awful lot into it.

Adam Smith, knifemaker

In today's society, a professional craftsman is undoubtedly a special kind of person leading a special kind of life. It must start, of course, with a total dedication to the craft, fascination with all its aspects, and an enjoyment of it. These alone are not enough, but without them it is hard to see how much of consequence could follow. The craftsman also needs many other things: self-discipline, good critical judgment, patience, perseverance in the face of difficulties, respect for and sensitivity to materials, mastery of technique, and above all, an ability to work. The last is perhaps the most important, and not only in terms of putting in long hours: as Sandra Brownlee says, 'anyone who is self-employed knows you work longer hours.' It is important because in the creative process it is usually work that produces results, not that ancient myth 'inspiration.' Renée Lavaillante is aware of this: 'Things like inspiration are completely unimportant. Let's say you have a small idea or two small ideas; what is important is working on these ideas afterwards.' Elsie Blaschke reinforces this feeling: 'The notion that artists sit there and wait for inspiration to descend upon them is ridiculous. It you were to do that you would never get anything done.' Natural talent and imagination certainly have a role, but things just don't happen in a flash of rosy light. They arrive as the result of work – hard work, long hours of often exhausting work. Most craftsmen understand this and accept it as the way things are. As Tam Irving says: 'Being a potter is like everything else in life, part of it is fun and part of it is hellishly hard work.' Fascination with what they are doing is the driving force. Solutions arise because of thought and effort. Sudden insight plays its part, but the prime way is surely slow evolution through work.

The notion of work in this context is one thing as understood by the craftsman and quite another as perceived by a large segment of society. This is illustrated in remarks overheard by one craftsman at an exhibition. The man: 'God, these things are beautiful. I just don't know where these people get the time to make them.' The woman: 'Well, they don't work.' It is perhaps amusing, but it is also sad that many people do not realize that work can be so much more than they know from their own experience. Some hint of the craftsman's rewards from work are given by

Karl Schantz: 'When all the conditions are right you're like an open-ended spirit. It's a natural process. The subconscious and the conscious come together; all your accumulated experience comes together. It's as high as you will ever get.'

For the serious craftsman time is a problem – time to improve his craft and time to accomplish all that lies ahead. Once one level is reached, the next higher one must be faced and mastered. There is no conclusion. The end of one thing is the beginning of another. The next piece will be better than the last. As Annegret Hunter-Elsenbach says: 'I'm not near the stage I want to be. Every time I do something new for myself I see the next five hundred steps towards the next kind of perfection, and that just goes on and on and on. I doubt that there will ever be an end to that.' The good craftsmen are, thus, quite humble about their achievements and look to the future for improvement in their craft and the unfolding of themselves. John Reeve, now in his fifties and one of Canada's outstanding potters, says: 'I still have so much to do. I have more to learn. I haven't really begun.' Paul Epp feels the same way: 'I'll never get to the end of my craft. If I didn't consider myself still beginning I would look around for something else to do.' Or David Orban: 'I feel I could be lost in leather forever' and Robert Lyons: 'There are goals that are infinitely far away, that cannot be reached in any short time. But I can occasionally glimpse them and go towards them a little bit.'

For these people the craft, the object, and their own lives are all inextricably mixed. Because of this many craftsmen perceive that their craft is not only concerned with making things but also involves themselves. As Karl Schantz says: 'I think you have to be aware not only of how to manipulate the material. You also have to be spiritually aware of yourself in order to develop something to its fullest potential.' While the craftsman may be working at a craft he is inevitably working with himself and working on himself. This feeling is shared by many. As Stephen Hogbin says: 'I'm exploring materials, I'm exploring myself, I'm exploring relationships between myself and society to create some sort of picture of living that makes sense, that I feel comfortable with.' And Stephen Harris: 'Your battles are with yourself.' These battles can obviously take many forms but the ego, for the creative person, is the main and ever-present threat. In creativity, as in life, it has its place, but most would agree that control must be placed on it and the work allowed to evolve smoothly. As John Reeve says: 'What you make is what you are. Let things flow naturally rather than from ego,' and again: 'It is the clay that centres me and that's the way I want it to be.' This is a revealing insight into himself and shows an understanding of the true creative process. While such an attitude pervades the work of the best craftsmen, it is by no means generally understood. One can only hope that more will have the wisdom to grasp that this is a truth which can have profound and beneficial effects on what they do.

Working with the hands is an important motivation for nearly all craftsmen, and for most a compelling need. 'Doing things with my hands is very strongly the centre of my life.' 'My hands are always going.' 'Working with the hands – it's like walking, very important.' Since some of the work in a craft involving the hands is repetitive, even tedious, craftsmen have to deal with this in their own ways. Yet there is little talk of boredom – quite the contrary. It would seem more the case that absorption in the craft carries over into its occasional seeming drudgery, which even possesses positive aspects. Several talk about this work inducing a special state of mind. For many it is a soothing, even a therapeutic, process. For others it approaches meditation, and for some undoubtedly is just that. It is certain that working with the hands can clarify and focus thought, inducing a calm state of

mind, a kind of detachment. As Stephen Harris says: 'If you get into a rhythm of working, you can … watch yourself work.' There are, of course, many who would not welcome long hours of such work; but for the craftsman the lonely pursuit of some elusive creative goal, a goal that encompasses his very being, has an irresistible appeal. Not only the hands but the whole person is involved in this complex process in which messages flash back and forth between hand and brain – the mind producing ideas and solutions to problems based in part on information about materials and processes coming from hand and eye.

But working with the hands, while an essential part of a craft, is not all of it. The ability to produce an idea for the hands to work on is also a vital and essential part. Therein lies the difference between the genuine craftsman and someone who is simply 'making things.'

Tools can be very, very precious. You find a tool that suits your needs and you cherish it. If you know the use of a tool well, you can create your own.

Pierre Lemieux, jeweller

The curved knife is a superb tool. It's like an extension of one's fingers; it so answers to one's needs … The draw knife scoops as it draws; it slices through the material and leaves a sheen.

Bill Koochin, woodcarver

Tools are the extension of the craftsman's hands. They are his essential and much-respected allies. The various media, of course, have wildly differing needs. It would seem that the woodworker really does require most of the tools that cover the walls of his workshop; at the other extreme, one leatherworker says he can carry all the tools he needs in his back pocket. Some, like him, resist the use of tools as much as possible; the majority, however, welcome what a good tool can do for them. As David Miller says,

'good tools produce fewer frustrations … greater flow to the work and a greater pleasure in it.' A few craftsmen are purists, in the sense that they resist the use of power tools. But this is rare. Tools can, of course, become too elaborate, getting in the way between the craftsman and his work. But power tools are accepted by most since they often do the job faster and make it easier. As Paul Epp says: 'I don't like the vibration and the noise but I don't want to pass on the cost of my slowness and, perhaps, sentimentality, to my clients.' There is, however, an evident desire for simplicity and a recognition that many things can be done with extremely simple tools. According to Adam Smith, knives can be readily made with nothing more than a few files and sandpaper. Indeed, some of his small knives are made this way. But on balance craftsmen don't want to make life harder for themselves and, therefore, welcome any tool that works for them.

Nowadays a wide range of tools is available to craftsmen in all

media, but inevitably occasions arise when no tool can be found to do a particular job. The craftsman must then spend hours, perhaps even days, making what he needs. Such tools may be used for only a brief moment and never again. It does not matter: the work required it. That is the important thing, and in the process the craftsman gains greater understanding of his craft and the part tools play in it.

The tools and the craftsman become one. His tools are old friends and acquire for him their own special beauty. Indeed, tools are beautiful and fascinating. It would be unnatural, therefore, if craftsmen did not express a feeling about tools which goes beyond simple function. They become part of the craftsman and, through his hands, make their own special imprint on the finished work.

MATERIALS

I can recall dipping into the tank and, coming out, the glass was dripping around, and I was just agog. This was so splendid and to think of possibly doing something creative with it, to think of making a living at it … and be able to live out in the country and having that sort of lifestyle. The joy in the nature of the material itself was a treat on top of all those other possibilities.

Daniel Crichton, glassblower

I really enjoy working with leather. There is something about it. There's the smell of it, and the texture, and what you can do with it.

Victor Bennett, saddlemaker

The initial attraction to any craft and the continued absorption in it have much to do with the appeal of a given material. The potter is turned on by clay, the glassblower is excited by the 'power and magic' of molten glass, the weaver loves wool, the blacksmith has an affinity for hot metal, the jeweller is fascinated with precious metals, the shoemaker enjoys the sensual qualities of leather, the instrumentmaker is 'passionate about wood.' So it goes through all the crafts; and it should not be otherwise. The joy and excitement in the use of materials is one of the mainsprings of craft, and the material itself is often the major source of those insights from which the object finally emerges.

The substance used to make something is, therefore, a major influence on what that thing will become. An understanding of what his materials are telling the craftsman is one of the vital factors determining the quality of the final work. As Marta Dal Farra says: 'My ideas come from my materials.' Pierre Lemieux knows this as well: 'I'll start working with the material and soon I've got the basic imprint on a piece of metal. Then the metal tells me what to do. The piece makes itself.' To ignore the essential nature of the material is to make nonsense of the whole process of craft. It often isn't enough, however, just to work within the strict limits of a material. All craftsmen must do that, but some go further and feel the need to look more deeply into the origins of what they are working with. Only full knowledge brings respect for what a material truly wants to be. An Ontario potter, Ruth Gowdy McKinley, felt very strongly about this: 'We presume to take these materials … that were formed so very long ago, and grind them up and pulverize them and wet them yet again, and shape them yet again and, for heaven's sake, submit them to fire yet again, and make our own forms with them. I feel a kind of awe and reverence about the material. I feel somewhat like an interloper. The earth has already ground and shaped and formed and blasted and used these materials. They've come to their present state through their trials and tribulations … As a potter presuming to do it again clay is alive to me. It's not just an inert, wet, sloppy sort of thing, and I refuse to treat it that way.' Not all craftsmen have sensitivities to match those of Ruth McKinley but the good ones do, and hold the materials they work with as a legacy from nature demanding their respect, even reverence.

When I make knives I don't try to make sculpture, I don't try to make jewellery. I try and make an article that is going to work as a knife …

I am somewhat appalled by the influence that art is exercising over craft.

Adam Smith, knifemaker

I'm not really interested in committing novelty upon the world, but only in making objects which have some hidden magic to them, which are good objects to use and therefore might make it better to drink coffee.

John Reeve, potter

In the comments of craftsmen in this book and elsewhere, one encounters a wide range of opinion about what the craftsman's aim is and what craft is all about. Some of these men and women consider themselves to be artists, or at least emphasize this aspect of their work, while others are happy to call themselves craftsmen, fully accepting and being content with what that means. Adam Smith is in no doubt:

'I am a craftsman, not an artist, and I feel very adamant about that.' David Orban goes even further: 'I do not consider myself an artist. I don't even consider myself a craftsman. I consider myself a tradesman.' There are, on the other hand, many who find the description 'craftsman' too limiting, even demeaning, and yearn to distance themselves from it. Too much can perhaps be made of these different attitudes and it is possible that no fine line can be drawn between art and craft. There are, nevertheless, some points to be made.

In our society there is no question that in many people's minds, and this includes some craftsmen's, the values of art and those of craft are arranged in some kind of vertical scale with art at the top and craft somewhat lower down. This attitude implies, of course, that one is to be more highly valued than the other. Thus a tendency is created in the crafts to feel inferior, and for craftsmen to aspire to the supposed superior position occupied by 'art.' There may be very practical reasons

for doing this since it is a strange fact in today's world that a work of art will usually sell for more than a work of craft. But this is beside the point. As several craftsmen have argued, it would surely be more appropriate to consider craft as occupying a middle ground in a broad range of activities stretching between the extremes of practicality on one end and the values of art on the other. Work may be closer to one than the other, but the best of craft should contain elements of both. Art is not better than craft. They are simply both important and interrelated human activities. Each has its own special emphasis. That of craft has traditionally evolved from function, and here surely remains its special nature and its strength. It is not imprisoned, however, within function pure and simple. Function is a starting point and reference. The rest is up to the maker.

Of all the craftsmen interviewed for this book, there is hardly one who would deny the impact of use on the objects he makes. Before

anything else the object has to satisfy the purpose for which it is to be used, and any additional treatment must take that purpose into account. Indeed, the discipline imposed by use is welcomed by some: 'I find designing for use a restriction that is very rewarding.' But too often the contemporary craftsman tends to ignore the hard truth of function and allows himself to be led astray by 'art' values, the real meaning of which he may not understand. The artist and the craftsman are not doing the same thing. The craftsman is a maker of objects which have a purpose in addition to the other qualities he can endow them with. The artist, on the other hand, is primarily concerned with ideas. The good ones are pursuing personal visions of the human condition or the world about us and are trying to find ways to open our eyes to them. The starting points of the craftsman and the artist are, therefore, not the same. One is not higher or lower than the other on any scale of values – they are just different. Many craftsmen do not

understand this. Their sorties into the misty vapours of 'art' often reveal only too clearly their misconceptions and shallow perceptions of what art is all about.

Making an object with a definite use in mind should not be thought of by any craftsman as an unworthy goal. The museums are full of work starting from this premise and representing some of the highest artistic achievements of man. Function is a strong and honourable source of form, but when its demands are distorted in what is often no more than a shallow attempt at 'art' the result can only be something which has delusions of grandeur. The work is saying that it is ashamed of itself; it is denying its own nature; it is putting on fancy dress. There is none of that in this book, but it is increasingly evident and does damage to the worthy name of craft.

The good craftsmen are not seduced in this way and avoid such obvious pitfalls. Yet, while solidly rooted in function, their work does indeed aspire to more than that. It does not strive for novelty. It does

not try to ape the work of the artist. It eschews fashion. It may not even try to be different. Instead it evolves honestly and slowly from the sources of function, materials, and their own selves. To use Adam Smith's comparison, it seeks truth in the sunflower seed rather than in the solar system. As Renée Lavaillante puts it: 'I don't very much like the idea of wanting to do something different. I would rather wait until it happens by itself, until I make an object that is really good. This originality that everybody is talking about – I don't think it is necessary. In fact I think it is quite secondary.' Exceptional work done by such craftsmen may, in due course, be considered as art. But this judgment is not usually made by the craftsmen themselves, for that might presume too much. It is more properly made by others only after the passage of considerable time.

It is not easy to define the special quality, the 'something extra,' that puts a work of craft on another level beyond mere function. It is possi-

bly a sense of timelessness and universality in the piece, an utter rightness, a sense of life or 'dynamic energy,' even some 'hidden magic' or, as one potter put it, 'an inner innocence.' It can be some or all of this, but it is an elusive quality that is not easy to explain and much more difficult to achieve. It is obvious, however, that the best work, no matter what the medium, is much, much more than the mere sum of the parts. When seeing such work one is immediately aware of an inevitability, a presence which can be strongly felt. The work does indeed transcend function and enters a different state. It is this which the true craftsman seeks to achieve. So many aspire to attain it, and so very few do.

The idea that my work should really function in people's lives is very rewarding ... that's really important to me, and the idea that you can have that sort of contact.

It is important for there to be a small number of people who preserve actively some values which are not in contemporary use but which are, nonetheless, very important ... and which have been swept away during the rush of the last fifty years.

John Reeve, potter

It is perhaps worth considering why craftsmen and their work are, or should be, important to us at a time when the machine has eliminated our dependence on them. It is, of course, the machine and its electronic children which have made us what we are – a society in which people live compartmented lives deprived of real contact with real things. Work for many is an activity with little real meaning, separated by traffic jams twice a day from an increasingly synthetic suburban family life. It is becoming

harder and harder to locate a reality with truly human values in this cold, computer world.

Craftsmen are important because of what they make and because of what they are. It is unfortunate that for most of us the only contact possible with craftsmen is through the objects they make. There is more, perhaps, to be gained by knowing the craftsmen themselves. Still, the object alone has value. It has meaning because of the attitude of the maker, the imprint of that attitude on the object, and the small but vital embellishment that object brings into our daily lives. Through their work, craftsmen can inject an extra quality into everyday things: not only uniqueness but something more that is only in the gift of another human being – the thought, time, and love spent in making something to be used and cherished by someone else is the nature of that gift. This is what makes the work of the craftsmen important to us. Through it our lives can be enriched and the minor rituals of the home enhanced.

The craftsman puts much of himself into his work. It is part of him and retains much of what he is. His work embodies his values. As David Orban says: 'The fact that things are created with love and care is what craft is all about.' This contact, through the work, with another human being is what is particularly special. To be able to feel closer to the source of something of real value, and to bring some of that into one's own life, is perhaps not a large thing, but it is a precious one.

We can benefit from what craftsmen make, but more significant is what those craftsmen are telling us through their own lives and thought. They have found something that has been lost or cast aside in society's rush towards tomorrow. They have in a sense rediscovered a reality that for them at least makes some sense in a confused world. Their values and objectives are quite different from those of most people today. Through their own thought and effort they have, for the most part, arrived at an

approach to living which integrates the different parts of their lives. They have found fulfilment and joy in their work; they try to live in harmony with nature and their fellow human beings; and they wish to impart, through what they make, some of this to others. Their lives are in tune with what they believe. These values are not new. They are to be found in the past, but they have even greater relevance for us now. They should be preserved and cherished in a world that seems to care little about such things any more. The craftsmen – what they do, how they live their lives, and what they believe – are indeed important. From them we can learn something of a reality many of us are no longer in touch with and might wish to recapture for ourselves.

HART MASSEY
Canton, Ontario
May 1981

ACKNOWLEDGEMENTS

Since this book would not have happened without the collection on which it is based, the two are inseparable. It is right, therefore, that the Massey Foundation should thank all those who have helped us in both endeavours, making the collection and producing the book.

The Massey Foundation would, first and foremost, like to express its gratitude to John Flanders. He was commissioned by us to photograph and interview nearly eighty craftsmen across Canada. During two summers he travelled from coast to coast, spending many long, arduous days talking to craftsmen and photographing them in their workshops. Later he also undertook to photograph some of the objects in the collection for this book. The latter commission was accomplished in what now seems like an impossibly short time. All the photographs on the following pages are, therefore, by John Flanders, and much of the text has been taken from his interviews with craftsmen. We are grateful to him not only for his professional skill but also for

his commitment to this project, his unflagging interest in it, and the unusual sensitivity he has shown to its special needs. The Massey Foundation is much in John Flanders' debt.

Assembling a large and diverse collection such as this required the help of many people. From the beginning, the Canadian Crafts Council in Ottawa has been most helpful, not only in receiving and recording the hundreds of objects arriving from all over Canada but also in making available information about craftsmen in the various regions. We are especially indebted to Orland Larson who was, for a time, president of the Canadian Crafts Council, Peter Weinrich, its executive director, and Manon Dubé, his executive assistant. Mariette Rousseau-Vermette, then a director of the council, joined us on some of the early buying trips. She was a delightful travelling companion and brought not only broad knowledge of the crafts but also good judgment to the task.

In each province of the country

we depended heavily on local people for their special knowledge. Some were local directors of the Canadian Crafts Council; others came from provincial crafts organizations, worked for provincial governments, or were simply knowledgeable individuals. In all cases they gave their time and much invaluable information. As the result of their efforts, our job was made much easier and far more enjoyable. Two should have special mention. In Newfoundland, Colleen Lynch, then working in the government department concerned with crafts, seemed tireless in her efforts to bring to our attention the work of Newfoundland and Labrador craftsmen. With her help we were able to accomplish much more than would otherwise have been the case. In Nova Scotia a similar and more extensive role was played by Joleen Gordon, whose research into the traditional craftsmen of that province made possible the inclusion in the Massey Foundation Collection of many surviving old crafts which, without her, would

have remained undiscovered by us. Because of problems of time and distance, she also made many of the actual purchases and arranged for their shipment to Ottawa. The Massey Foundation is most grateful to her for what she has done on our behalf.

When we make buying trips in various parts of the country, the available time is packed to overflowing. During long, hard days we meet and talk to many people before we must move on to the next place. That on occasion one or two of our wives should have joined us on these journeys was a great bonus and made it all go more smoothly. At some risk of embarrassment to them we want, therefore, to express our thanks for the contribution they have made.

Making the collection and preparing the written material for this book has entailed much office work. Apart from the typing of several drafts, much correspondence, and many lists, almost eighty interviews with craftsmen had to be transcribed from tapes. This was

largely done by Kathleen McHugh, who gave many long hours to it, meeting at times quite difficult deadlines. The Massey Foundation is grateful to her for her interest and for all she has done to help us. At certain times the work was just too great for one person and we would, therefore, like to thank Ruth Surman for her assistance on these occasions.

We owe much to the University of Toronto Press for their part in bringing this book into being. Its final form reflects the skill of William Rueter, who designed it, and we are grateful to him for the important role he played. The editing of the final text was the responsibility of Ian Montagnes and Jean Wilson, for which they both deserve our thanks. But most particularly we would like to express our gratitude to Ian Montagnes, the general editor of the Press, who supported the idea of this book with enthusiasm from the beginning and skilfully guided it through its various phases. He and Will Rueter deserve credit for transforming the original mass of ill-organized material into the final distillation evident on the following pages.

The craftsmen themselves have, of course, made the biggest contribution to this book. They form its subject and substance, both through their work and through the glimpse they have permitted us to have into their lives and thought. It is a fascinating and important record and we would like to thank them for making it possible. We greatly hope that they will be pleased with the resulting book. It is, after all, really their book and is in many ways a tribute not only to these particular men and women but to all Canadian craftsmen and what they represent.

Hart Massey, Chairman
Denton Massey
Geoffrey Massey
Vincent Tovell

The Massey Foundation

The Traditional Crafts

This book is primarily concerned with men and women working in what has come to be known as the 'fine crafts' – those which have, to some extent, been liberated from the exclusive and rigorous demands of daily use. But there are still craftsmen who must obey these demands, and it would be unwise to ignore them. Included here, therefore, are several of these last Canadian survivors of a tradition stretching far into the past. In some cases they are self-employed, but in others the work is produced in small shops employing several craftsmen. More are to be found across the country, but these are representative: they are here for themselves and for the link they establish with the ancient roots of craft.

The people photographed on these pages – the boatbuilders, tinsmiths, coopers, harnessmakers, and others – survive because their work is still valued and needed in their communities. They are largely concentrated in the Atlantic provinces, an adherence to older ways,

and for some the sea, being the main reasons for their existence.

Freeman Rhuland is one of the last dory builders still working in the Maritimes: in his spare time, he makes model dories. He works in a shop at Lunenburg, Nova Scotia, as does Vernon Walters, a blacksmith who supplies many of the tools and fittings required by fishermen and boat builders. Ralph Smith, an aptly named tinsmith at Heart's Content, Newfoundland, makes, among other things, the 'quicks' or kettles used on fishing boats: their wide bottoms and narrow tops make them relatively stable and spill-resistant. Much of the tackle used on fishing boats, such as the rigging blocks, is made at A. Dauphinée and Sons Ltd, another Lunenburg enterprise; they also make dory oars, ice mallets, and similar wooden tools.

Some of the other traditional crafts carried out in the Maritimes are land-oriented. The cooperage at Ross Farm Museum, Lunenburg County, is the only place in Nova Scotia still making apple barrels;

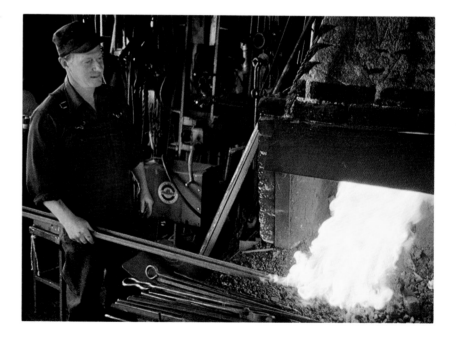

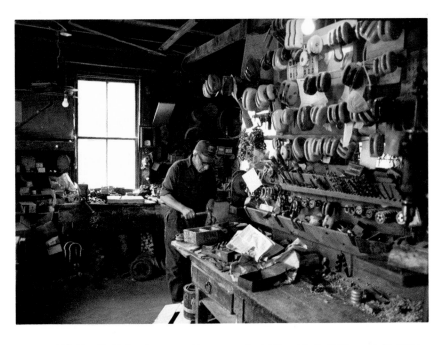

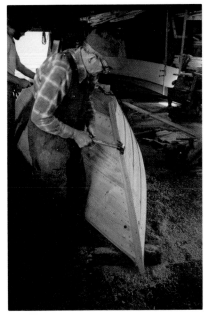

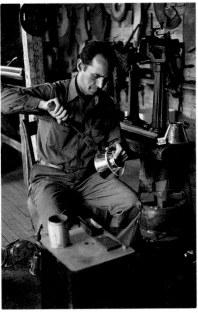

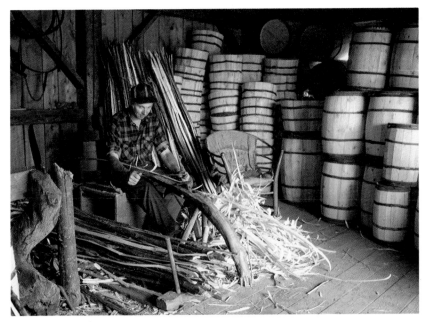

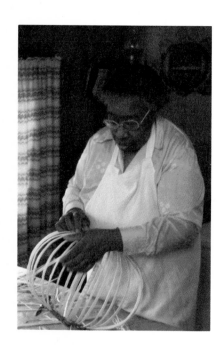

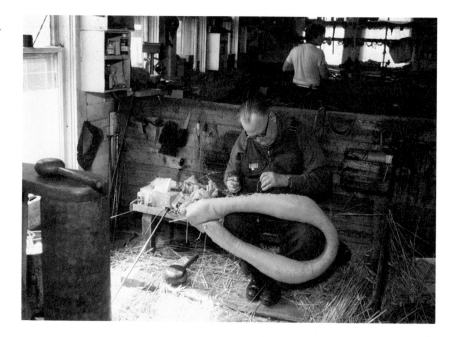

creels and baskets of various kinds. The Sackville Harness Company of Sackville, New Brunswick, is one of the few shops still making harness for work horses. The collar-maker in the photograph, now dead, was Jack Mackenzie; his apprentice, Bill Long, is carrying on the craft.

These are craftsmen of a rather different kind from the others in this book. The work they do is to a large extent repetitive and the creative element small. It is the stringent demands of function that determine their final product, not an urge for creative self-expression. The object simply must work properly for its allotted job or it is useless, as also would be the craftsman. Therein lies their strength and relevance. They show us how important the craftsman once was in supplying the needs of daily life. And they give us a glimpse of a sturdy working functional tradition from which the crafts have drifted.

these are called 'dry barrels' to distinguish them from the 'wet' or waterproof barrels used for fish and liquids. Edith Clayton sustains the craft of basketmaking at East Preston, Nova Scotia; her ancestors came to the province from the southern United States during the War of 1812. She makes fishing

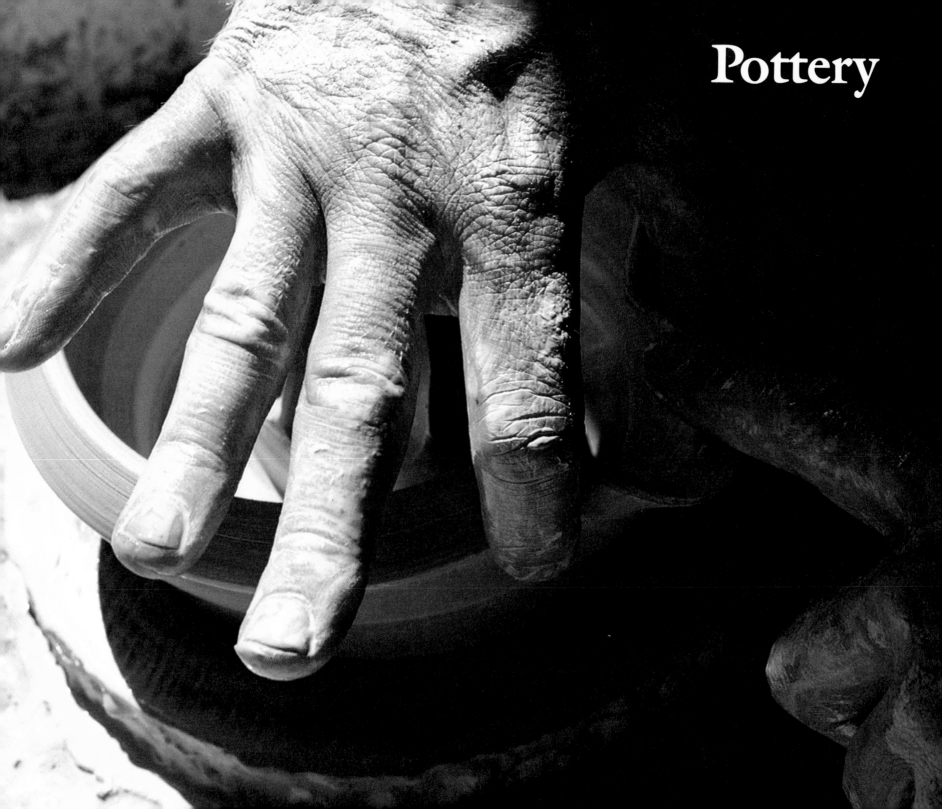

Pottery

John Reeve

POTTER · HALIFAX, NOVA SCOTIA

When I went to art school, pottery departments were very unattractive. They were all literally small rooms beside the furnace. I don't know anyone who went to art school to do pottery. Everyone who did get into it, people my own age, went to do something else and somehow got into the clay room and discovered it suited them. My own reasons weren't very clear and at the time I didn't commit myself, but gradually I realized I was no longer doing all the other things.

I have found a work I really enjoy. I can come to the end of the day thinking that that was not a bad way to spend the day. Such simple feelings are far more valuable than riches or other kinds of power. So I have real power, it seems to me, real power over myself.

Nowadays a potter is not just someone who makes for the local market. He is someone who makes objects with a real concern for the qualities of those objects which exist beyond – not excluding, but beyond – their simple utility. Someone who makes pots with love. That is a

quality that can be transmitted through the objects to other people.

I feel connected to the whole history of art, and the sources for my work are not shells, or clouds, or whatever, but pots and my own senses of pots. All I'm trying to do is make what seems the relevant new version of things. In a way, the obvious aspects of the form are not really what is important. I'm not really interested in committing novelty upon the world, but only in making objects which have some hidden magic to them, which are good objects to use and therefore might make it better to drink coffee.

I like the idea that my work should function in people's lives. That is, it is very nice to have your pottery in collections – who could deny that? – but it is more rewarding when someone says, 'I have this cup of yours and I drink my coffee from it every morning.' That gives me a sense of having an effect, that my work should insinuate itself in that way into people's lives. It is not viewed in a purely aesthetic way, like when we go to the art

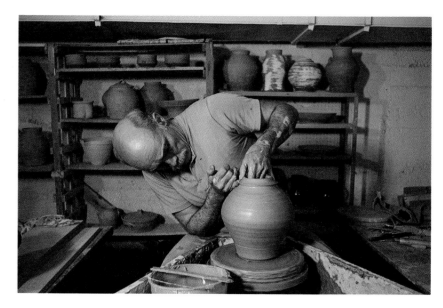

gallery on a Thursday evening in order to look at art, but really enters into the ceremonies of people's lives. That's important.

As well, the objects are sort of a model for me, aside from what they might be for other people. They are a way for me to try to embody values. When my own life is so complex that I can't make it work well, the pots are a way to work at

that. It is the clay that centres me, and that's the way I want it to be.

There is a time to think and a time not to think in regard to my work, and the thinking should all be done before the working begins. Once the working begins you should rely on your grammar of knowledge. At best, things come more directly from your skills than from your silly little ideas.

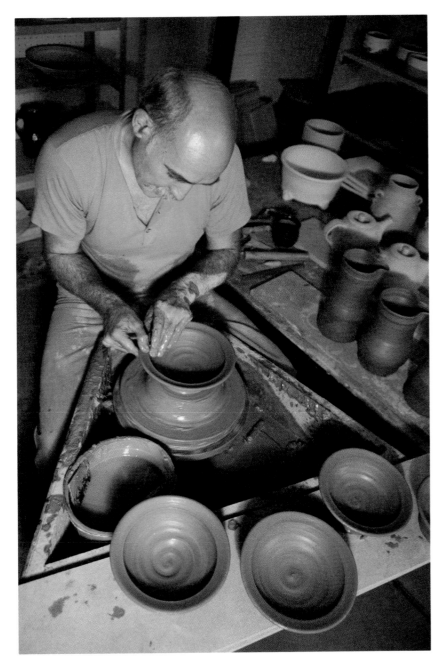

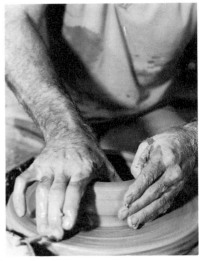

We have lived in a brain-over-rated world where we have placed far too much value on brain processes. I think the brain is not really the centre of the human being. It's only one of them, and for me the work must come from some centre, not from ideas. Ideas are a dime a dozen, kind of trivial. Occasionally people pass by and say 'How on earth can you have all the ideas?' and I don't know what to say because it seems to me that what you do with ideas is try to get rid of them; they are underfoot like pieces of paper. What is important is to learn how to transmit what you know into the actual material, how to let things become.

The older I get, the less I understand specifically what it is that makes an article special. It seems to me to be like a person: when we meet someone we think somehow special, no matter how we cut and slice it, it always seems to be greater than the sum of the parts. I think objects are like that, too. No matter how you count them and weigh them and measure them and try to define them, there is some kind of quality which is greater than all that. I don't know what it is.

One of the great costs of the industrial civilization we live in is the separation of people from their work and ultimately from real contact with their own lives. People become more and more adjusted to the pace the machines set for the world and the means of production and the systems of selling things, and so we line up patiently to buy rubbish that is overpriced and of no great use. It is critically important that there be some small trace of people who still understand how to make things. The time will come when it's more and more important. I think already people are far more interested in real things, in the sense of things not manufactured, than they were five or ten years ago.

Covered stoneware jar 1976
6" d. × 10" h.

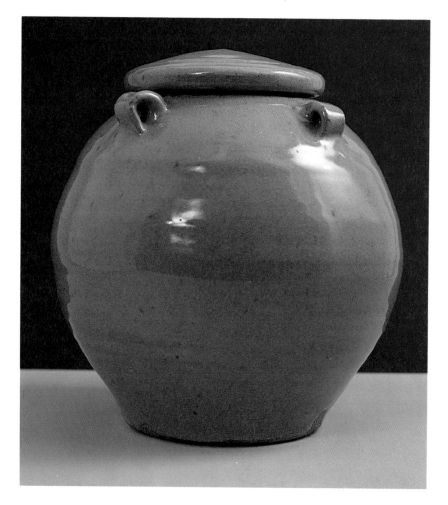

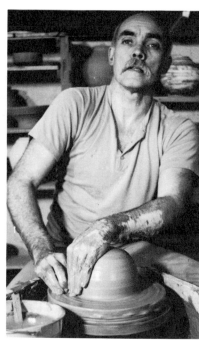

Craftsmanship is a very special quality in things people make. I guess things made with real care and with real attention for quality are things made with craftsmanship. When I was young I was very lucky to have met, largely out of my own curiosity, a number of old-time carpenters and tradesmen, the like of whom hardly exist any more. These men had no pretensions to art whatsoever, but they were fiercely proud of being able to do a good job. If the work wasn't right they would rip it out and do it again. They had from that a self-respect that really impressed me and which I have never gotten over. The sense that it is really a good thing to do work well. It's perhaps not a popular idea any more but it's an idea that is talked about a whole lot where I am. And the best students begin to understand it.

Renée Lavaillante

POTTER · ROUGEMONT, QUÉBEC

I never thought of pottery at first when I was little. I didn't even know that pottery was a trade. When I was grown up I was fascinated, like everyone else is, seeing someone throwing a pot on televison. Everyone is always fascinated. But I only started to think about it when I realized that it was impossible to continue my studies, that things had become impossible. On my way to university, I often walked by a potter's workshop. One day, without really thinking, I went in and asked if I could work there, and that is how it all started. At first, it was just one way of getting out of a dead-end street. In the final analysis, this is what I needed.

Perhaps it was the way one works when doing pottery – you have both hands in it and it is a very sensual thing. To me, hand contact is a rather natural thing. I won't pretend that I was attracted by things like colour. It was making shapes – to start from scratch, to make a shape, an object, which is going to last a long time, which is going to be used by people.

I don't consider myself as an artist at all. To me, things like inspiration are completely unimportant. What is important is work. I don't believe in inspiration. I never had the impression of being inspired in my life. Let's say that I look a lot at pottery: pottery made by others, pottery found in books, pottery in museums. I make sketches of pots, I sometimes sketch the pots of others, pots in museums. I also sketch the pots I feel like doing, but to me inspiration means nothing. It's simply work. When I feel like making a bowl, I wonder what kind of bowl a person could be comfortable with, how easy it is to drink from, how easy it is to hold, how well it can hold a liquid or a solid. On that basis I make a bowl. It is not an idea that just comes to me from heaven.

What often happens to me is that I make something almost without thinking about it; then I either throw it away or keep it. Going on from that basic idea, I continue making other things – like my jugs. At the beginning, I wanted to make a jug. The first one I made was very

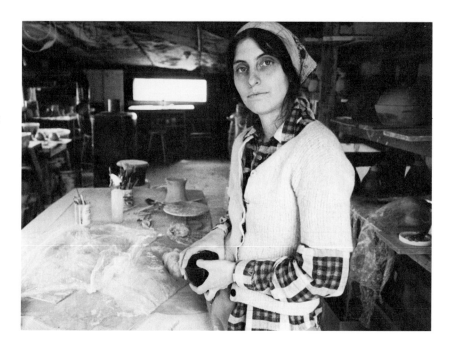

haphazard; from there I developed my own desire for what I wanted as a finished form. I tried to get closer and closer to what I had in my head, what I tried to define for myself over the years – the ideal shape that I had in my head. Time is important. If I have an idea for an object, I won't arrive at the right form by

making a thousand copies, but rather by pursuing that form over the years.

When you look at a lot of pottery, some things seem to be completely amorphous, shapes that have no tension whatsoever. Sometimes you get the impression that a piece could be anything, even if it is well

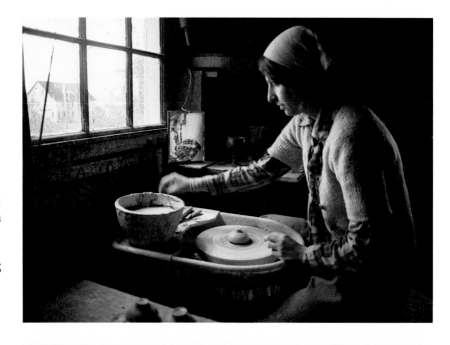

made technically. You don't feel that there is a line of thought behind it. You can see that better when you look at many pots by one person. When you only have one piece in your hands, you may be quite wrong in your judgment, but when you are looking at a good sample of someone's production you can feel whether there is a soul behind it or whether it is all just a front – pots made from the outside. These concepts are difficult to describe; they are even difficult to feel. It is only by looking at many pieces of pottery, talking to other potters, reading about it, that you feel it a little. But I would say that I am beginning to feel it.

I have friends who say that a great potter cannot be someone stupid, but that's wrong. That's why I talk of the soul of the work rather than the soul of the person. In the final analysis someone who is very unlikeable can do work with a lot of soul, work that is very beautiful, very much alive.

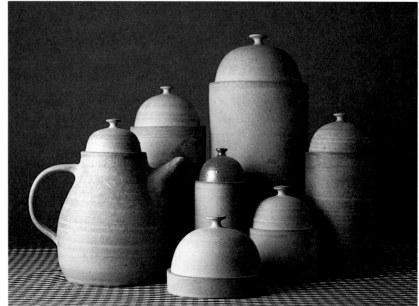

Stoneware teapot 1978
5″ d. × 8″ h.
Covered jars 1978
3″–5 1/2″ d. × 6 1/2″–13″ h.
Sugar jar 1978
3 5/8″ d. × 4 1/2″ h.
Covered butter dish 1978
5″ d. × 3 1/2″ h.

Wayne Ngan

POTTER · HORNBY ISLAND, BRITISH COLUMBIA

When I came to Hornby Island, about 1968, I had no money. I was living in a chicken coop, just a temporary shelter that lasted four years. The first thing I did was build a kiln. It had no shed, just a few pieces of plywood. Then I began making pots. At the same time I began building with the help of a friend on the island who is a good carpenter. We found stones and moss, logs and lumber on the beaches: the environment is free, so I built my house of natural products instead of spending a lot of money. There is lots of driftwood. I show the best parts of it; the parts I don't like are inside the walls, but the best parts are where they can be seen and touched. That's how I built my home and my studio, the same way I like making pottery, using the local materials as much as possible. That way the building or the pot has a way of belonging to the environment.

I started playing with clay as a child in China. We were very poor, but I was born in a country with a lot of clay. I would watch over the water buffalo and take them where the clay was. I made toys of it. Now I do the same thing, except when you become older you become more conscious of what you are doing.

You can never produce the same pot twice. It's like trying to speak the same word twice, with the same sound and feeling; you never can do it. You think you can, but you can't. This particular blue, for instance, is a very beautiful blue. To try to make another like it could take many, many kilns and you still would never get the same blue because something unique has to happen – exactly the right firing, the right timing, the right ashes, the right temperature.

When you make a pot you involve the whole body. Your body contains three parts: the head, the heart, and the limbs. The head is for thinking, the heart for feeling; the limbs connect them. Western and Oriental pottery are very different. The Western pot is very much an idea. If you buy *The Ceramic Monthly* you see that Western potters want to be unique, but it's just

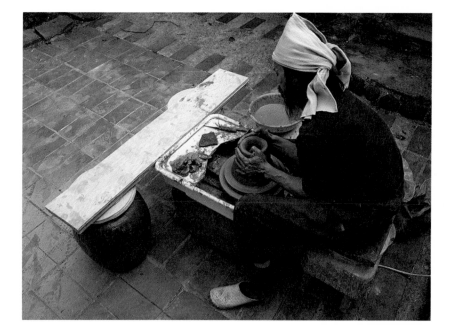

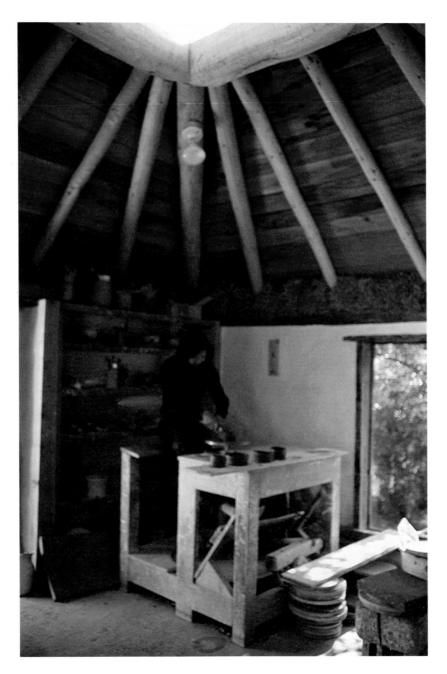

Stoneware bottle 1977
6″ d. × 8″ h.

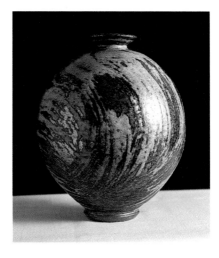

the head wanting to make that kind of pot. That's why the pot doesn't have much feeling: the idea is not digested in the whole body, so when the pot comes out it is just content. Oriental pots feel.

When you are making something it is direct communication. You kick the wheel and start the energy that way. You receive it through the hands. You complete the circle: the clay is between your feet and your hands.

For me, sitting at the wheel is like putting energy out and having it transformed. It's like talking to yourself and putting yourself wholly into that moment. You know exactly where you are in that spiral of energy. A pot is a container with a million particles in it. When you are pulling up a pot you are making a very important statement; you are putting your energy exactly where you want it. After you have done that for a while it becomes automatic and then the pot is born without notice. In the beginning you have to make a conscious effort, but when you have worked for a while, made maybe fifty or sixty of the same shape, you don't have to watch to make it. You can close your eyes and the pot comes without any effort. That no-effort pot has the kind of freedom you can't achieve by thinking. The pot speaks for itself.

I prefer a primitive kiln, a wood kiln. When you cook rice on a wood stove, the rice tastes much softer and more human. On an electric stove it is very dry and doesn't have that natural taste. I

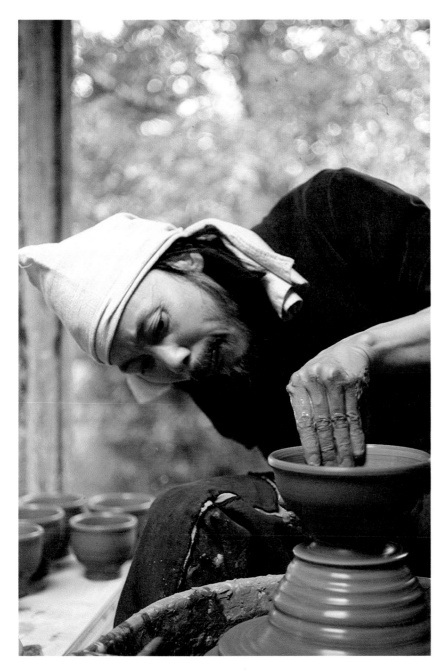

Stoneware vase 1978
9″ d. × 10″ h.

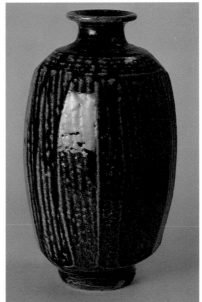

If your whole being is caught up with the electrical machine, you don't make better pots and you won't be a better person either.

My way of life, my way of being a potter, and my way of building are all the same. I don't know if you would call them spiritual. I'm just a peasant potter living in the twentieth century, and it is not easy for me because the twentieth century wants to speed me up. But the other side of me wants to slow me down, and all the things I learned in school I have to unlearn.

think it is the same with pottery. When you fire with wood the glaze is softer. When you fire with an electric kiln, you turn the switch on and that does the work for you. If you use wood you participate with the element of fire. You really get into it because you are sweating for hours.

Covered stoneware jar 1975
9 1/2" d. × 9" h.

Raku bowl 1977
6" d. × 6" h.
Raku jar 1976
8" d. × 8 1/4" h.

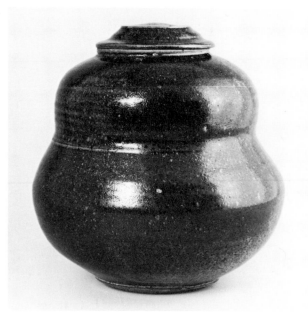

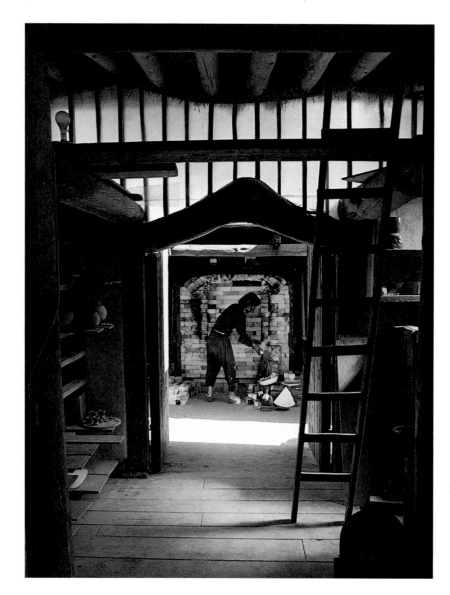

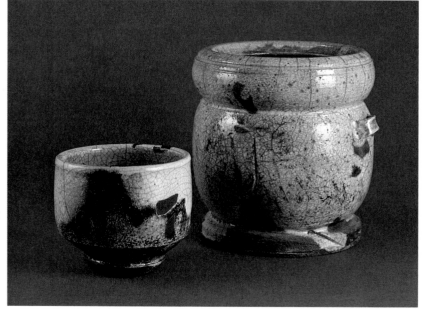

Tony Bloom

POTTER · CANMORE, ALBERTA

I got interested in ceramics when I was living here in Canmore and wanted to build a flute for one of my brothers who's a musician. I'm not sure where I got the idea I wanted to build it out of clay, but I went to the Banff School of Fine Arts and worked on it. It took two months to get the sand out of the first one, so between firings and the development of it I started making pots to pass the time. I turned professional within about fourteen months.

I'm still making flutes. They are made out of porcelain. It's got a beautiful timbre. I've also made drums and horns, and a lot of percussion instruments. It's a break with tradition, but I'm certainly not the first person to make a porcelain flute. They made some really beautiful ones back in the Renaissance.

I like the feel of clay. The French have an expression, roughly, that clay is a whore: it has no imperative, it's just a pushover, and it is nothing more than what you make of it. That's a rough way of putting it, but it's also affectionate.

I really enjoy having a potting wheel around. On days when I'm feeling less than a hundred per cent on the creative edge I sit down and I throw. I throw forms that I have worked out, so that I feel them and react to them on the spot, rather than reacting to them as a whole form. I've never sat down and thrown fifty pots like Wayne Ngan, but I can see how that could happen. What I do is make juice glasses by the score. But I've got it down: I can't say that the ones at the end are any better than the ones I started with. When I sit down to throw a pot, at some point in my past I've already gone through the design problem, and come up with an answer, so by that point it's more like a formula I can follow. Of course, there are always variations within it. That's what makes it interesting. You come up with the design first. You do the initial work on that hot edge, and from there it's pretty cold.

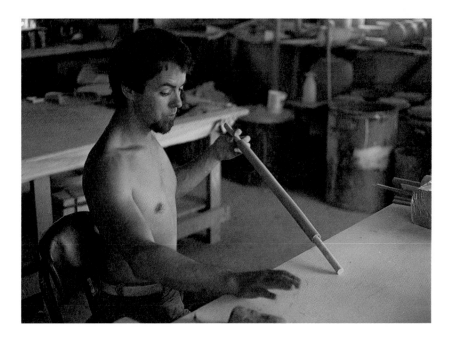

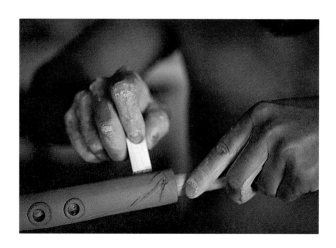
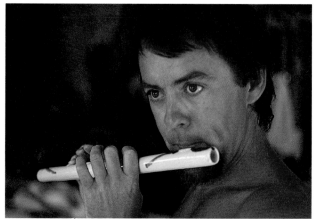

Porcelain flute 1977
15 1/2″ × 1″

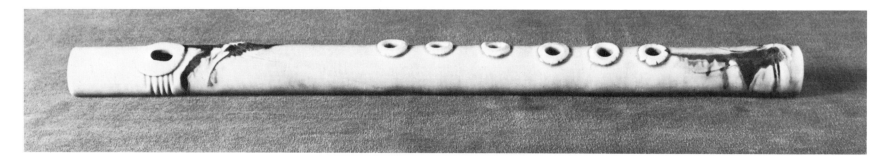

David Taylor

POTTER · DAYSPRING, NOVA SCOTIA

What draws me to pottery is the combination it brings. It's sculptural, painterly, and functional. It's also a way of making money, of being independent. I try as hard as I can to make enough money to be reasonably comfortable. We live here in an old country store, about twenty feet from the bay. High tides in the spring, maybe once a year, the river comes over the lawn.

People don't come into our shop sometimes because they think pottery is high-priced. Well, pottery is high-priced, that's all. But it doesn't hurt a person to come in and take a look and just see what you do. It's always a compliment if they look, whether they buy or not.

I like to work on the wheel, but I always try to carry it a little bit further. What you do, you can throw a piece, you can cut it off, you can foot it, and you can glaze it, and that's it. But normally I throw the piece and foot it and if it's a shaped work I'll maybe change it into a square – making a transition from a circle on the bottom to a square at the top, just to make the

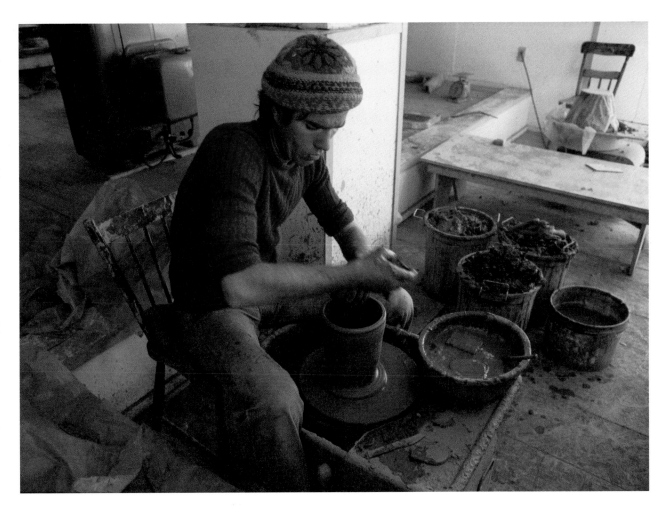

Stoneware plate 1977
13 1/2" × 13 1/2"

Stoneware vase 1977
4" d. × 10 3/4" h.

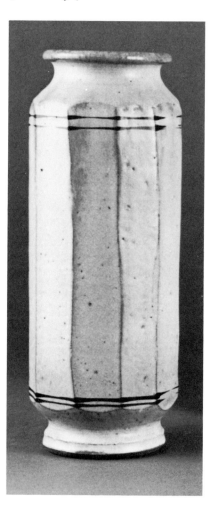

piece a little more interesting – or use brush work or a carving or stencils, or whatever I can.

I don't like to be too conscious of making marks in pottery, but I use a wooden tool sometimes and I'll just move my arm a bit, sometimes unintentionally, and leave a tool mark in the piece. Or maybe the piece is distorted a bit because it's been handled. I like to see things that have been handled by people, to feel that the thing really is hand-made.

Take a piece that has been made in a press mould, maybe eight thousand years ago. There are thumb prints in the back because a wad of clay was shoved into the mould and that's how the piece was made. Whoever made it could have finished it really well; he could have pol-ished the back and left no evidence of human contact. But to me those thumb prints show part of the pro-cess, how the piece was made, and that's really important. How are you going to describe to someone eight thousand years from today what the machine looked like that

cast that cup? If you see thumb
prints, at least you know that it
started off with a human being.

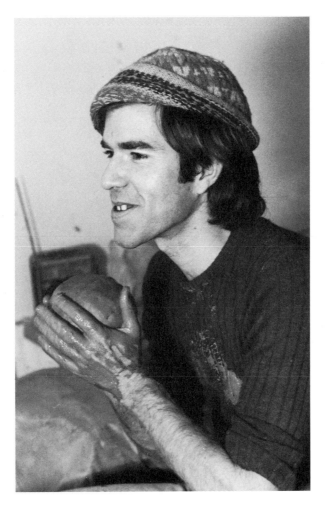

Enid Legros

POTTER · PASPÉBIAC, QUÉBEC

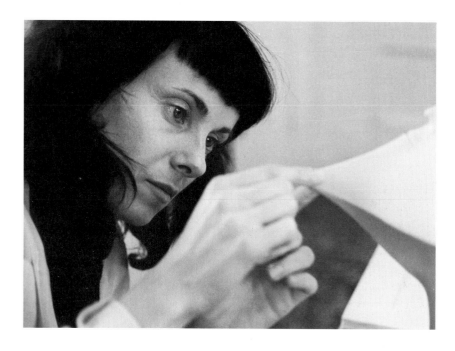

I've always liked clay. I used to play in the mud as a kid and I still have this thing about mud. I always laugh about it because when I was a kid I would get scolded all the time for getting dirty. Now it's my work. I make a living from it.

I'm really into materials and I love tools. A lot of my ceramic tools I've made with other tools. There is nothing more frustrating than a tool which is dull or doesn't do what it's supposed to do, a tool of poor quality. It's a great pleasure to master the tool, to be able to accomplish a certain job with that tool. I have a mechanical mind. I have an eye that can figure out mechanical problems and come up with new ideas related to them.

The thing that I love about porcelain, which I work in, is its translucency and its whiteness. That's very, very special. Translucency is the quality of light going into the ware and coming out again. Even if you don't have a light behind it and you can't really see the translucency or appreciate it as such, it has that quality of playing with light. It's just like silk.

When you know what work has been done you can draw on other people's experience, and I do that all the time, of course, technically as well as aesthetically. But a lot of my inspiration comes from the things going on in my life at the time. For instance, I'm into birds and birds' nests and flowers – these are things I've always had contact with, growing up in the Gaspé. I've done some star-gazing; I really get off on the Northern Lights. I'm very practical in a lot of ways, and yet I try not to get bogged down in mundane things that are heavy or routine. I try to maintain a romantic ring about my life in general. I think that life is not worth it if it's not happy. It's great to be learning things – it's very, very important – but it's important to be positive and happy and draw everything that's good from experience. If I'm feeling good physically, and I usually am, I find there is just a little excitement about absolutely nothing at all and if you can maintain that then it's very nice. I try to get this out in my work. There is a touch of whimsy in a lot of my work. The work itself, in a sense, looks serious – technically, it's serious – but I like the fun, the whimsical overtones to it.

To do this work I had, of course, to learn expression, visual and tactile expression so that I could express something personal. At first I felt very much that I was a craftsman. I was very taken up with the technical aspect. You have to be, with most things that you are doing, until you master the technique. Until then, especially in ceramics, you are really the servant of technique, but as you become more proficient it becomes secondary and then you are able to go further and express things that are more personal. As I get to that point more and more I'm finding that I'm less of a craftsman – or perhaps it's not that I'm less of craftsman, it's just that I'm less conscious of it and more and more conscious of the artistic part of myself. In talking about myself as an artist, I'm talking about pieces that are one of a kind.

Right now, this year, I'm in a state of transition. I love porcelain – I have been absolutely infatuated with it – but this year, suddenly, I'm beginning to feel frustrated by its limitations. I don't know where I'm going, but I feel I'm in a state of change and so I'm trying painting,

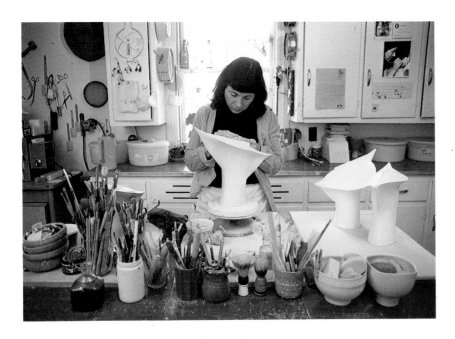

I'm trying sculpture, I'm trying photography. I know I'm going to continue with the ceramics for sure and I love that, but I need other ways to express myself as well now.

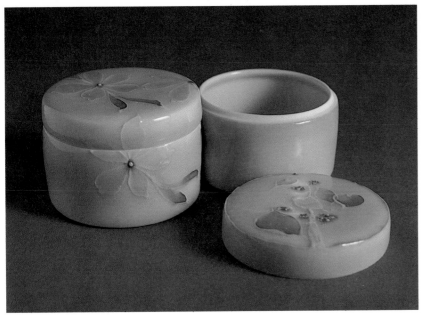

Two porcelain boxes 1979
3″ d. × 2 1/8″ h.

Louise Doucet-Saito and Satoshi Saito

POTTERS · WAY'S MILLS, QUÉBEC

LOUISE: A craftsman is someone who likes his work. First you're a craftsman, and that means you like what you are doing. Also, you have a tremendous respect for the material you are working with. And you learn gradually. We picture a craftsman as someone who is working quietly somewhere. That kind of image is important because you need to master movement.

There is a point in anybody's trade or career when you are learning. You are still a bit awkward with some tools, you don't have the easiness, things are an effort. Suddenly you reach the part where it comes to you and you become a master of your work and then you enjoy it. Then you can communicate with anybody.

SATOSHI: It can be very lonesome, too. That means very often that certain things which are very important to you, you cannot communicate to the majority of other people.

LOUISE: But there's the joy of achieving something that, suddenly, we think has reached maturity and belongs to us. It's our creation. To be able to communicate with someone through that kind of work is a fantastic joy. And it happens without words. It's as if we don't need to exist any more; the piece exists and can go ahead without us.

When I am on the wheel I feel that my eyes are not in my head, they are in what I am doing. You have to develop your hands so that you feel you have your eyes at the ends of your fingers. I learned to work with my hands and never used tools on the wheels. But when I went to Japan I found they would use tools to shape a pot or to emphasize a shape. For me, at first, it was almost like cheating.

If there is an influence on our work, it's in art created by pre-Columbians or Greeks or Egyptians or Etruscans. I feel very close to their proportions, to their sensitivity to the material. They had the capacity of choosing, of putting a fantastic generosity into shape.

SATOSHI: Sometimes Louise and I come across some shape, and we take a piece of drawing paper and

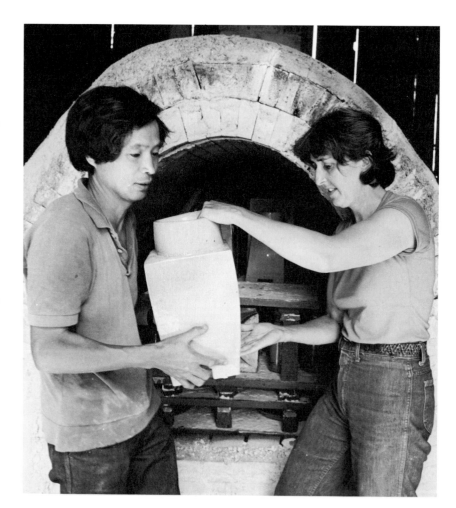

Three stoneware plates 1978
8", 9", and 10 3/4" d.

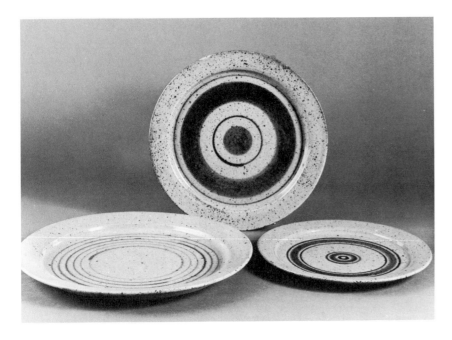

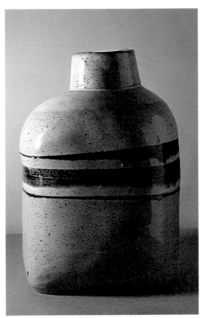

Porcelain vase 1978
12" × 15" × 21" h.

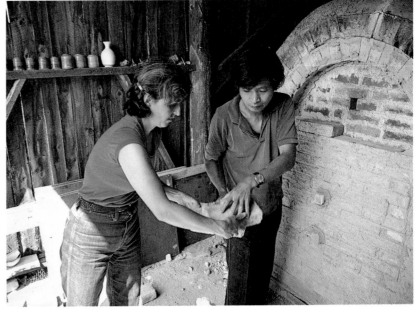

start a shape from it. We try quite a few times but it never works. It's very funny. And then, after trying, trying, trying, one day we do a piece that gives exactly the understanding of that shape, and we are very surprised.

LOUISE: We have always been interested in good-looking shape. We are very selfish, in the sense that we want to go ahead with our way of doing, our way of thinking, and we want to develop our shape because we feel that it belongs to us. We worked for it, we researched, we got the material we wanted, we really went from one extreme to another.

Tam Irving

POTTER · VANCOUVER, BRITISH COLUMBIA

I never had any formal art training, but my father was a very good water colourer. In a very traditional sense he was quite skilful. We went out, as kids, on painting expeditions and I would have my little paint box and he would have his. So I did dally a bit with water colours, but that was the only kind of formal art training I had. My mother was a hobby potter when we were in Portugal for a time. She bought an electric kiln and we used to rent one of the local potters to come in and throw things that we could decorate. We went through a phase of interpreting local folk crafts for wealthy Americans and made the most appalling things. I became very good at hand-painted tiles, a hot number in those days.

Anyway, many years later I was working for an oil company in a laboratory. It was a job I knew fairly early I couldn't become involved with, but I stuck it out for seven years and moved with it from Vancouver to Winnipeg. There I started, once again, to think about clay. I took night classes, and then I started making pots in a basement at night and had a small exhibition. I was getting more confidence in my own skills, so I sold all my belongings, left Winnipeg with nothing but the clothes on my back and a healthy bank account – at least it was healthy in those days – and spent a wonderful summer at a crafts school in Maine. Then I moved back to the west coast.

I'm really hooked into pottery now; I wasn't when I first started. It was a necessity; I had to earn money and I liked to make things. It was an escape route in that I couldn't see a future as an executive in an oil company.

As a potter, I have been able to do some things that are more concerned with – how shall I put it? – the expressive gesture. I find that satisfying because the values you apply to your craft inevitably overflow into other values in your life which you might think are rather peripheral. Somehow pots have a very important bearing on the way you see life.

There are so many marvellous

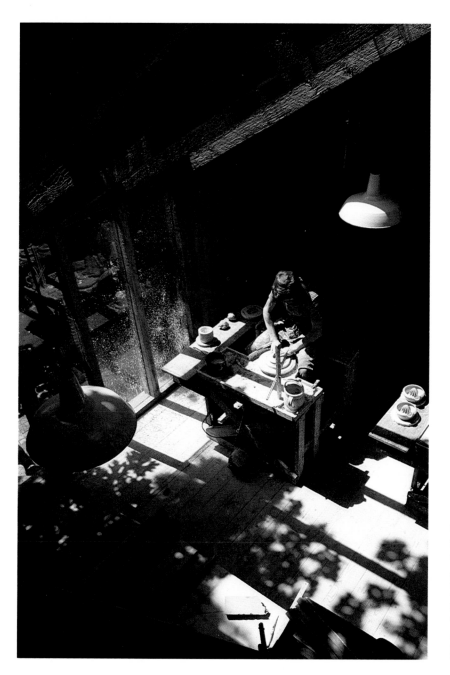

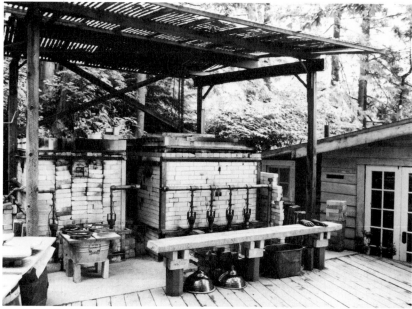

aspects to a pot. It is a vessel and serves that utilitarian purpose. At the same time it can carry all sorts of spiritual values, and that's what we lack so much these days. We tend to live in a bit of a spiritual desert. The objects we have around us are pretty hideous, most of them. Go into any department store and just take a look at the merchandise: it's inhuman.

I'm not able to sit down and think up a good pot. Any time I sit down and try to intellectualize something I'm going to make, it doesn't work. You have to simply work and hope that something will come out of that work, almost in spite of your-

self. I think those values apply to life generally. You cannot intellectualize your life; you have to accept what you are, your limitations, and be what you are.

I love materials and tools and I like to make tools that are beautiful in their own right. I make most of my own tools or find them. And I make all my own glazes from materials which I go out and find myself. I buy very little in the way of commercially prepared materials. Some of the feldspars that I use I find in the province: I go out and collect them in rock form, and I do all the cutting and all the milling. I derive a great deal of pleasure from knowing that the glaze that I have on this pot is made from these materials. I know where they come from; I can visualize the actual outcroppings. That is a very satisfying use of my environment.

Craft is the skill one has with one's tools. With art I associate words like vitality, life, movement. Art is a metaphor for life. I see things that have all kinds of craft, that are very skilfully made, but they are absolutely dead as doornails and they don't interest me. So, while I think craft is very important I, personally, want to see work that gets beyond that. I want to see work that really lives. I look for a point of view in pottery. I look for feeling, for character. These are, perhaps, rather vague words. I look for a sense of form and by form I don't simply mean shape, I mean the relationship of one thing to another, the counterpoint of line, rhythms, and I look for a work that is convincing. In a work that is complete, all the parts reflect the spirit of the whole. I strive for that in my own work and fail most of the time, but I hope I slowly get a little closer to it each time.

Like everything else in life, part of it is fun and part of it is hellishly hard work. Basically, however, I think it's a pretty good life. But it's not quite the romantic thing that people think it is.

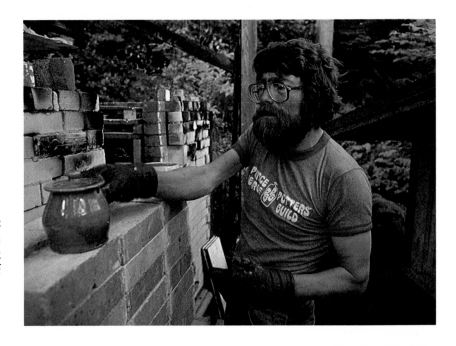

Stoneware plate 1978
Tenmoku and celadon glaze
13" d. × 2 1/4" h.

Stoneware watering jug 1976
11" d. × 9 1/2" h.
Two stoneware bowls 1976
9" d. × 6 1/2" h.; 6 1/2" d. × 3 1/2" h.
Stoneware funnel 1976
5" d. × 5" h.
Stoneware lemon squeezer 1976

Stoneware jar with lid 1978
10" d. × 13" h.

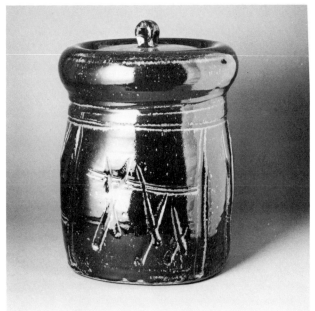

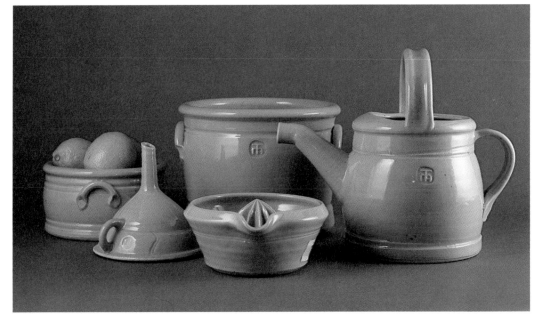

Ruth Gowdy McKinley

POTTER · MISSISSAUGA, ONTARIO

I had always liked to draw, and what I drew would be designs I thought might go on dinnerware. This goes back almost to kindergarten. It could hark back even further, to the ladies in late Victorian and turn-of-the-century times who painted bisque. My mother had some of it around that she and some of her friends and her great-aunt had done. They would buy bisqueware cocoa pots and cocoa sets and decorate them. Then the pots would be whisked away and glazed and fired. The idea of drawing designs that could be put on dinnerware fascinated me.

At first I had only this idea of decorating, of surface embellishment. But when I began to study it was like all the windows were suddenly opened. Here were people making the whole pot and then choosing to embellish or decorate it or not. This, to me, was incredible.

I like to make forms that sit in space. I like to make the forms very clear so that there is no question in the viewer's mind as to whether I meant it to be a little higher or

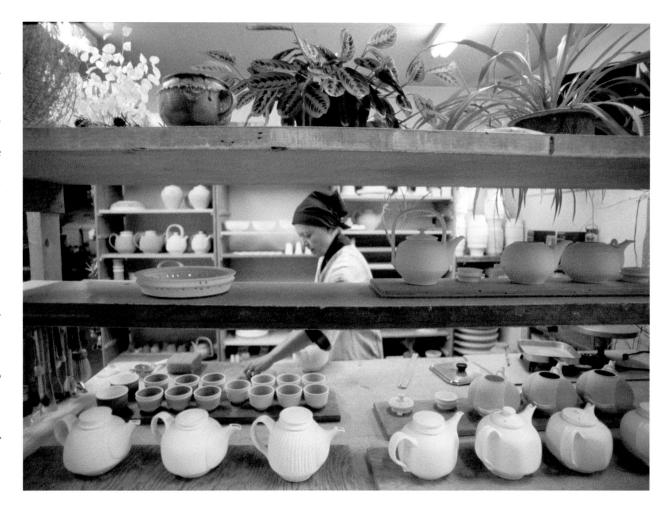

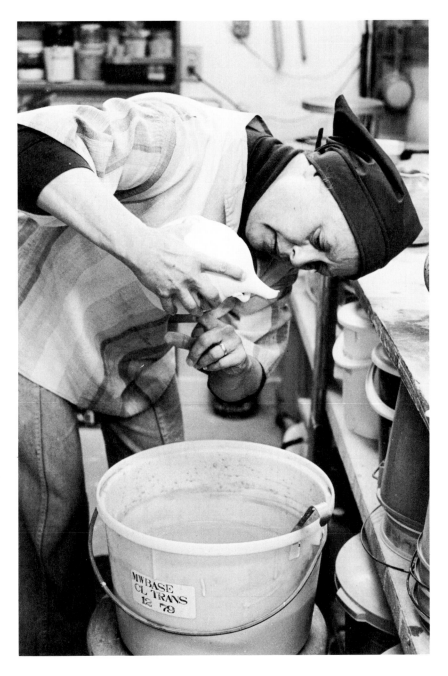

wider; the curve doesn't hesitate from foot ring up through the belly to the lip, or if it does it makes a clear change in direction. It's much like music. There, there may be an andante passage, a sostenuto passage, and these things are well-defined and marked. Some of that happens in pots. Some pots are very much allegro and move along, and others are just moderato, they move at a walking pace, not too excitable or excited. But the form should be clear, just as the function that the form states should be clear. If it is a covered jar, then the cover should not only fit the pot well and be comfortable to use; possibly more importantly, it should fit the piece visually.

Function is important, but the visual quality has to come first. One could have, let's say, an incredibly functional teapot – the best thing that has come down the pipe in centuries as far as function goes – but it could be so ugly that no one would get near it to find out how well it functions. That's an extreme example, but I do believe that a piece has to be inviting – to be beautiful, if you will – so that a person will want to see and feel and experience and hold it and use it.

I've been told I make tight little forms. I prefer the word 'clear.' I know very well that I'm not a spontaneous potter. I do not just sit down and whip out forty-eight pots in an afternoon. That's not to deprecate those who do. It's just a fact; I can't. If I did, presumably only twelve would survive. I wouldn't keep more because they wouldn't be good enough. I cannot work that quickly.

For me, pottery ties in with going to museums. I feel a past presence very strongly. I can remember very clearly as a youngster, probably even a pre-schooler, going into New York with my mother and prowling about musuems. She loved to look at the paintings and sculptures and I would head off down to the Egyptology section. It's curious (and I'm not wanting to be awfully metaphysical) but I'd been there before. I can remember feeling this incredible, powerful feeling of 'Yes, I've

seen that before,' 'Yes, I understand that.' I didn't, of course, but there was that kind of feeling, of awareness.

Well, there is a bit of the sense of reincarnation in my feeling about pottery. All potters living today have it, because we're not doing anything that different; we're really not. We presume to take these materials, and use these materials that were formed so very long ago, and grind them up and pulverize them and wet them yet again, and shape them yet again and, for heaven's sakes, submit them to the fire yet again, and make our own forms with them. I feel a kind of awe and reverence about the material. I feel somewhat like an interloper. The earth has already ground and shaped and formed and blasted and used these materials. They've come to their present state through their trials and tribulations.

If it sounds as though I'm thinking of clay as a living thing, I guess that *is* how I feel about it. Clay is alive to me. It's not just an inert, wet, sloppy sort of thing, and I

refuse to treat it that way. Years back there were pottery conferences that were called 'Mud Works' as if they were conferences about mud. I took such umbrage at it! Mud is mud. Mud is fine, I have no quarrel with mud. But mud is not clay.

Stoneware teaset 1975

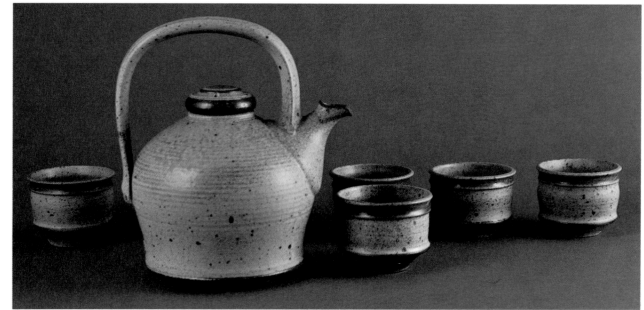

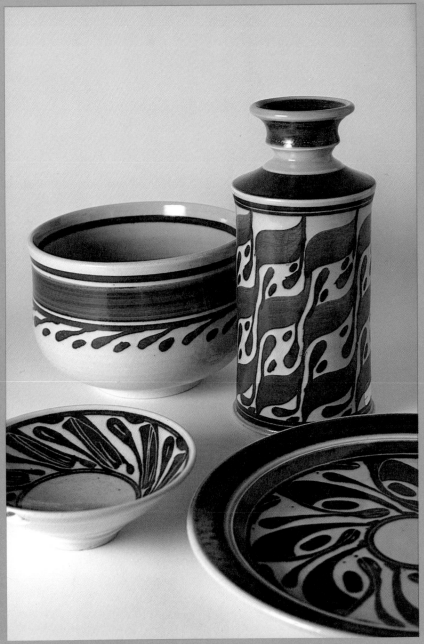

1 WALTER DROHAN
Porcelain plate 1978
10 1/4"d.
Bowl 1978
5 5/8" d. × 2" h.
Bowl 1978
6 3/4" d. × 4 3/4" h.
Vase 1978
3 3/4" d. × 8 3/4" h.

2 WENDY BROOKS
Covered porcelain jar 1978
4 3/4" d. × 4 5/8" h.

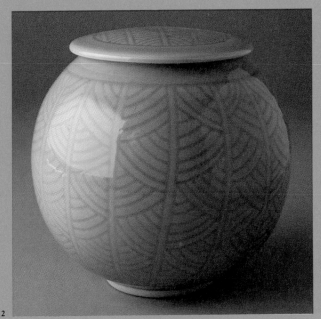

3 JACK SURES
Porcelain plate 1979
13″ d. × 2 1/2″ h.

4 HARLAN HOUSE
Porcelain bowl 1978
13 3/4″ d. × 3 1/2″ h.
Porcelain vase 1979
6 1/2″ d. × 9″ h.

5 JOHN CHALKE
Stoneware plates 1978
7″ d.
Stoneware mugs 1978
3 1/4″ d. × 3 1/2″ h.

6 TED DIAKIW
Stoneware vases 1978
5″ d. × 8″ h.;
2 1/2″ d. × 5 3/8″ h.;
2 1/8″ d. × 5 1/8″ h.

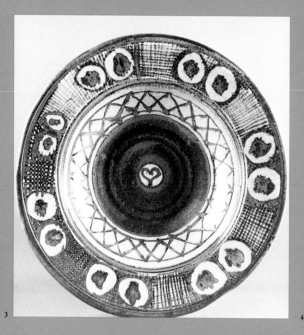

3

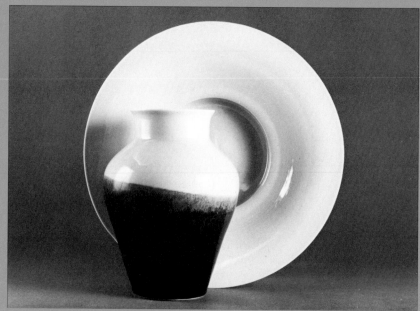

4

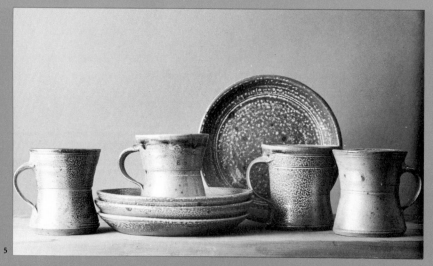

5

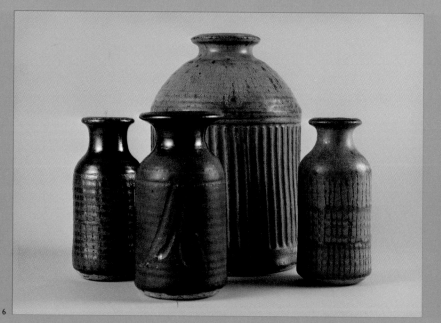

6

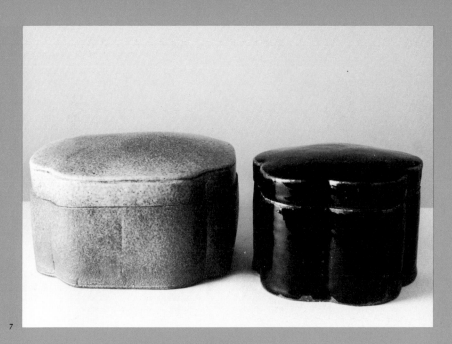

7

7 SUSAN GROFF
Covered stoneware boxes 1979
7 1/2″ × 7 1/2″ × 4″ h. 6″ × 6″ × 4″ h.

8 ANGELO DI PETTA
Red stoneware vases 1975
3 1/4″, 4″, and 6″ h.

9 DUANE PERKINS
Stoneware bowl 1979
8″ d. × 6 1/2″ h.

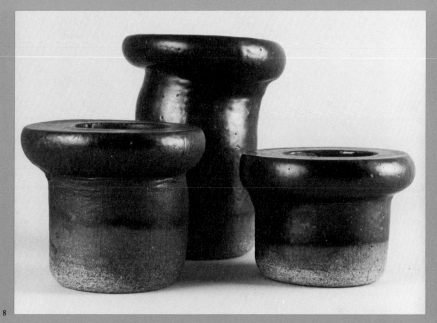

8

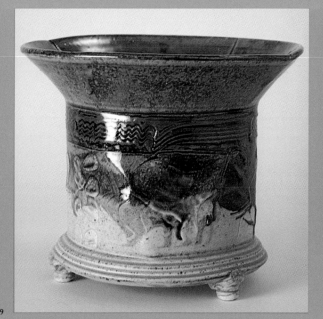

9

Wood

Paul Epp

WOODWORKER · CAMBRIDGE, ONTARIO

Wood is fantastic. Trees are the most marvellous things that we've got. There's the linear grain. Grain is the way it is because it has a function – taking the minerals and moisture, back and forth, from the leaves to the ground. It gives the wood its character. The whole life of the tree, all its problems, its deprivations, its good years, its bad years, are there in the wood. That is what gives the richness, the diversity of colour and texture and pattern and rhythm and form, all those things which a designer works with. They are all there because the tree is what it is. Beyond that, wood is a material that holds the shape. You can cut it, you can work it, you can very easily impose yourself upon it, give it your character. Still it is going to hold the character of the tree. Working with wood is working with nature, very directly and deliberately.

Using a variety of woods, I have a tremendous range of hard and soft, dark and light, strong and weak. In wood, diversity is the key word. Wood is, in one instance, heavy and very earth-bound: it's a log

cabin, it's something bigger than us, out of scale with us. In another instance it's light, it flies, it's an aeroplane, it's a kite – very delicate, very graceful, very ethereal. It's a boat, it floats in the water. It's a flute, it sings. Wood has all these possibilities. The fact that wood resonates is particularly beautiful. I don't make musical instruments, but just in handling wood and feeling it I have that echo, that sound coming back. It's not a metallic clank, it's not a harsh sound; it's melodious, always in harmony. It's a lovely material.

I believe in the value of handmade furniture. When I make a piece of furniture it embodies certain qualities that I believe in, and if somebody else values those qualities that piece will be of value to him in a way that a machine-made piece will never be. The process of designing and making, intimately and expressively, leaves something in the piece that other people can relate to. They can look at it, they can feel it, they can live with it, and there is the presence of another

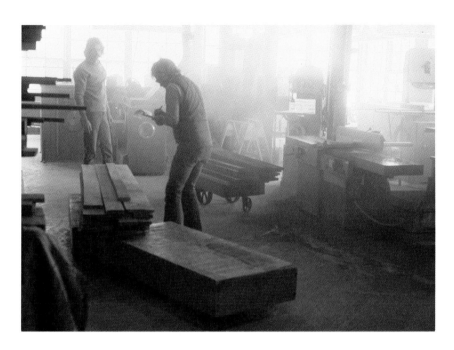

human being, full of doubts and indecisions and neuroses – another person struggling his way through life. It's there in the home. It's not an abstract, impersonal, unnatural thing; it's something people can feel a kinship with. It can remind them of the outdoors, of God's nature; it can remind them of their own inter-est in shaping their environment, by selecting the things they are going to be with personally, by having someone make them. Even if they are not the creators, in a sense they are, because they've chosen to have a certain kind of piece which has certain kinds of forms and textures which are almost like themselves.

Not that I think industrially-made furniture is bad or that there is no place for it. Quite the converse. Our culture needs machines. We are locked into a developing process that we can't readily back out of. Industrial production is very im-portant; we need it. I value it but we also need this other thing, the hand-made, and the pieces which have, maybe, a spiritual content that machines cannot instil.

That's what makes my pieces worth anything – their religious qualities. I'm reluctant to use that word because of the connotations it has. I don't think our culture has managed to straighten itself out on its religion enough to be able to speak intelligently, or articulately, on the subject but, yes, I'm in-volved in a religious activity. Not with cults or the occult or anything like that, but a very non-religious religion.

I was in Japan a while ago at the World Crafts Conference and found that there they speak about the spirit of craft and of hand-made things. I found that reassuring, to think that I am struggling here, and that this sense of spirit has been in Japan for thousands of years and has a strong and vital place.

Certainly the selections of shapes and forms and textures in my work say something about my values. But as I studied what I was doing I found something else. I was treating the parts of a piece as individual parts, and yet I was marrying them together in a way that would dis-solve the identity of the individual pieces. Separate parts were being brought together in such a way that they both retained their identity and lost it, a tricky kind of balance between the individual identity and the collective identity. I suppose you could say I'm trying to make the world a peaceful and harmonious place, which I didn't find it as a child.

Beyond that, I want the individ-ual pieces to accomplish as much as possible. I want simplicity and effi-ciency. For instance, I don't like to attach a handle to a board and call it a door or a drawer front. If that board is to be moved, the board

itself provides for the movement – not something almost foreign attached to it. There are few parts, and those parts are maximized in what they do and how they live with their neighbours in harmony and grace.

As a teenager I worked at all sorts of unskilled jobs. I ran a store in Toronto, I worked in the bush with a seismic crew looking for oil, I was an office boy, I picked apples, I was a truck driver. At one point I ended up with enough money to do very little for a while, and I found it was boring. That surprised me. I thought, 'If I don't like doing nothing I will have to do something,' but I couldn't think of many of the things I had been doing that I liked. Then I remembered that when I owned the store I would sometimes design things to be made. They were things I thought I could sell but they weren't available, so I had them made. I had had the suspicion before this that things I lived with could be designed better than they were. So, very naïvely, I set out to become a designer so that the things

we use and live with would be finer, and also I would be productively and happily employed. I was nineteen.

I went to design school in Toronto. At first I thought I should work in plastics, the material of the future. But then I found that in Canada most furniture is made of wood, not because wood is a nice material but because it is more economical for low-volume furniture industries like Canada's. I decided that if wood was what I would be designing with, I'd better learn more about it. To that end, I arranged a three-month apprenticeship in a cabinet shop. It was a fairly impersonal, high-production, high-tension factory, but it got me involved with making, and I liked making. Later I studied for a time in Sweden, with a cabinet-maker. After that I got a job with an industrial furniture design firm in Toronto. I worked as a draughtsman. I knew more about wood and wood technology than any other designer in the office, so I redrew a lot of the furniture they were producing to cut costs, make

better joints, that sort of thing. But I felt a growing sense of frustration. In Sweden I had learned that the product you get is very different if it is designed by an industrial designer and made by someone else, and if it is made by one person. In industrial design you must reduce your concept to a drawing that can be read by someone else, perhaps a thousand miles away. That means a lot must be left out. If you are making it yourself the design process never stops. There is a constant feedback between your hands and your mind.

Then the firm I was working with broke up. I could have stayed with one of the partners, but a woodworker I knew, Stephen Harris, was

setting up a studio and offered to share it with me and two others. I had some savings and bought a bit of equipment and got one commission. I had a wife and infant daughter, and I felt pretty reckless casting off a secure job for a very tenuous position, but I knew that if I didn't do it then I would probably never do it. So I set myself up in business.

The first time I had an exhibition and I had a whole room full of the things that I'd made, I remember very vividly, I walked in after it was set up and thought 'Oh my God, is that really me, is that who I am?' I had to have a hard look at who I was. Certainly selections of forms and shapes and textures do say

Stool, bird's-eye maple 1978
19″ × 12″ × 15″ h.

Wooden boxes with horizontally
pivoted lids 1978, 1979
5 1/4″ × 2 1/4″ h.
bottom: imbuya and English brown oak
top: mahoe, bird's-eye maple, and
Mediterranean olive

something about what I value. Certain things came through. They were there in every piece, or almost every piece. I told myself that these must be important to me. It triggered a major introspection about what my values were. I don't think that introspection has really stopped, although it was strongest then.

One of the strongest values in what I'm doing now is the integration of many aspects of my life.

Running a business involves a lot of skills, and they are not all craft skills. I need to have a sense of marketing and management. I have to know something about teaching because I must train my assistants. I have to know something about bookkeeping and law. I have to know where to buy the coffee, because I seem to end up doing that. But I don't feel cut and divided. I don't have to pretend I'm different people at different times. I feel fortunate that I have understood some things about myself well enough and early enough for me to arrange what I'm now doing.

Stephen Harris

DESIGNER AND WOODWORKER · TORONTO, ONTARIO

Tools – I love tools. I'll stop at any window that has tools and look at them all, even if they are common things like gardening tools. Some tools perform well, some don't; some show a high degree of thoughtfulness by the designer and others don't. I suppose anyone who works with his hands is trying to get a rhythm, which is a way of being efficient. If you can get into a rhythm of working, you can excuse yourself and just watch yourself work, and certainly good tools, the very best tools, can help you do that. They don't have to be elaborate, they can be extremely simple, but they can be very beautiful if they do what your fingernails can't do, by being harder and sharper.

Certain things are repeated in each thing I do. I suppose I'm after a kind of grace, or gracefulness. I'm interested in exterior form more than anything else, and while I love wood I like trees better. I'm not particularly interested in the fine details; I want an over-all pleasant aspect to my work, an over-all richness. I don't have a great deal of interest in bird's-eye maple for the sake of the fine quality of it, for example; it has to have a quality, but that is only like the tool. The wood is one of the tools and I'm interested in its interior and exterior form.

I think a good piece is more than good craft. Good craft is just part of the tool: it's part of the engineering, which is essential – we are making things and they have to hold together well and the mechanics of it have to be good. A good piece has more than that; it has something which it shares with good art. It gives you a feeling – that you cannot describe the whole thing in one instant because, when you look at it again, there is something else. There is perhaps its outline, and the next time maybe its interior shape has snuck up on you. It can be a simple object but it can also be more than that. I really don't like fussy work. Yet there is work that can be extraordinarily beautiful, but which must have a great many hours in it to make it that way.

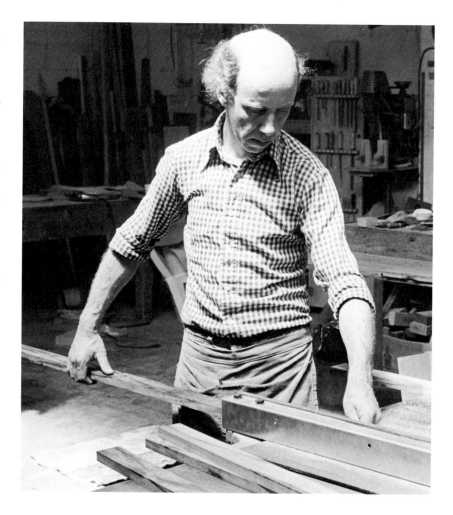

Chair, imbuya 1980
18″ × 18″ × 33″ h.

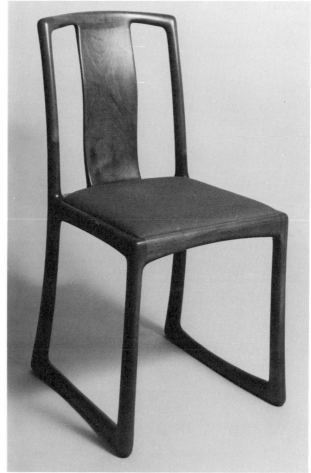

Bill Koochin

WOODCARVER AND METAL WORKER · VANCOUVER, BRITISH COLUMBIA

I was born in BC, in the Kootenay, in a place that used to be called Brilliant, a community of Doukhobors. I think my upbringing was my reason for going into sculpture. I'd always seen people working on things like wagon wheels, or repairing a wagon and using the forge. We had a huge cranked wood-turning machine; my grandfather was still making furniture and spinning wheels, that sort of thing, and as a young boy I would be pushing the machine. I came out of a background where craft was still practical and fitted into the way of life. The idea of going to the store to buy goods was not ethical. You relied on the community to provide for your needs.

After I had become a carver, there was a time when I felt my work was lacking a robustness I needed. The bowl shape appealed to me, that slightly in-turned shape. I wondered at first whether it fitted in with the log form or the fact that wood grew that way. That was what aroused my curiosity but then, as I was going through the museum, the bowls seemed like friends because almost every museum, everywhere we went, had several. Although the shape was recognizable, the variation was endless. The Indian ones from the north tended to have specific birds, and the ones from the south were slightly different. Then as they got more and more sophisticated and abstract – the bejewelled ones in the czar's collections, and that sort of thing – the shape was still somehow reminiscent of wooden ones but transformed into a different material and a different expression.

I suppose my designs, in the end, tend to reflect the tools, which I have designed and made myself. The curved knife is just a superb tool. It's like an extension of one's fingers; it so answers to one's needs, and it's also practical – it's almost more practical than a borer: by twisting the blade I can get into all sorts of nooks and crannies. The draw knife scoops up as it draws; it slices through the material and leaves that sheen, like a planed surface. I accept tool marks in the work because the stroke indicates the shape and the way it's done leaves a mark, like handwriting, I suppose.

Twenty years ago I found getting craftsman's tools was almost impossible. Now I'm getting catalogues shipped from all over the place, even with tools that were used

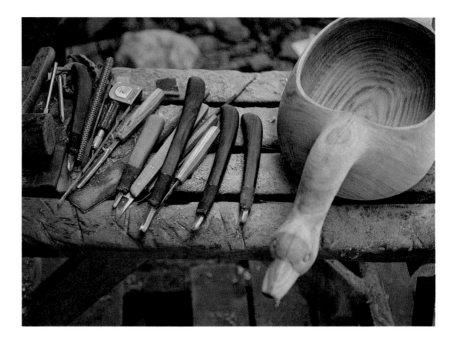

in the villages long ago. The chisel that I use, for instance – just four years ago I noticed Woolworth's was carrying them. Ten years ago if I asked for a carving gouge nobody knew what I meant, or people thought I was completely daft to be looking for an object like that.

Working with one's hands gives a

Carved 'Canada Geese' bowls 1979,
1980
Black cherry 28″ overall × 10″ × 7″ h.;
24″ overall × 11″ × 8″ h.

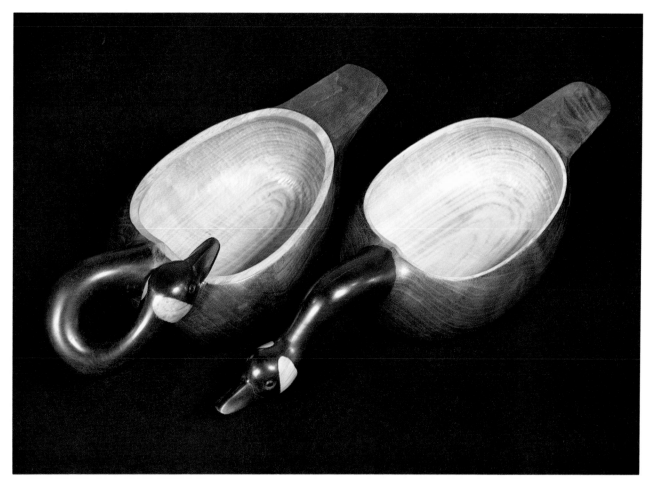

kind of mesmeric state. If one is fighting it, it could be a tedious thing, a chore, but if one can enjoy it then it becomes a flow of activity. Woodcarving is not as spontaneous as working with clay. With wood, spontaneity requires preconceived action; but then, in the act of doing it, you can lose yourself.

Carved 'chicken' bowl 1980
Black cherry 24″ overall × 11″ × 8″ h.

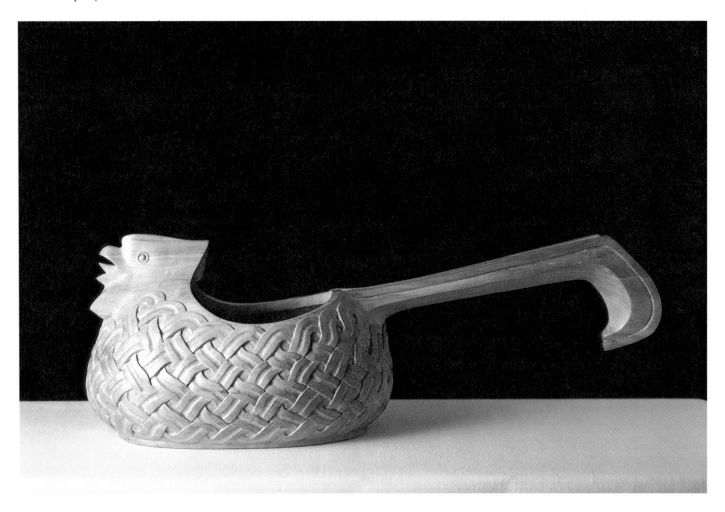

Stephen Hogbin

WOODWORKER · KILSYTH, ONTARIO

Wood is not a religion that I feel obliged to follow. It's a convenient material and I continue to work with it because that's how my workshop is set up. Wood is a material that I respect.

The lathe, as a machine, is like a potter's wheel or a weaver's loom. It's a one-person work station. You can get a finished product coming off a wood-turning lathe, or one very close to being finished, just as a potter can from his wheel.

People normally stop after the wood has been turned: that's it, the product. I've taken it one step further. What I do is like cutting up and reassembling. In actual fact, after a few years of working at it, I discovered that my technique had been used before in central Europe in the seventeenth century. In architecture a number of forms were turned on the lathe, cut in half, and then put on the face of the building. To me it's an exploratory activity. I'm exploring materials, I'm exploring myself, I'm exploring relationships between myself and society. I'm trying to piece things

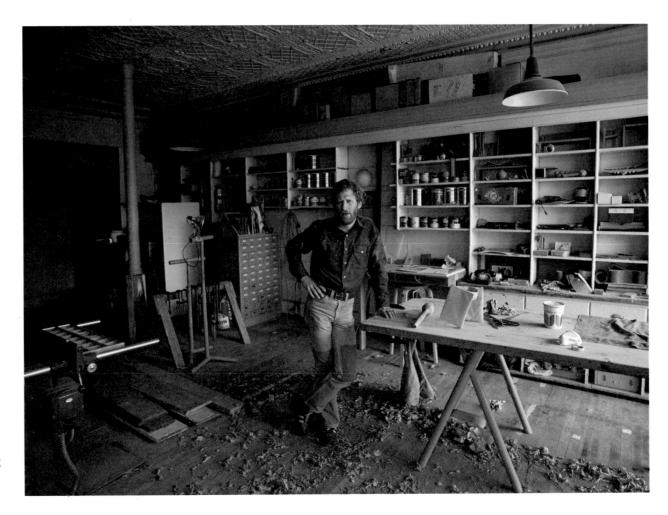

Black cherry bowl 1980
Turned, cut, and reassembled
11" × 6 1/4" × 6 1/4" h.

together, piece the jigsaw together, to create some sort of picture of living that makes sense, that I feel comfortable with.

It is very important to me that I work with my hands. When I was only designing I was unconsciously uncomfortable. The activity of work is critical to me – involving myself with things physically, not just using my head but using my hands. I may be using my heart, too. One works to discover and remain interested and alive and excited and involved.

There are a lot of things that I personally wouldn't want to sit down and make. Like styrofoam cups; I think the machine does that extremely well. There is a place for styrofoam cups, but not for every occasion. There are other occasions when a different kind of cup is appropriate, such as a chalice or a ritual cup which would be very dull if it were styrofoam. You need something else. Potentially the machine could make those, too, but when something is mass-produced it does lose that individuality of the maker, or of the person who has commissioned it to be made.

I've had people come into the workshop with a branch from a tree saying: 'This is from a tree that my grandfather planted and it has died. Could you make something out of it?' It's all that is left of their memory; they want something they can use daily as a reminder.

Crafts are an important supporter of conviviality. One place where conviviality happens is when you visit somebody's house. They bring out food and drink to share with you. It's a gesture from one person to another. It eases a situation and moves you into conversation. The sharing that takes place and the objects that are used to serve that food are, I think, critical to supporting that notion of conviviality. Again, in that situation they become ritual objects if the person is aware of that ritual, and wants to support that ritual. For example, breakfast is a celebration of a new day; that first meal can be treated as something to do in a hurry and get it over with. Or you can get very involved with it as a ritual, celebrating, 'here we are again.' The egg cup then can be important, because the egg is a symbol of new life. But everyday rituals have been downgraded in normal living patterns.

The difference between art and craft is often put on a hierarchical scale: art is more important than craft.

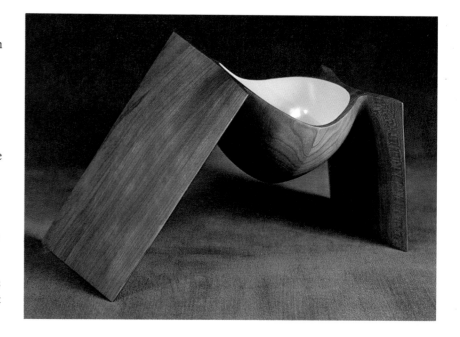

I see a kind of horizontal scale, with extremes going from left to right, from art to science, and craft somewhere in the middle involving technology. It's not that one is any more important than the other. They are all pertinent activities and we need all of them. A craftsman is a skilled maker and as such

may not be concerned with ideas. An artist is, I think, preoccupied with ideas and needs a craft to be able to facilitate those ideas. I'm somewhere in the middle. As a maker I see myself with, say, a pair of salad servers towards the craftsman end, and with a sculpture I did recently towards the art end because it was more concerned with ideas. But some objects I make are right in the middle, being concerned with the idea as well as the technology.

When I'm designing something or making something I'm aware of where it is on that scale. Sometimes it's necessary to concentrate more on

techniques if you are trying to resolve a technical problem and so the idea tends to be much weaker. At other times the idea is coming over strong and technically you've done that exercise before so the idea is far more important. Sometimes you get a good blend of both and that's when I feel happiest.

A term I like is 'laminated culture.' Things are glued together and there is a connection from one layer to the next and they really can't operate separately; they are integrated and working well together. Ideally I like to see the thing I'm making as being laminated. It doesn't ignore science, it doesn't ignore art; somehow it's all connected and related.

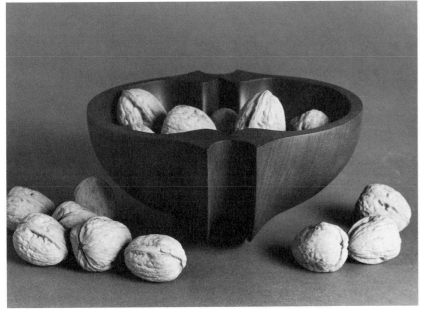

Mahogany bowl 1977
Turned, cut, and reassembled
8″ d. × 4 1/2″ h.

Herbert Hatt

WOODTURNER · BRIDGEWATER, NOVA SCOTIA

When I was a boy we never had a manufactured toy in our home. We made our own toys, fashioned them with our knives – boats, carts, little wagons. But I don't think that was the beginning of my interest in crafts.

I had a chance to take a course in woodturning in Fredericton in 1942. All the places in the class were taken but the teacher let me watch while he taught; and I had a lathe I'd made myself at home. I'd come home from the class late at night, and then I'd do the project I had seen in the class.

I became interested in woodturning because I had already become interested in weaving. One of my neighbours had a loom and was always talking about the satisfaction she got from it, so I made a loom of my own. I needed accessories like bobbins, reels, and so on, and I thought if I could do woodturning I could make my own. That's how I began.

Later on, about 1950, I was asked to exhibit at the Central Exhibition in Truro. I had made a lathe of my

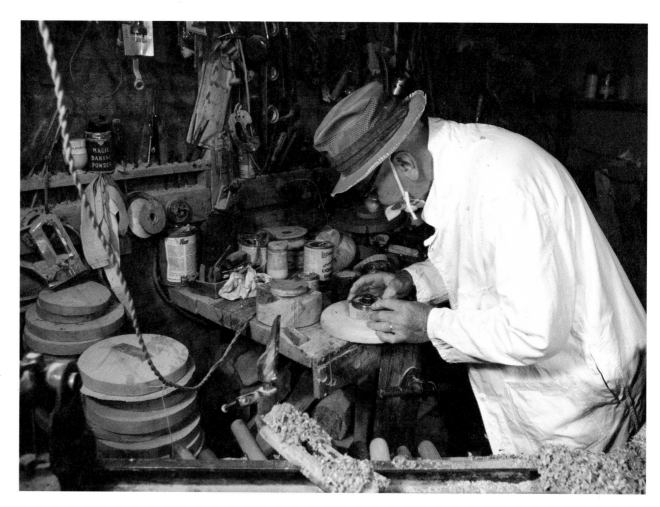

own out of scrap for about five dollars, and said I couldn't possibly take that thing because I'd be ashamed of it. The exhibition people wrote and urged me to come. The reason they wanted me was because many people who could not afford to buy a lathe would know how to make one when they saw mine. It turned out that way, too. A lathe is the simplest thing this side of a hammer, a very simple tool. But the one I have downstairs I bought later. The one I made out of scrap has gone the way of all flesh.

I've also demonstrated stone-cutting and grinding. I've been scouring the Bay of Fundy shores for agate for maybe twenty years. No other person in Nova Scotia, I'm sure, has as much agate as I have. I've also done leatherwork, but not for some time.

There's a satisfaction in craft-work, and it's mighty good therapy. I can go down into that dust shop, the basement, and spend three hours very, very satisfactorily, very enjoyably.

Of course, I like to work with my hands. And I like the satisfaction that I give people by making these objects. A lady gave me a piece of sumac when I had a display in Halifax: her daughter was to be married in June, so I made two bowls, one for her and one for the daughter. The satisfaction those two women had the day I presented them – the love of the objects themselves and the happiness they derived – did me a lot of good. I get a good deal of satisfaction out of doing a piece of work for some-body. That goblet there – somebody will buy it, somebody will pay $15 to $20 for that; they will be very pleased with it and the pleasure will last over many months and years, and that does me a lot of good.

The kind of spiritual man I be-lieve in is alive to all the good things in the world. Why should I worry about the things of the future when there are so many lovely things to do here and now? I spent forty-two years in the church in Nova Scotia, New Brunswick, Ontario, and Quebec. Then in 1963 I came here and built my own house and re-tired. I get more satisfaction out of my crafts than I did out of my religion.

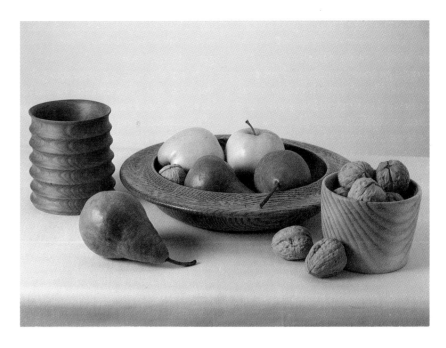

Turned collection plate 1977
Oak
11″ d.
Fluted cup
Black cherry
3 3/4″ d. × 4″ h.
Cup
White pine
3 7/8″ d. × 3″ h.

Rickey Lair

WOODWORKER AND INSTRUMENTMAKER · DORCHESTER, NEW BRUNSWICK

About the time I was in grade 11 I had a funny notion of what I would do when I finished high school. I would go to university and get a general, liberal arts education. I was interested in English literature. And then, according to my plan, I would become an educated carpenter! I did actually go to a community college, taking all academic subjects, but after one semester I was bored stiff. I needed to be doing work that was a little more manual, and so I transferred to a design school.

At the end of second year there, in whatever time I could spare from school work, I made a guitar. That was the first guitar I made. I got a book on guitar-making, and I studied a good hand-made guitar which a friend owned. I looked at it closely and measured it. And I came up with a design that was partly my own, but was fairly conventional looking: six strings, an acoustic guitar. I wanted a professional opinion so I found a guitar-maker and took it to him, and he seemed to think it was pretty good for a beginner. That was really encourag-

ing. Then he showed me his studio and what he was doing. That really got me interested.

When I'm making something, I don't like the primary motivation to be economic. I can spend a fair bit of time producing something that will have quality of workmanship and design, that will meet a high standard of craftsmanship for people, say, ten or fifteen years from now, or even fifty or a hundred or two hundred years from now. They will be able to look back and say: 'In 1970 this is what instrumentmakers were doing. This is the quality of work they were turning out. These pieces have survived because they understood the principles, and their workmanship was good enough so that these pieces are still usable.' And they will be able to see that the pieces were carefully and thoughtfully made.

It really gives a little boost to my ego that somebody wants to put one of my instruments into a collection. There are only two places for them – either in a museum or collection, or in the hands of a good

musician. It bothers me to see somebody with a precious, hand-made instrument who's not really interested in playing it, who sees it as just kind of a wall-hanging, or who isn't concerned about taking care of it and using it to its potential.

I have friends who are musicians. Many of them are quite poor, but if they are good musicians, or serious about music, the most valuable things they own are their instruments. Even among musicians, though, there seems to be a certain type who is more interested than others in hand-made instruments. A lot of musicians tend towards the security of buying from a well-known, established company – getting a guitar, say, that is made carefully, and much of it by hand, but basically in a big production situation. Those are nice instruments. But I feel that I can produce a guitar with better material at a cheaper price. I'm working towards that. I feel confident that it'll come. But I don't expect it to happen really quickly. It just takes so many

subtle little tricks to get your own recipe for a guitar that is a quality instrument and sounds well and will stay together.

Keeping it together seems to be the most difficult thing. You can make a really fine guitar and five years later it will look like hell. Over the last four or five years I've learned a lot from things I've seen happen to some of the earlier instruments I made. Also, I've repaired a lot of instruments, to bring in enough money to keep things going. The instruments that I sell at the moment, I'm confident, are made well enough. They are good instruments. They will stand up.

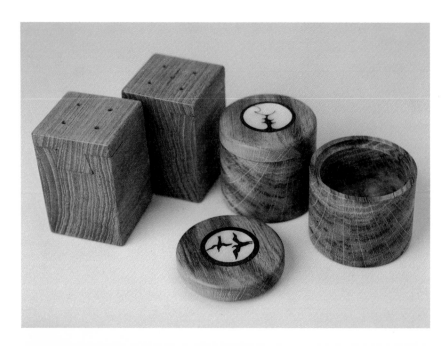

Salt and pepper shakers, Burma teak
1979
Boxes, English oak, tops inlaid with
ebony and mother of pearl

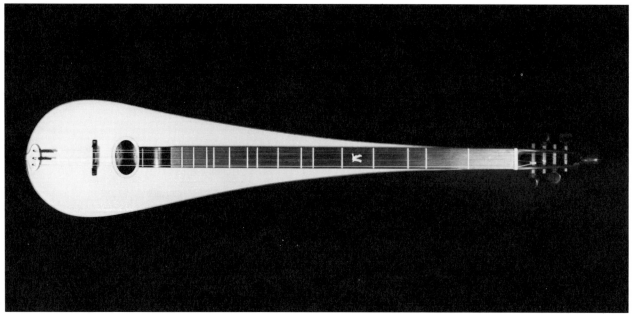

Appalachian dulcimer 1980
Rosewood, mahogany, and Sitka spruce

Joseph Kun

VIOLIN- AND BOWMAKER · OTTAWA, ONTARIO

In Czechoslovakia, I had two professions: professor of music and violin-maker. The violin-making was my second profession, because it was almost impossible to live the life of a free artist. That's why I emigrated here at the time of the Soviet invasion in 1968. I wanted to spend all my time in violin- and bow-making. Now I spend all my life and all my work just for that.

Violin-making is a family tradition, always a family business, in Europe. It was very, very difficult to start a violin-making business if there was no violin-maker in your family. The old makers had their own secrets and were very secretive. Even if you were an apprentice, they didn't tell you everything. You had to guess what they were doing. They didn't really want to have more violin-makers, you know; just a family member, a son or somebody who was closely related.

There's a difference between factory-made violins and handmade violins. A factory-made violin doesn't have any identity; it is a violin but it doesn't have any

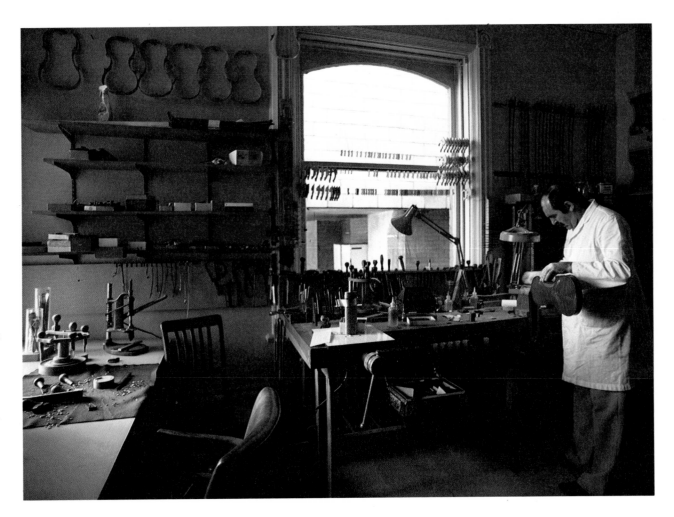

personality. When your instrument develops a personality, many things are involved: the quality of the tone, how it looks, how it responds. Many, many things make a good violin. You must have excellent material. You must have excellent tools. You must have excellent talent. If something is missing from these three things, just a little bit, the violin will not be so perfect.

The material is simple. The top is softwood, and the rest of the instrument is hardwood. Spruce for the top; the rest is maple, but of course a very special, curly maple. The fingerboard and the pegs are ebony. As for tools – you need many, and mostly I make my own. Every violin- and bowmaker uses some of the more sophisticated modern tools – the bandsaw, for example – and the great makers of two hundred years ago would have used them too, I am sure, if they had had the opportunity. We use many traditional tools as well: finger planes and cutting knives and many chisels and clamps. But if you develop some new technique in

making a violin that is not one hundred per cent traditional, then you must right away create some new tools. I am a person who is always thinking about developing new techniques, so I am always making new tools.

Today I don't make many violins – about four or five a year – but I make many more bows and they go all over the world. Violin- and bow-making are different professions. Today there are not many who do both. It used to be that the man who made bows just made bows, and the man who made violin bows never even made contra-bass bows. There is a distinction between heavy bows and light bows.

I make every part of my violin and every part of my bow. I think it is very important to make every part of the bow. If you buy ready-made frogs, you are just using somebody else's work. Frog-making is difficult, and needs lots and lots of skill. But if you have a beautiful stick, I think it is nice to put on a gold-mounted frog. Gold involves jewellery work, or if you want to

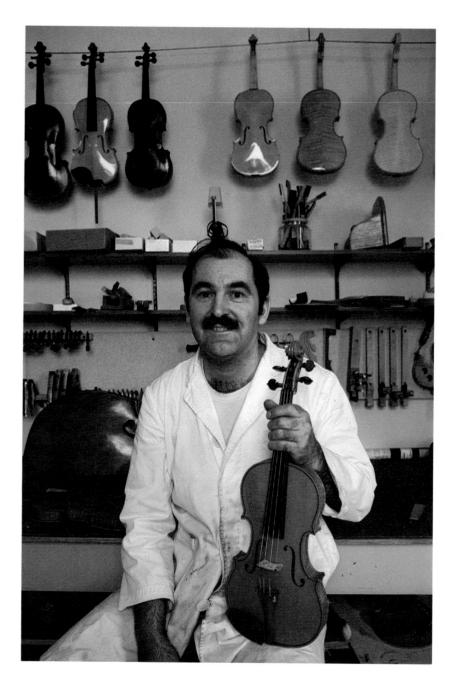

make a nice carved frog that re-
quires carving. There is much in the
profession of bow-making besides
working with the wood. You must
know how to work with elephant
ivory; you must know how to work
with the metals, gold or silver; you
must know how to do casting; you
must be able to make a screw and
eyes; you must know how to work
with mother of pearl. But the most
important thing is the wood.

I like my work, and I really don't
worry whether I will change, or
whether I will starve, because for
me it is fulfilment. It is very, very
creative. You know what you create
will be in this world after you are
dead. You are making things to last
many generations.

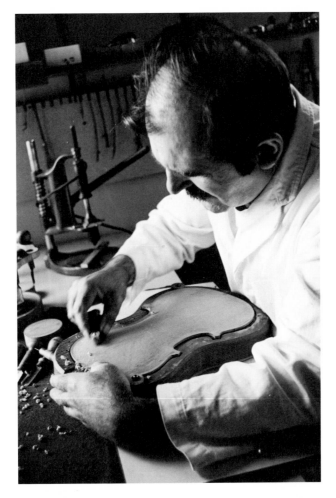

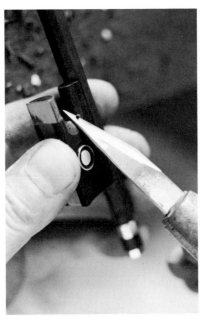

Violin bow 1980
Octagonal stick: pernambuco
Frog: ebony
Frog and tip silver-mounted
Thumb leather: crocodile, silver wire

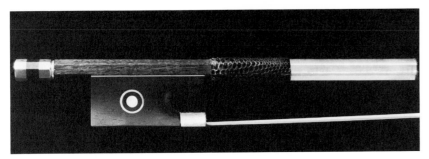

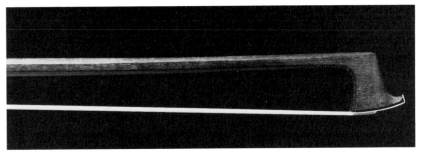

David Miller

INSTRUMENTMAKER · SASKATOON, SASKATCHEWAN

Here's how I got into instrument-making. I was living in Halifax, between engagements as an actor, moderately broke, and I saw an Appalachian dulcimer in a shop window in the Folklore Centre. I couldn't afford to buy it, but I could afford to spend $3.50 on a book on how to build Appalachian dulcimers. I scrounged a bit of material from a friend who was remodelling his basement, some plywood, some 2 × 4 studs, and I carved them up, mostly with his tools, and turned them into a dulcimer that actually played music – much to my surprise. I decided I would like to try another one, a little more complex, and the thing grew. I discovered after I had done three or four that, in fact, I was developing an ability with my hands. This was an utter shock. I had tried to make things as a boy in Alberta, but my boats always turned over in the slough, my bird-houses always leaked. I had given up on my hands being useful except for gesture.

My wife is an artist and encour-aged me to try. She gave me a set of very bad Japanese carving chisels. On the second dulcimer I built, which I still have, I used them to carve a dragon's head tuning-box. I discovered I had developed a patience I didn't have when I was a child. With that patience I was taking great joy in bringing things out of wood.

There was virtually no one to instruct me in Halifax in 1972. I got a little help and advice from Tom Durward, who runs the Folklore Centre there, but basically I learned on my own. I read whatever books I could find and made a lot of mistakes. I tried not to make any twice. Last year, for the first time, I went to England and got a chance to work with some other instrument-makers, under the same roof, as an equal it turned out. I went over without knowing how good I was; I wanted to measure myself against an international standard, because living here I'm very isolated from other people and their work. It turned out that I had developed a fairly good groundwork. I've been

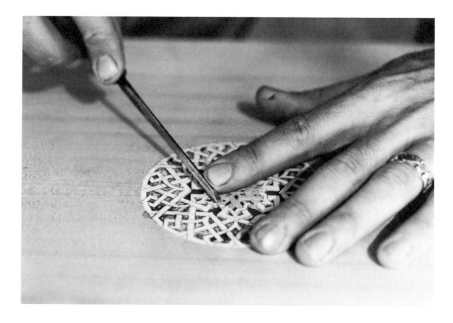

at it seven years now and by my own standards I graduated about a year and a half ago from apprentice-ship to the journeyman level. I have bestowed upon myself my own journeyman's papers.

When the time comes that I can call myself a master, I'll want somebody to work with me. Right now, I am approached constantly by people who want to apprentice but, quite frankly, I don't know enough yet to have any right to influence anybody. I suspect that when I do reach the stage where I feel I have something concrete and wise to pass on, I won't look for someone who has been building musical instru-

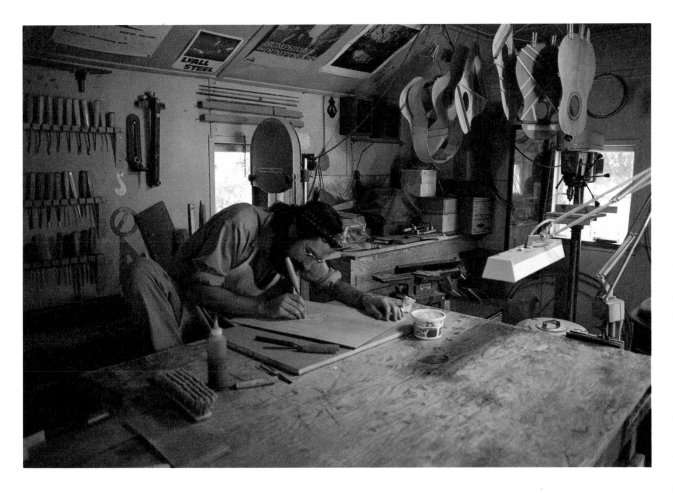

ments or who necessarily demonstrates any skills, because I demonstrated none. I'll look for somebody I feel is prepared to work very, very hard and wants very much to master this craft. Diligence – that's the first requirement for a craft person.

The best way to learn is to be able to work near or under somebody who already has the basics and be able to work with them long enough to get established yourself and then go away and decide what your own statement is. But if a young man walked through the door today and said to me, 'Hey, Dave, I want to be a musical instrument-maker,' I'd show him my bookshelf. I'd tell him what I thought of the books and tell him to go home and build some instruments and come and see me as often as he liked.

The books get you going as a judge of wood. Certainly it would be quicker if there was a master craftsman who could take a piece of wood, rap it with his knuckles, and say, 'You hear that, boy, now that's what it ought to sound like.' What

Elizabethan lute (15 strings) 1979
Maple and rosewood

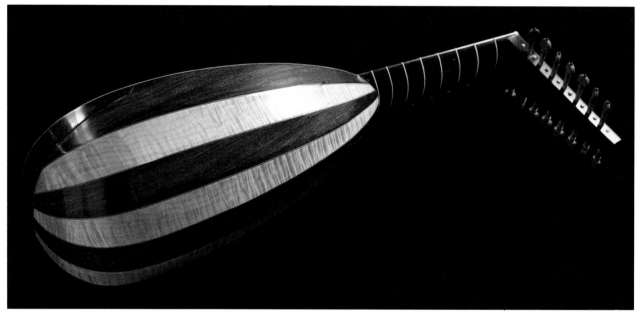

I've got to do is build ten guitars, rapping all of them as I go along, trying to remember how they responded, and seeing how they turn out. I keep very detailed notes on all the instruments I make, right down to weighing the major components. I write little editorial comments about the particular piece of wood – whether it seems responsive or soft or brittle – and then I assess the instruments when they are done, and with luck, a few years after they've been played. I try to keep track of them. I'm always glad when a musician comes back and shows me how my babies are developing. That's the way for me to learn.

Right now there are very few people around who can judge my work. Very few people have a background in fine instruments. One of my difficulties is that too many people say, 'Wow, that's beautiful' and not enough can say, 'You know, the treble on this is a little tight.' I hope that will come.

Instrument-making is very different from acting. Acting happens only in the instant. The thrill and excitement of it comes from the fact that it's now or never, that it will only be for this little group of people. Part of the excitement of acting also is in working with other people. The joy of this work is that I can point at a guitar and say, 'that is what I did with three weeks of my life.' I may be happy or sad about the end result, but I have something to show for it. And I like the fact that those results are mine and mine alone. It's good to work co-operatively with people sometimes, but I've found it good, also, to have things that stand or fall on my merit alone.

Like most instrumentmakers I am something of a tool addict. I love beautiful tools. I make tools, I make musical instruments. There is a certain joy in a really well-made tool. For instance, I have a set of hand-made Japanese saws. They have something a little special to me because I know that one individual

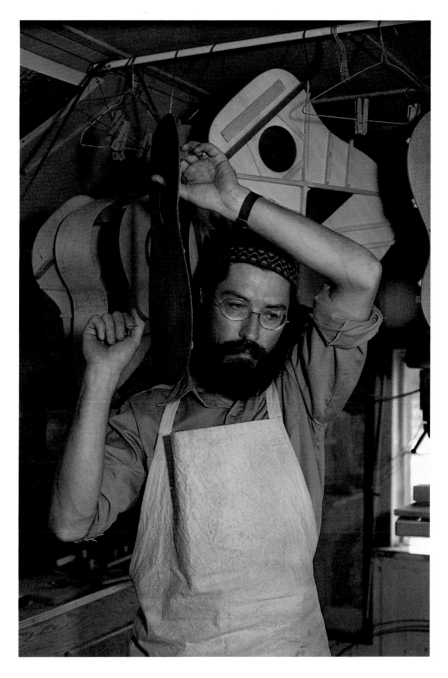

cut every one of those teeth by hand. You can build excellent musical instruments with very minimal and sometimes even shoddy tools if you know how to handle them and how to sharpen them, but if you have superb tools, that you only have to sharpen once in five minutes instead of every thirty seconds, there are fewer interruptions, there are fewer frustrations, and it feels like a more musical process; there is more of a flow to the work and a greater pleasure in it.

As for wood – there I feel passion. Under my workbench is a plank of Brazilian rosewood. It is eight inches wide and has a very fine figure to it. It has a few wormholes and a couple of cracks. I've had that piece of wood for two and a half years. Now it's been sufficiently aged and could be put to use. Brazilian rosewood is very hard to come by; the best trees have been cut down, and there is an embargo on the export of logs. For two and a half years I've been taking that plank out about every six months and making chalk marks on it,

trying to decide how I am going to cut it in order to get the best use from it. I still haven't decided, but there is enormous pleasure in looking at that wood and handling it, anticipating the difficulties and the joys in the grain.

Wood is very important. No matter what skills you have you cannot produce a good musical instrument without the very best of wood. The first and most important thing in building an acoustic stringed instrument is choosing, and cutting or splitting, the wood for the top. Without a good sound board you can't do much. The rest of the instrument is almost decorative. I use European spruce for the sound boards when I can afford it and find it. I also use Sitka spruce which I get from Vancouver, and Western red cedar which I get from a shingle splitter in British Columbia because the demands for really good hand-split shakes are the same as the demands for a good piece of instrument wood – very straight, very tight, close grain. I'm not sure yet whether the red cedar is as good

a wood as the spruce. I'm going to have to hear some of my instruments when they are ten and twelve years old to really know.

To me, craft is making objects with skill. First of all, the object must fulfil the function for which it was designed, be that function to give pleasure by being a decoration on a wall, or be it to hold hot tea and pour it without scalding the person who is pouring. Then I look for the actual technical skill shown. On a guitar there must be no tool marks, the finish should be even, the glue shouldn't show. Finally, after function, after niggling technical details that may not actually affect the function, I suppose craft has something to do with a personal response that the object draws from me or from other people. When I speak of function in a musical instrument, of course, the first function is the sound. It must carry sound which a musician can use to help him do his job.

I'm not creating a finished product, but a tool for a musician to use to create the music that is the fin-ished product. I listen to all sorts of music as often as I can. I'm not much of a musician myself, but I'm constantly trying to hear what musicians are attempting to say with

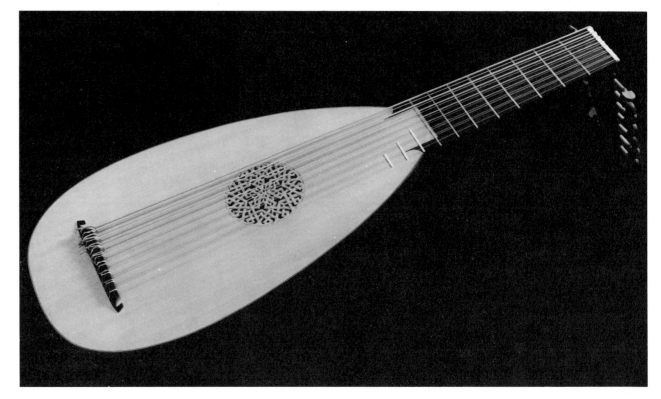

their music. Gradually I'm refining, in my own imaginary ear, the sound of what to me is the perfect guitar. I spend my whole life trying to re-create that sound in an actual instru-ment. That's the goal. I'm going to continue to make musical instruments, and I'm going to get better.

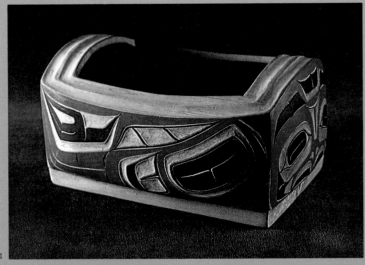

1 DEMPSEY BOB
Haida carved box 1976
Painted cedar
8″ × 4″ × 6″ h.

2 HAN REIJERSE
Child's puzzle 1978
Black cherry
11 1/4″ × 9 1/2″ × 1″

3 MICHAEL FORTUNE
Hand mirror 1978
Koa wood
12″ × 5 3/4″

4 DON McKINLEY
Staved bowl 1979
Walnut (steam-bent)
18 1/2″ × 12 3/4″ × 5″ h.

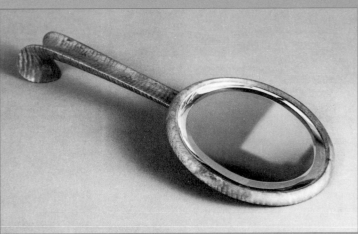

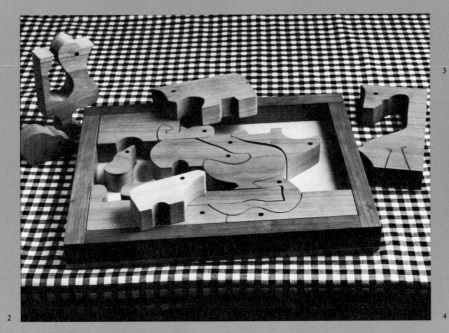

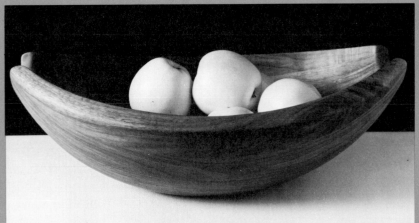

DEMPSEY BOB, HAN REIJERSE, MICHAEL FORTUNE, DON McKINLEY 79

5 MICHAEL FORTUNE
Box with hinged lid 1978
White oak
12" × 6" × 6" h.

6, 7 DAVID QUIMBY
Table loom 1977
Walnut
27" × 21" × 33" h.
Bobbin and shuttles 1977

5

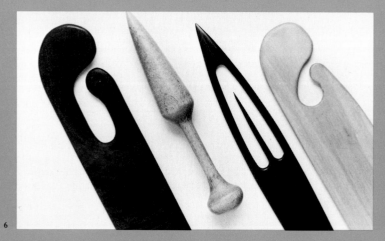

6

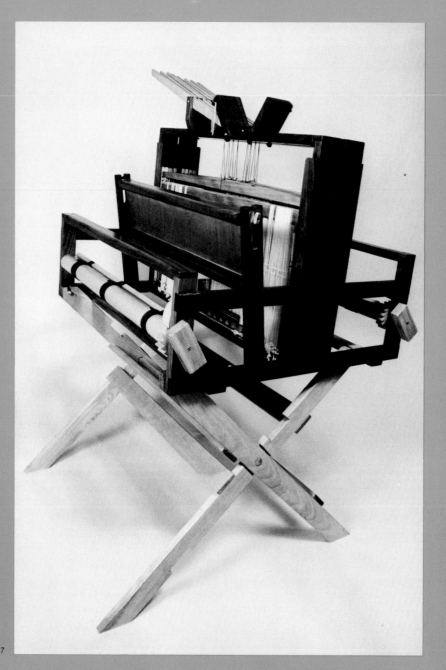

7

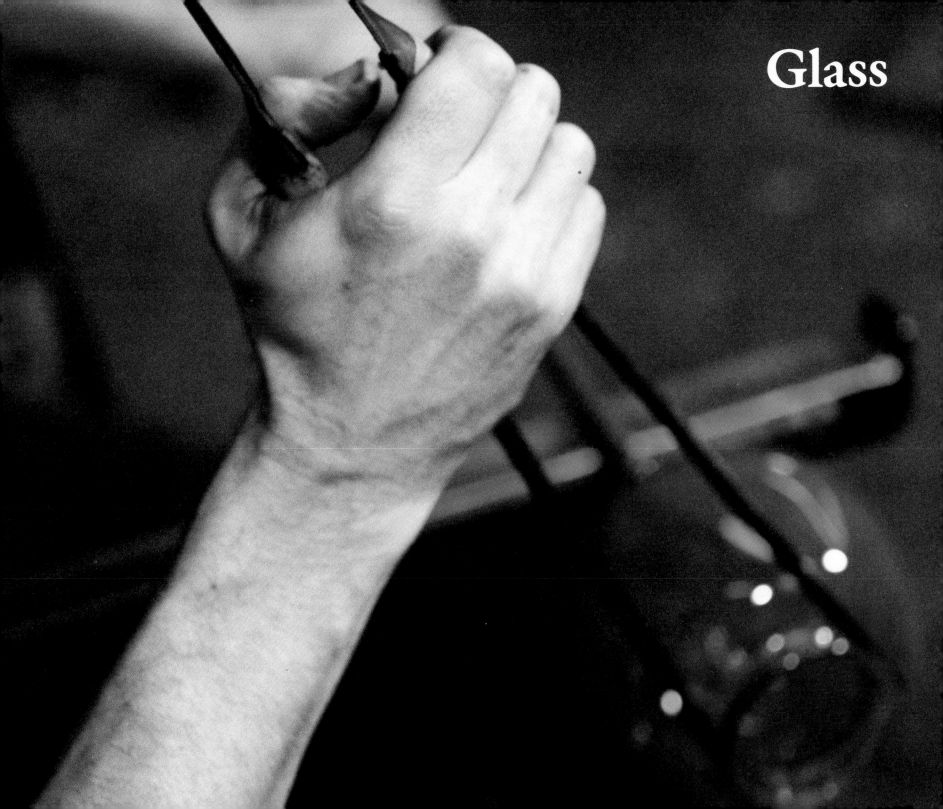

Glass

Brenda Malkinson-Powell

STAINED GLASS ARTIST · EDMONTON, ALBERTA

I have always liked the idea of the light coming through stained glass. I also like illustration and working with my hands. Stained glass gives me both. It is a very illustrative technique.

I considered myself an illustrator before I got into glass. When I got out of art college I wanted to work for a publisher or book illustrator. I wrote to everybody in Canada and got several offers for freelance work but I had no money and needed a full-time job. I was lucky and did get a job, as an illustrator at the provincial museum in Edmonton. Then I picked up a magazine somewhere and saw some stained glass in it. I was a little bored at the museum and wanted some extra work so I thought I would try to design for stained glass. Eventually I met someone who gave me some glass and a couple of books, and that's how I got started.

I really enjoy cutting glass. I like the colours, particularly of the antique glasses – they are very clear colours, no cloudiness whatsoever. I have quite an affinity for the feel of glass. Besides making the design, I enjoy cutting glass the most.

Up until about a year ago my main customers usually had an art background or were artists themselves. I do a lot of work for architects, for private homes: a lot of the homes now are much better designed, and in order to sell them the builders will put in stained glass. That's the direction I would like to go eventually, making glass strictly for homes. It's amazing, the amount of work I get from people who have just seen stained glass elsewhere and would like it in their own homes. People buy it as they would buy a painting.

I'd like to continue. I don't always like having to rely on business; I would like to get more into being able to produce what I would like to produce, but that may be a long way down the road, using the kind of colour and glass that I want rather than being restricted by how much a buyer wants to spend.

I think that glass right now tends to be a bit of a fad. It can't last forever, but it will go on as long as

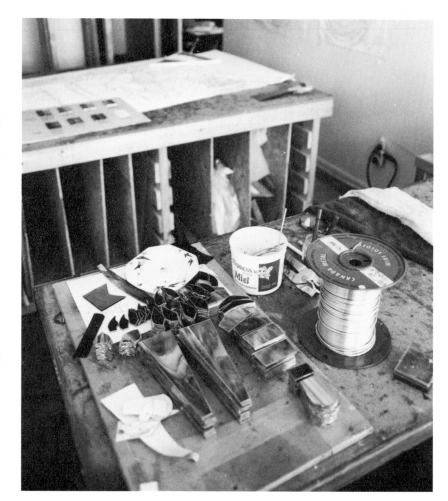

Stained glass window panel 'Fuchsia'
1979 (detail)
Handmade European glass; copper foil
technique
58″ × 21″

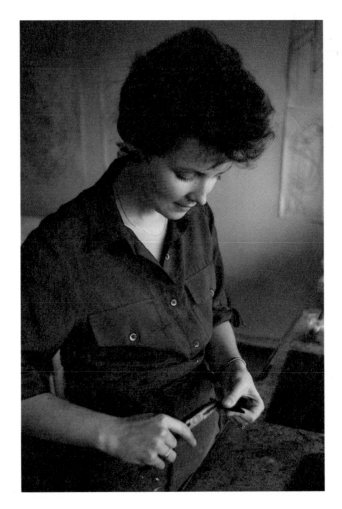

the building boom continues. Because glass is considered an old craft, there will always be a market. People always have old homes and need glass windows. But I think now it has become sort of an art investment, so I would like to continue in more of a painterly fashion, selling my own panels rather than doing work on commission for someone else.

Daniel Crichton

GLASSBLOWER · TORONTO, ONTARIO

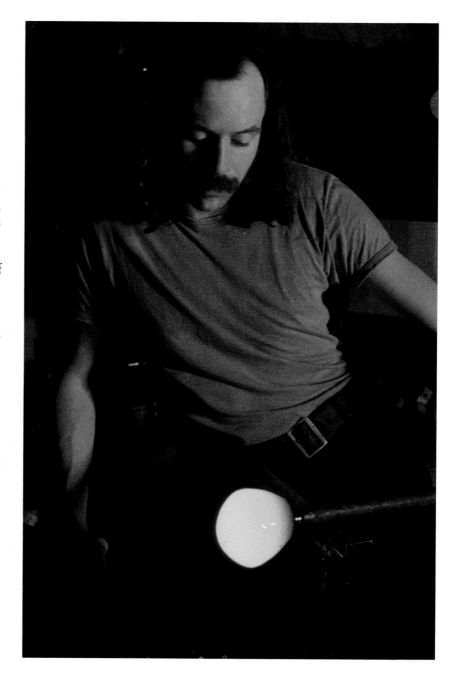

Before I became a glassblower I had been into a number of things, jack-of-all-trades and master of none. I had studied in the States and got involved with politics, had come to Canada and studied philosophy, had become disenchanted with that and moved to the country, worked in a library, drove a bulldozer. Gradually I found my way into stained glass. I was making tulips and lamp shades and all the other beginner's things and then, at Sheridan College, I discovered hot glass. There is such a difference between cutting up glass as if it were sliced meat and actually dipping into a tank and experiencing it as a plastic, sensual medium. I was just agog. It was so splendid to think of possibly doing something creative with it, to think of making a living at it – and I have to say that that was one of my major objectives, to make my living at it and be able to live out in the country. The joy in the nature of the material itself was a treat on top of all those possibilities.

I'd been a city boy all my life, born in the Bronx. Things as simple as cutting wood, putting a nail into wood, very primitive construction, were foreign to me, but I had begun to get a taste for them. It began, perhaps, to uncloud my mind that was clouded from years and years of academia. I still read, perhaps not hard-core philosophy – the journals of Plato and that sort of thing – but layman's philosophy, and it still rejuvenates me in a spiritual way. I love ideas, ideas that can be a beautiful object, an inspiration, a piece of art. I guess eventually I became disenchanted with philosophy because it seemed to me that you always ended up asking questions and never getting answers. At first I thought that there were answers. I think this is an attitude many beginners share when they go into an experience like that, or into any new medium: 'Oh boy, there is actually something here that is absolute.' You find out shortly that what is there is just more and more and more investigation. I think I stagnated in philosophy. I wasn't the academic type.

Glassblowing is very demanding.

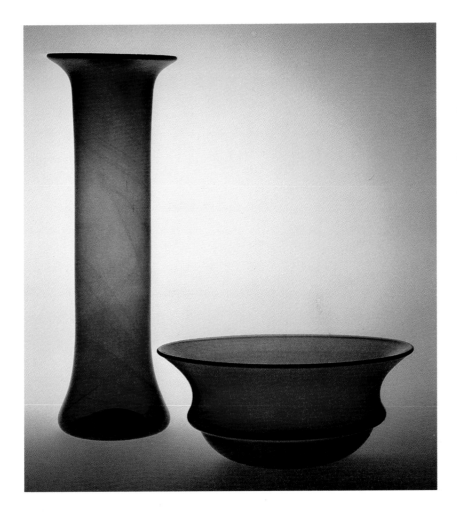

Glass vase 1979
5 3/8″ d. × 9 3/8″ h.

Glass bowl 8 1/4″ d.

It takes years before you can begin to feel completely confident about making things. You have to have timing, you have to sense heat distribution, you must have facility with the tools. These are crucial. Even if you are an accomplished glassblower, if you've had a bad night – you're hung over, you're not feeling well for some reason – and your timing is off, you might as well put your pipe away and go home. It's a very intensive experience. You may go an hour, an hour and a half, for a piece, sweating profusely, and the piece may, at the last moment, fall onto the floor and smash. You have to accept that sort of thing: just pick up your pipe and start all over again. On the other hand, you may do very well. I find that I am becoming more and more consistent with what I'm doing because my level of concentration and seriousness about it is increasing; I am not as easily jogged by the heat and by people around me.

When I know I'm coming to the studio on Saturday to blow I'm generally ecstatic, unless I'm very tired. I guess I love the plasticity, the viscosity of glass, the way it glows and moves. If you watch a glassblower quite often you will see him dance, because the stuff on the end of the rod, when it's being heated, flops, moves, flows back and forth. You just start going with it, rocking. Just the light of the furnace brings out the power of it, the magic of the stuff itself as it glows on the end of the rod.

I think also, especially if you are going to be involved in it full-time, that you have to be slightly masochistic. It's hard on your body, you know. There is a history of illness with most glassblowers. Most of it relates to not wearing dust masks – or not having them to wear in the old days – and ending up with silicosis or asbestosis or some similar thing. Not wearing proper eye protection can cause glaucoma or other eye problems. I think with those two taken care of you still have to watch out. We take salt pills in the hot season. You have to watch yourself because it is very easy to get worn down and exhausted from the process, just from one day's blowing.

In Canada today we have a handful of glassblowers, all of whom are getting along on fairly little actual profit. We need to broaden the base for producing, for competition, for new and different experimental things. I am in a peculiar position of having this year fifteen students in first-year glass at Sheridan College, and many of them come to me and say: 'What do you do when you get out of here, what is there to do?' I say: 'What there is to do is either continue studying or set up your own studio. What I will do is to give you everything you need, by the

Glass vase 1978
2 1/2″ d. × 13″ h.
Glass bottle 1979
7 1/2″ d. × 9 1/2″ h.

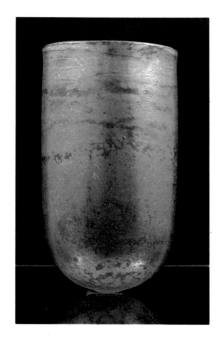

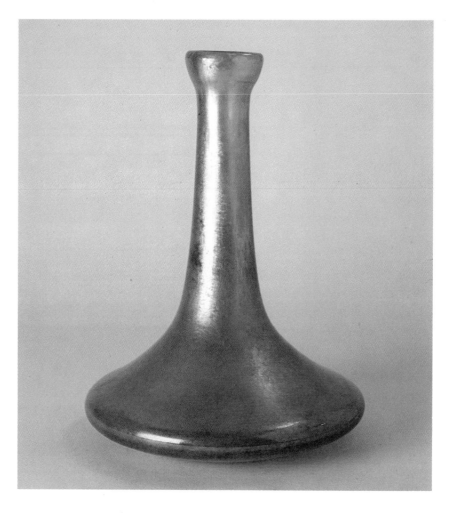

Originally it was the opacity that stunned me and the brilliant, almost plastic, qualities of the colours you could get with opaque glass. Now, more and more, I'm interested in the transparency of glass, heading away from the ornate and more and more to the subtlety of the form and the quality of the glass itself. I want the form to carry the expression, to make the statement about me. I have faith in that as a direction and I hope to encourage my students to take that road.

Freeblown glass is absolutely unique. There is no other way you can get it, there is no way it can be mass-produced. When you blow glass, you create something you hope is beautiful. You have to work hard but also you are in control of the work you do. It almost sounds as if I'm talking about an economic spirituality, but I'm not really. The independence, the freedom to will a life, that's what I am talking about – the will to love the stuff, to love that which you are working with.

There's a feeling, a sensitivity, an excitement I don't ever want to

time you leave here, to set up your own studio. If you think you want more, or if you need more, you will have to go to the US or to Europe.' The field is wide open. I think more and more people are buying glass and are interested in collecting it. But there are not enough glass-blowers doing different things.

lose. It has filled up in my life an emotional, psychological gap, a need on my part that nothing else has ever filled. Being able to be my-self, to carry and capture the char-acter of a medium like glass, to create with it, to sell it, to engage in the business of it – all those things have brought to me a whole feeling

about myself, a healthy feeling that it took me quite a while to find.

Ione Thorkelsson

GLASSBLOWER · CARMAN, MANITOBA

The day-to-day life that I lead revolves entirely around glass – the business of glass, the technology of glass, the creativity of glass. I ended up living in the country to blow glass, and I chose Manitoba because I like living here. I put up with being far away from other glassblowers in order to live here, but I like the isolation from other glassblowers because I can develop my own way. I know that if I don't blow glass for a very long time I get very hard to live with.

Living on the prairies has had a lot of influence on my work. Not inasmuch as I try directly to translate where I'm living into the piece, but as a powerful environmental influence.

The sky is what's always here. It's constantly changing. After those bright blue skies you often get evening thunder storms. It's great when the light starts to change in the evening and the clouds start to build in the northwest. You are always in a different environment, the sky being what it is. I like to get at least that freedom into the glass.

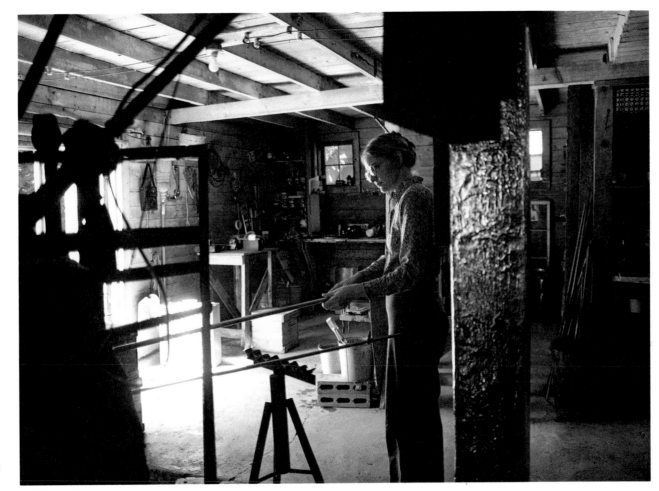

A lot of my raw materials come right out of Manitoba, too. I use the very basic materials. I don't like to get into a lot of fancy chemicals. And I like to get away from tools. I sometimes use a simple pad of newspaper – that's the closest you can come to really touching the glass with your hands. I like to use just the centrifugal forces and the force of gravity. I try to form a large part of the piece that way.

There is no one point that I can pinpoint as beginning my interest. From the time I graduated from high school I loved glass. But I didn't know that you could do it on anything but a factory level. At that point there wasn't any studio glass-work being done; it was just be-ginning.

I don't use other glassblowers for inspiration as much as I do, probably, certain painters. Also I like to read, and I try to let that be an influence.

Right now, I'm trying to control the colours that I'm using. I work basically with colour; I've restricted the shapes I'm making to a min-imum of functional pieces, and I'm working with the colour and what I can do with it. It's a matter of trying to control but maintain a sense of free flow. When I've finished a piece I want it to be as well crafted as I can make it. Then it's a matter of reacting, whether I like what is happening to the colour or not.

Glass vases 1976
Purple glass: 13″ h.
Clear glass: 3 1/2″ d. × 7″ h.,
4″ d. × 6″ h., 5″ d. × 7″h.

Glass vases 1978
4″ d. × 9 1/2″ h.; 4 1/2″ d. × 7 1/2″ h.
Plate 1978
10″ d.

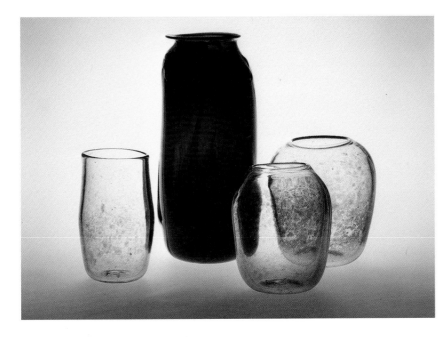

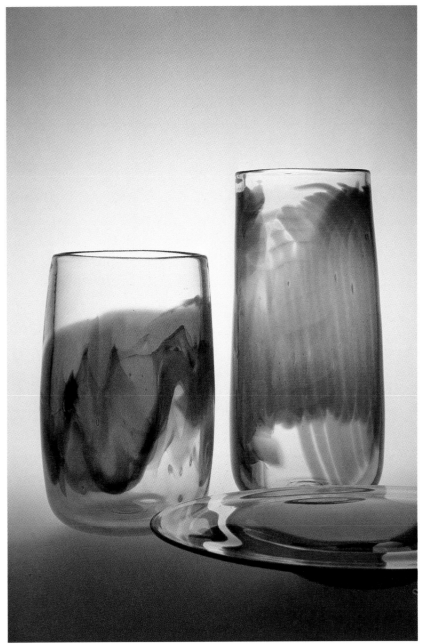

Karl Schantz

GLASSBLOWER · TORONTO, ONTARIO

I was visiting a friend one day and and he said: 'Come in the studio. I'm doing something new. I'm working with glass.' It didn't impress me at all. I went into the studio and was fairly intrigued by all the primitive technology, the furnaces, the tools, and watched this fellow do a bit of gathering. He said: 'Take this rod and take a gather out of the tank like you're gathering honey, just to see what it's like.' I was holding onto the end of the rod in the blast of the heat coming out of the furnace, and I went in to gather a bit of molten glass and pulled it out, and I didn't know what to do with it. It was dripping all over the place. I just held it and looked at it, and it fell off the punty rod. Just before it hit the floor it solidified into a perfect teardrop, in only that second. I said: 'This is outrageous. This is fantastic.' The next day, I laid my past involvements aside.

I've dealt with a lot of different mediums. I started in graphic design. I have made prints. I have worked on a very large, three-dimensionally stretched canvas mural with polyurethane foam and photo imagery and stuff. Of all those mediums, glass has been the most enjoyable, the most sensuous, the most manipulative, responsive.

You're always in a constant state of fluid motion. You're working in tune with the viscosity of the medium. The basic nature of the medium is sensuous: it's warm and organic.

Dealing with glass in a molten state, the studio becomes the total environment. You've got the heat to contend with. You've got the noise to contend with. You have a lot of movement to contend with and you also have the object – a plastic object – to contend with. You're totally engrossed, consciously and subconsciously. It is like a performance or a dance.

It's frustrating sometimes. You want to touch the glass. You want to manipulate it. About the closest you can get is using wet newspaper as insulation and actually using your fingers to pull and form a piece. One time, out of energy and

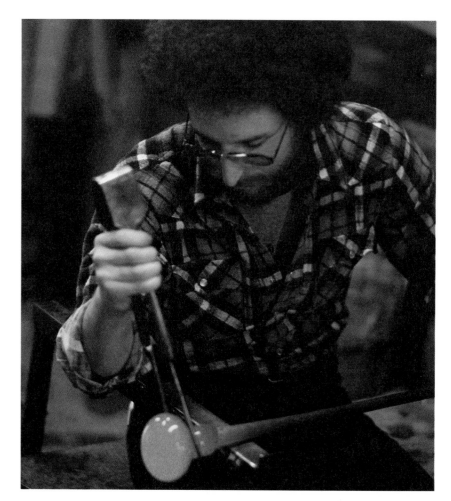

Glass vase 1979
Trailed design
5″ d. × 8 3/4″ h.

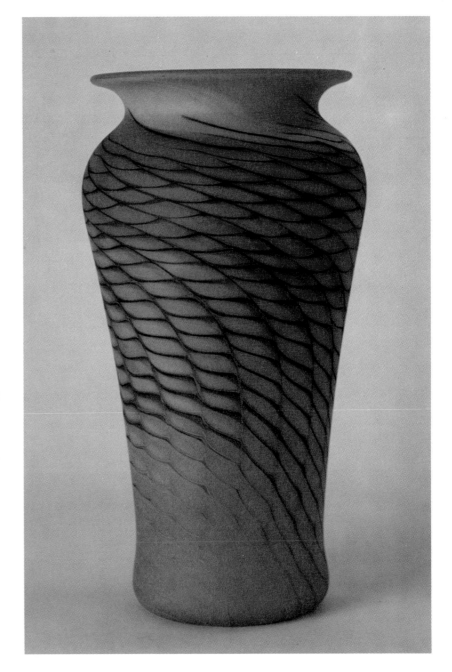

enthusiasm and frustration, not thinking, I actually put my hand on it for a split second. That only happened once, of course. I'd love to be able to take a bite out of it sometime, but it's just not possible.

In its molten state, glass is such that it is not a social art form or a social craft. It is relatively spontaneous. That's not to say that you go in there without any ideas or direction. But it's not something that you can put down and walk away from, and talk to somebody about it. It has to be finished. It has to be taken through to its end, solid, frozen state. You have to make intuitive decisions continually. Most people who do not have the background to be able to make those decisions – form, colour, line, everything – as they go along usually falter, or they become technicians. They can make good forms but there's no spiritual content. Without background, without influences, without some process of caring, pieces are very shallow. There's no life.

When all the conditions are right

you're like an open-minded spirit. You're not really consciously dwelling on every point. It's a natural process. The subconscious and the conscious come together; all your accumulated experience comes together. It's as high as you will ever get.

You have to get yourself ready mentally for all this. Going in there, sitting down, preparing, is part of the ritual. I approach it as a daily diary. I have a particular direction that I'd like to follow. At least, it's a point of departure. It's a matter of letting out an accumulation of experience that particular day. Because of that, things usually end up developing in series, progressing from one piece to the next. You may feel you have reached an end, but that always tends to lead you on to the next plateau.

I tend to draw my influences from life situations. I get a lot of energy from natural conditions, just by going out in the woods and drawing things and experiencing nature, or by experiencing the city and people. My wife and I, in the

Glass vase 1979
Raised trailing on upper half
5″ d. × 4″ h.

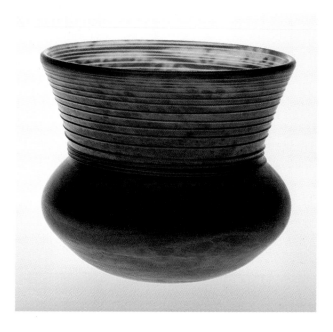

last couple of years, have gone to Mexico and have spent a lot of time there underwater: from that I drew a lot of material which came out in a series of work. Generally, you have to be a social receiver, to be receptive to your environment, to things that are happening and changing. You develop into a subconscious sensor, and the only way to get this out is through your work.

The general public sometimes has the idea that an artist or a craftsman is a person who is totally free, totally abstract, who doesn't have to work; he can do whatever he wants when he wants to. But to be an artist or craftsman takes as much if not more discipline than any other profession. You have to have the soul, the need to make objects, to put information down in those terms. It's a soul-searching way to survive. You are putting your raw feelings out to the public, to be chewed up at will. Therefore I think it's a fairly generous means of making a living.

I see craftsmanship as a technical caring for the object, whatever it

may be. Art is in the content. It's the spirit. It's the person. There is something of a stigma to craft, and an elitist attitude about art; but the thing most people fail to recognize is that there is a lot of craftsmanship in art even if the artist isn't aware of it. Inspiration can push you beyond the craft level into what we call art. I've experienced that. I've seen other people experience it. It's like walking upstairs. There is an accumulation of experience you may not be aware of, and at some particular point you become enlightened. That's when you start entering a different world.

There's a craft revival in Canada now. It's come out of the woods, so to speak. The things that came out of the woods, a lot of them, were fantastic pieces of art. But the presentation of them, until the past few years, has always been as craft, and usually put in an environment that is not conducive to saying 'this is art, sold by people who are not aware of art.' Now people's involvement in the crafts is slowly changing, getting deeper and more

extensive to the point where they're beyond craftsmanship and entering as artists.

There have been a lot of major influences from people who have had different backgrounds and come from different countries, as well as from some of the established people who were born in this coun-

try. The accumulation of that energy has developed competition. It's a very healthy situation, and crafts are developing as fast as the so-called fine arts, or faster. Glass in particular is a very new medium as an art form in North America. It's catching up very fast, although the numbers are still very small and

Glass vase 1979
Serpent design
4 3/4″ d. × 8 1/4″ h.

so is the exposure.

I think people are looking for more personal means of expression. A lot of people just become a cog in a big wheel, without soul: you become a machine after a while. A lot of people are looking for alternatives to get involved in, whether in a totally professional situation or strictly in an amateur, self-pleasing situation.

Let me tell you a story. A friend was eavesdropping on a couple in a gallery and the husband said: 'God, these things are beautiful. I just don't know where these people get the time to make them.' And the wife said: 'Well, they don't work.' That's the kind of situation that exists. But once people discover that there is a lot of joy in this, they may see it could be an alternative. Maybe that man who doesn't have the time, who's got ulcers and doesn't have time to think, will see some light.

1 ED ROMAN
Stoppered glass bottle 1978
2 5/8" × 1 1/2" × 3 3/4" h.

2 PETER GUDRUNAS and
DORIS FRASER
Clear glass decanter and glasses 1978
5 1/2" d. × 11 1/4" h.; 3" d. × 6 1/4" h.

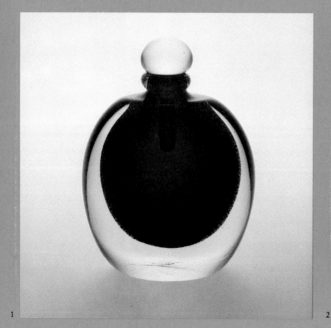

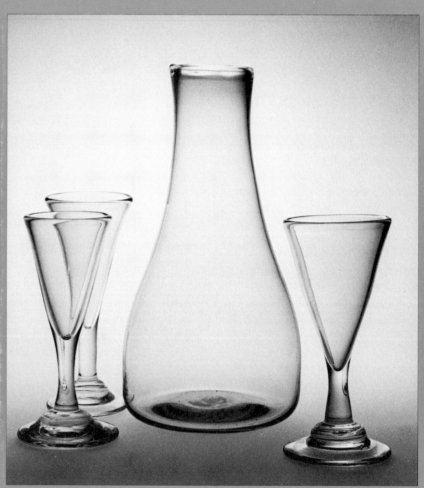

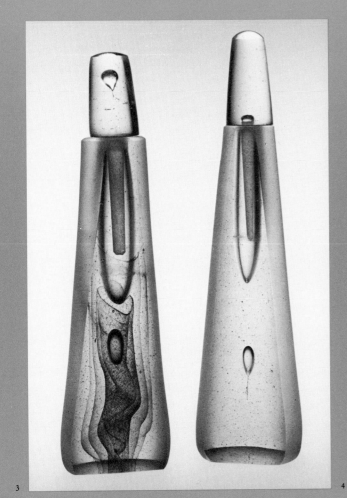

3 DARRELL WILSON
Glass vials with stoppers 1978
Sandblasted with one polished facet
1 3/4" d. × 6 1/4" h.

4 JEAN VALLIÈRES
Soda lime glass 1978
Glass bottle 4" d. × 7 1/2" h.
Glass bottle with stopper 5" d. ×
6 1/2" h.
Glass vase 4 1/2" d. × 6" h.

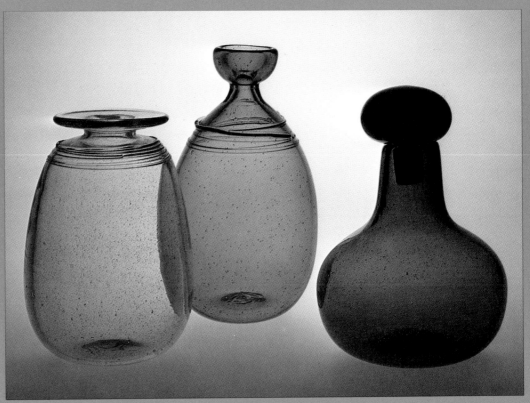

5 CLARK GUETTEL
Glass vases 1975
5 1/2" d. × 3 1/2"; 5" d. × 7 1/4" h.

6 MARTHA HENRY
Black glass box 1980
Sterling silver trim
2 1/2" × 1 1/2" × 3 1/2" h.

7 ROBERT HELD
Glass vase 1980
5 1/2" d. × 6" h.

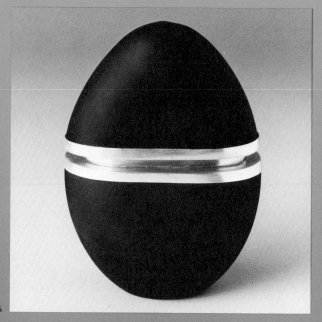

6

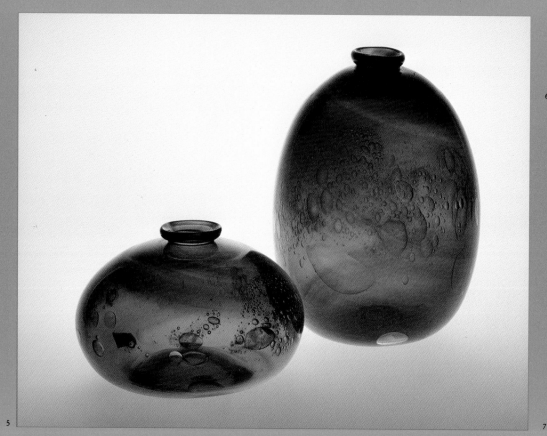

5

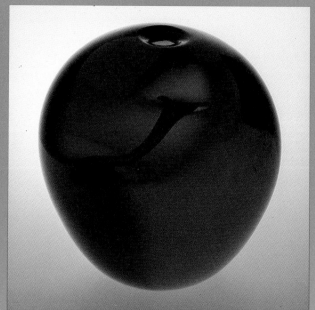

7

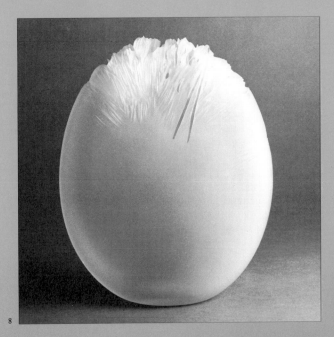

8, 9 FRANÇOIS HOUDÉ
Glass vase, sandblasted 1980
9″ × 10 1/2″ h.
Glass bowl, sandblasted 1980
9″ d. × 6 h.

10 ROBERT JEKYLL
Leaded glass window panel 1979
32 1/2″ × 27 1/2″

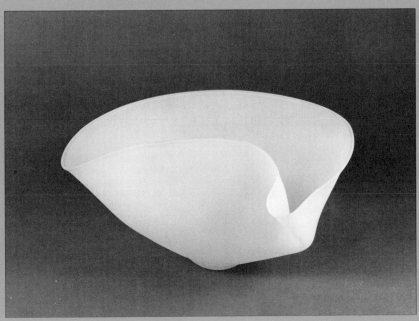

ROBERT JEKYLL, FRANÇOIS HOUDÉ 97

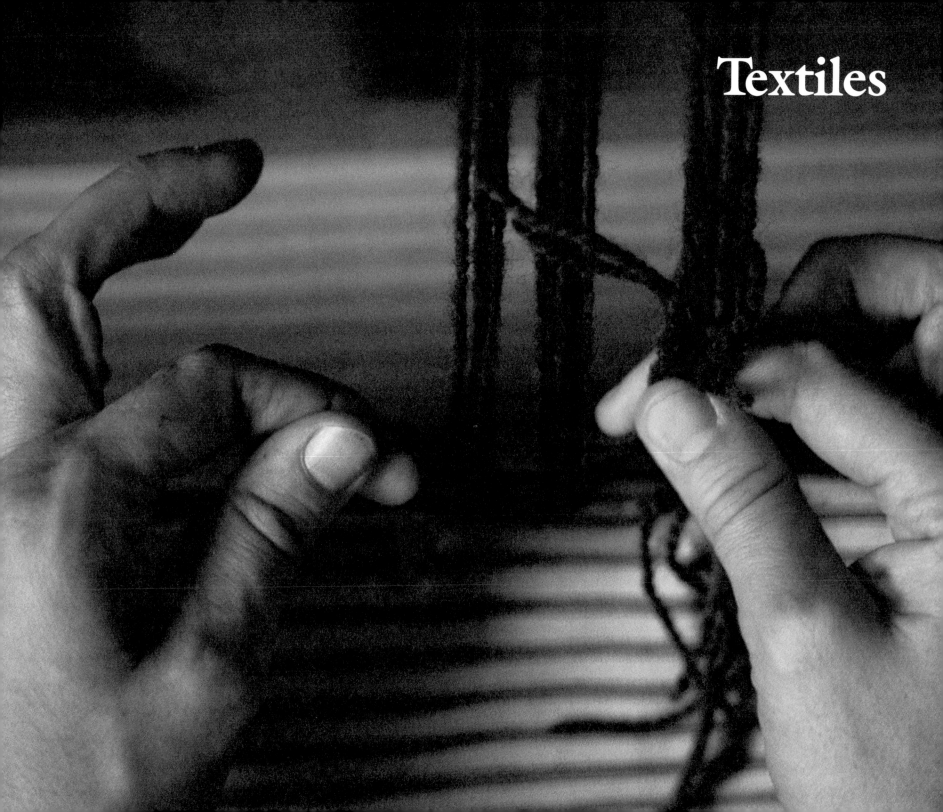

Textiles

Elsie Blaschke

EMBROIDERER · TORONTO, ONTARIO

My mother once told me, not long ago, that when I was two she could keep me perfectly happy by giving me a great big needle and thread and a piece of cloth. I used to stitch the thing together, sometimes catching the tip of my nose, to the great consternation of my grandmother, who always said: 'This child is going to poke out one of her eyes before she is six years old.' I remember making puppets at the age of four or so and delighting my brothers with them. But I didn't get interested seriously in stitchery until I was grown up.

I was teaching fine arts, painting and print-making, in adult education, and, you know, all teachers are always looking for something new and different to stimulate the students. I was doing a lot of print-making, and thought one day that I should print on cloth instead of always using Japanese paper. As soon as I saw the students starting on cloth I realized the possibilities and got terribly excited. That led to batik. Then I saw the work of the Cuña Indians and was taken with the

imagery and the joy that they express in their work and the naïvete plus the fine quality of workmanship. I had always loved working with needle and thread, I had always made my own clothes, and I had always loved fabrics – so I had to try. One summer I sat down and started working on a little piece and I was hooked. That was it.

It was very much like print-making: you develop the work in stages. You always have to think in reverse if you are doing a lithograph or block print; you have to think in stages and then the whole thing comes together in the end. I found the same with reverse appliqué. You start with a number of layers of fabrics and then you cut away one layer after another to expose the colour underneath: you develop a design but again you have to think in the reverse way almost, and that I found challenging and interesting.

Then, I love working with silk. I started out with cotton and then I discovered silks and many different kinds of silks – colours and textures. The first time I went abso-

lutely berserk over silk was when I visited a friend's design studio in Florence, Italy. She lines all her clothes, which are destined for New York's Fifth Avenue, with silk. She had a whole roomful of these colourful bolts. I walked in and saw them and touched them; it was such a sensual experience. I felt, 'this is for me.'

Many times I've called myself a designer/craftsman. I think that I am, in a sense, a designer and a craftsman at the same time. I think I'm also an artist. A work of art is like a person. It has a presence of its own; after you leave it's still with you in a sense, and of course some people have more presence and other people have less. Also I think there is a question of timelessness. Some works of art have survived, although they might have been painted in a certain style, because they have a quality that is timeless and universal. We have works in the field of craft that should be considered as works of art even though they might have a function; they might be utilitarian. A lot of medi-

eval art was functional and utilitarian. This idea of art for art's sake, that you just use something for mere decoration, is really a twentieth-century concept. Something can be functional and yet at the same time be one of a kind and if it has all the qualities that one looks for in a work of art I don't see why it should not be considered a work of art.

I think where the confusion really comes between art and craft is with the so-called professional craftsmen and the people who do crafts as a hobby. In Canada and the United States we have an enormous number of craftsmen but very few who do their craft full-time. They are really hobbyists who work at week-ends and then they go to craft fairs and sell every bowl and every whatever they make because the public is not educated enough to know the difference between the work of the professional and the hobbyist.

I always say to students before I start a course: 'I cannot really teach you art. Nobody can teach art. I can

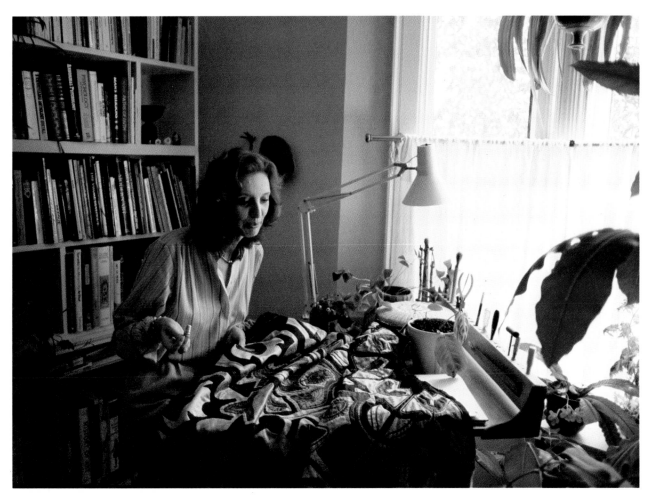

teach a technique: I can teach a skill; I can teach how to look; but I can't teach how to be talented or creative.' I believe that all people are talented or creative to some extent, but what a good teacher has to do is to inspire the students so that they are willing to dig deep inside them and find their own creativity, because it's all there.

One is influenced by so many things. One never tries to imitate, not consciously, but one is guided by impressions, sounds. You know, speaking of sounds, I come from a musical family, and I do hear sounds when I look not only at my art but at visual art in general. For me pictures have sounds. This is a strange thing to say but I do hear music. It's like the music in a movie. You never quite hear it, but it's there.

Whenever you work creatively, in the visual arts or any other art form, you delve into your innermost self, and sometimes it is surprising what you come up with. I do a great deal of detailed drawings before I start working on a project,

but once I get going, every now and again I have a rest period. I hang the piece somewhere and sit back, or I leave it overnight, and I look at it and ask myself: 'Why did I put this here?' or 'What happened there, where did this imagery come from?'

I solve a lot of problems in my dreams. Sometimes, if I have a design problem, or if I have an idea and just cannot find quite how to express it, I dream about it. I wake up in the middle of the night and scribble notes on the pad on my bedside table. Sometimes in the morning they make sense and sometimes they make absolutely no sense at all; it's ludicrous. But I do find I solve a lot of my problems in my dreams. Both dreaming and daydreaming are very important parts of our lives.

Sometimes when I work on something people ask what I am going to do next with it. I always feel like saying that I don't do it, it does me. Once I have started, I feel like I am just being used as an instrument. It's as if the thing itself takes over. It's like something

growing right in front of you, and you are just being used as a tool.

When I'm working I hate the interruptions of the telephone. You get almost into a state of trance. That is why it is so easy to over-work; you work too many hours because once you get into it you don't realize you are tired. It takes you away. It's a different world and it gives me such incredible happiness, like nothing else. I can't compare it with anything else. It gives me a terrific high. It's like I'm flying.

Our bodies are just shells that we try to keep in the best shape we possibly can. We have to live with them, and I think we should take good care of them because we need them. But the people we really are are the people who have this inner life. I'm not a religious person, but I could not live unless I could nurture my inner life all the time. It's a great strength to me. It's also very comforting. My creativity, my strong inner life, gives me incredible happiness – happiness that does not depend on other people, because you cannot count on that.

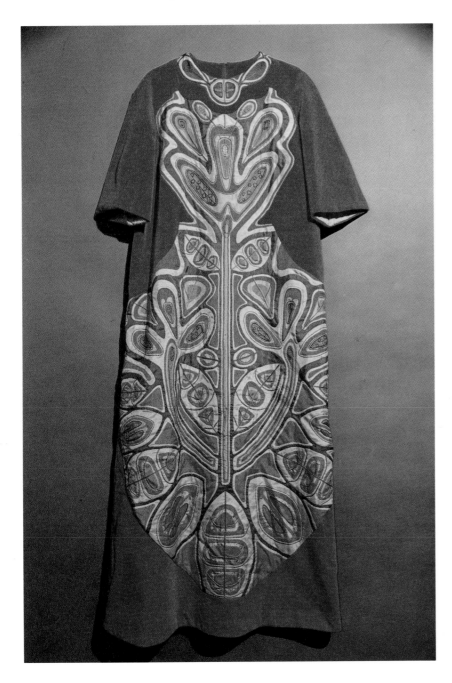

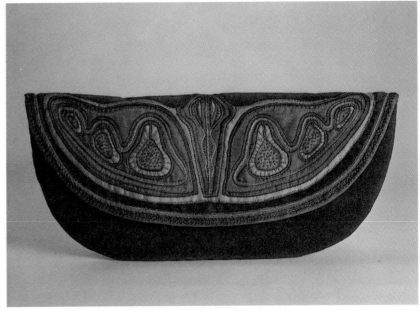

Full-length gown 1975
Velvet, silk appliqué with stitchery

The people you love may die, they
may leave you, something may
happen to them. You have to be
self-reliant. And you have to teach
children to find this inner resource
that they possess. You must point
out to them again and again that
this is where true happiness lies.
This is where you get your real
highs from.

Purse 1978
Appliqué with stitchery

Sandra Orr

WEAVER AND EMBROIDERER · BARRIE, ONTARIO

I can draw with a sewing machine, but I can't draw with a pencil very well. It's much more of a labour for me to lay out a design on paper before I go to work; it's much easier for me to be spontaneous with a sewing machine.

For a long time I didn't work with clothing particularly. I wasn't really using the fashion design part of my schooling – I was doing weaving and other things like wall hangings – but I tend to be turning that way now much more. It's fun to decorate people rather than just walls. It's nice to explore the older styles of clothing, but sometimes I feel that I'm almost more excited about finding the fabrics or the yarns than in doing something with them. I get excited by the colours and the textures and I constantly have ideas rolling around in my head. The material is very suggestive.

It's useful to know the person you are making clothes for, although very often I don't; I'm just doing the piece for the sake of the piece, the concept. I start with the

shape of the garment and work within it to create the decoration. Or I may have a technique I want to explore and pick out a garment that gives an area to work on. When you are doing that sort of thing you tend to work with simplified shapes, or I do anyway, because it's rather like working on a canvas – you don't want to have a lot of broken areas if you are laying out a design on it. The end product is not only the shape of the garment but the design, and some clothing is of a very constructed shape and doesn't always lend itself to this.

I think a lot of people enjoy crafts because they feel closer to the source. At some point there has been a human being who has made this article: it has an individual nature to it. I think that is what people are tapping into when they buy crafts, something personal.

That's why antique items have become quite valuable. They are the craft items of the past and if we don't continue making them there won't be anything like them. Just imagine what sort of artefacts people would be finding from this era if we had continued to go the way things were in the fifties!

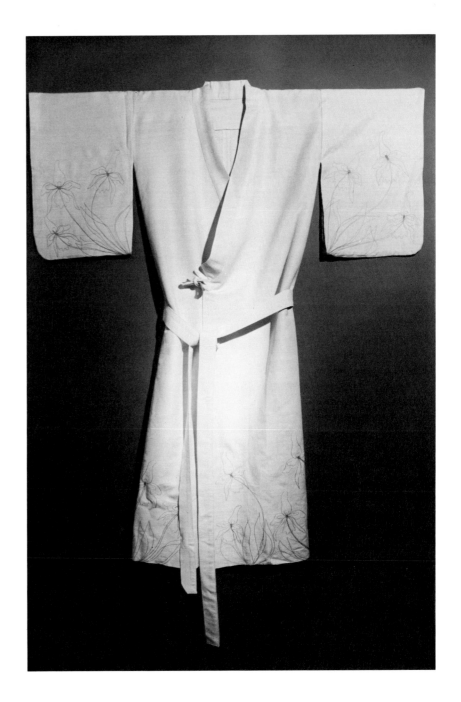

Formal kimono 1978
Natural silk with machine stitchery

Betty MacDonald

QUILTER · HALIFAX, NOVA SCOTIA

I have a quilt of my grandmother's which she made for her wedding in 1873. It was made of new material, very tiny pieces, all pieced by hand. My mother was a quilter too; at seventy-six years of age, she is still busy making quilts and giving them away to her grandchildren.

I come from a very large family. I have six sisters and three brothers, all still living if you can imagine that. There were enough of us in our family to have our own ball team. We had a really good life in the country. We had a river right behind the house where we swam. In the wintertime, we used to skate to school.

I know my mother used to knot together the odd quilt in England but, it's funny, I think if you were to tell her that she was doing something which was an ancient craft, I don't think she would understand. It was something that she did and that was it, like making rugs.

I made my first quilt when I was about twelve years old. As a matter of fact, I still have the old thing around here, but it's pretty well worn out, I can tell you that. There were a good many years in between then, through my teens and twenties, when I didn't make quilts. It's in the last few years that I've gotten involved with it again. I thoroughly enjoy it.

I do all my work by hand. It takes a long, long time. Oh, at least four hundred hours.

Usually I sit down with graph paper and coloured pencils and work out the design. In fact, the design for this quilt which I have in the frame was one I did at a workshop last summer. I'm finally getting around to putting it into a quilt.

Piecing is putting together the patches. As you can see, the big one in the frame now is made up of five different colours, and all those little pieces are put together by hand sewing. Then, when it gets into the frame there are more hours of work.

I look to see that the corners of the patches come together evenly, that they match up and that the stitches are even and close together

and very fine. I use a very short needle and a very slim needle so as to get tiny stitches. I think I usually have about ten to eleven stitches to the inch.

Originally, those small scraps were called suttles, scraps of material which women had left over from clothing. That's the way it was when my mother first started making quilts. Nowadays, there are so many nice materials available that most people use new material.

Handsewn quilt (detail) 1977

Suzanne Lanthier and Paul Marineau

WEAVERS · ST-SIMON-DE-LA PRESBYTARITÉ, QUÉBEC

PAUL: When we moved to the Lower St Lawrence region from Hull, we both planned to take a course in plastic arts, here in Rimouski. That is why we came here. But after going to school for two days we saw that it was useless. There was no equipment, nothing. Back home in Hull we had bought a loom, for work with macramé, and we decided to try to make a living with that.

SUZANNE: Where we first settled, in St-Anaclet, there were already fifteen women weaving. They came to see us because they heard we had a loom. We talked to them, and that's how we got the idea of making a living in this way.

PAUL: Besides, finding a job where two people can work together is getting hard. Employers were always finding ways to separate us. This too is how we came to weaving.

We had already heard about flax back in Hull, but there was a mystery attached to it. When we arrived here and talked to these old people who had always done weaving, they knew immediately what it was. They were surprised that we were interested in it. Then we wanted to weave some to see what it was like. They gave us some help. They also taught us to spin it.

We found that flax is not grown any more in this country and we had to buy our yarns abroad. But this did not give us any great opportunities, because there was only the one size of yarn. So we decided to grow our own flax and process it. You have to sow the seed very close together, so that the flax grows like the hair on your head, so tightly that it chokes the weeds. In the fall, when it is ready, you have to pull it out. You cannot cut it with a knife or scythe, you must pull it by hand to get a longer yarn. Then you spread it out on the field for the retting, to let the sun and the dew or rain make the bark more or less rot away and loosen the fibres inside.

Finally the flax is dried, and the fibres must be extracted. There are different stages in this. The first is called scutching. It is done with a wooden tool which looks a bit like a

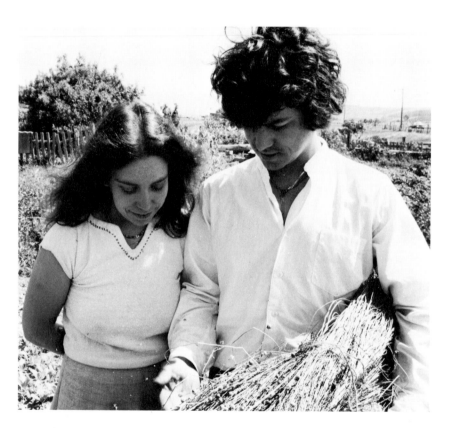

tobacco chopper except that it is made of wood. You take a handful of flax and put it under the blades to break up the bark, and then you repeat the process, but this time with a wooden knife. Then comes the hackling, when the flax is combed with combs of various sizes

to remove all the straw. Then it has to be cleaned. During the various processes, some flax always falls on the floor. This flax can also be used. It is called the tow. In the olden times, with the fine quality fibres people used to make clothes, nightgowns, bedsheets, and with the tow they made things like dish towels.

SUZANNE: If it rains a lot during the retting, the flax becomes silvery. When you have it ready for spinning, it is like the hair of an old lady, a grandmother. On the other hand, if there has been a very sunny fall, the flax becomes more blonde, more honey-coloured. In different years you get a whole range of different shades of linen, always in the natural tones. At one time we made a fabric which we called old barn fabric, because of all the flax colours we had from the different seasons. It reminded us of weathered barn shingles, always a different shade of grey with a bit of brown or blonde mixed in.

PAUL: Our incentive to work with flax is the fact that it has been grown in Québec for 345 years, since the time of Jean Talon. When we weave flax, we have the impression that we are continuing something which is done in Québec, and which has been abandoned quite involuntarily. There are farmers who would like to start sowing it again, but there is no industry: you would have to start again from scratch. But here in North America, all flax fabrics used to come from either Québec or Acadia or the French-speaking parts of Ontario, because in America it was only the French-speaking population who grew flax. This then binds us more to what we are.

SUZANNE: You could say it is part of our roots.

PAUL: Crafts in Québec are very different from what is being done in other parts of North America. In Québec it all stems from folk art more than from crafts. Here in Québec and Acadia, people who were doing things like weaving always did it for themselves, not to sell to others. In Ontario, for example, at the same period there

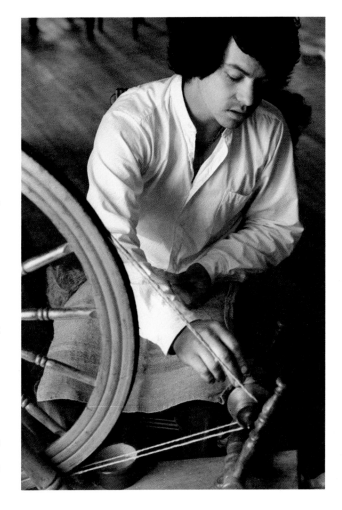

were professional weavers who were making a living by selling their things to others, but in Québec there were only a very few professional weavers. There were people weaving things for themselves. In Canada, for example, there were Jacquard looms and Seizman looms, while in Québec we had two-harness looms, one-harness looms especially, because they did not take much room and farmers could put them in the attic during the summer and use them only in the winter. As a result, crafts evolved quite differently in Québec. We are a bit special.

But in the field of flax, everything

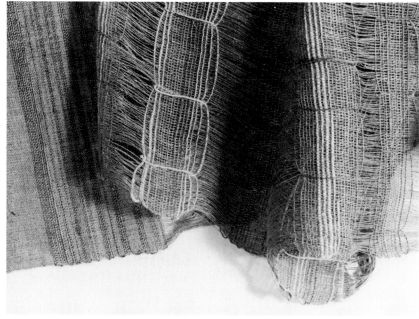

Four joined panels (detail) 1978
Linen and alpaca
252″ × 19″

has been forgotten. There exists no more knowledge of it. We have to go out and get the information, because it doesn't exist any more. We have to do all kinds of experimenting.

SUZANNE: When we have a problem, for instance with sewing or dyeing or bleaching, we have no one around here to whom we can go for advice. The people who have done this are our grandparents. They are quite elderly or they are dead, and nothing has remained in books.

PAUL: There is also this. Tradition is all very nice, but we are living in 1981 and we have to adapt to modern times. There are some routes we did not take, because we thought we were already doing enough, that we should not go overboard, for instance with vegetable dyes.

SUZANNE: There is also the fact that we don't necessarily want to be associated with the past. We want to pick out whatever was done well in the past but go further than that. We adopt old techniques, but always adapt them to our period, trying to integrate them into it, making them evolve, modernizing them as it were. In the final analysis we have to live with our own time.

PAUL: Teaching also plays a great part in it. Our coming exhibitions will be oriented in that direction. We want to show people the language of fibres, the language of flax and fabrics in general.

SUZANNE: We haven't been involved in this craft for very long, but when we started in 1974 we were not alone. We know a lot of groups in the area who went through the same experience we did, but many quit because, after all, being your own boss, having no financial security, no social security – it was difficult to function under those circumstances.

PAUL: In fact, when we first started we had worked for some time and were getting unemployment benefits. So we went to the Unemployment Insurance office and told them: 'We don't want it any more.

Adult's and children's linen socks and stockings 1980

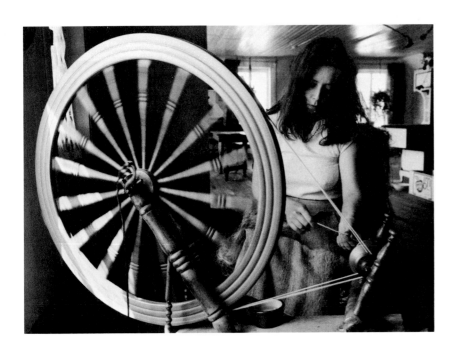

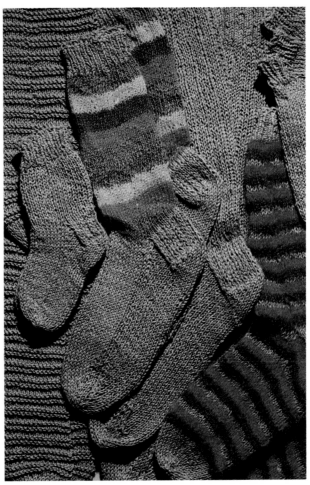

We have decided to make a living from our craft.' They were very surprised. But you always have to get rid of your crutches. Unemployment insurance, welfare, grants, all these are crutches. When you don't have crutches and you go your own way, you have the right to stand up and talk louder than others. Others have the right to speak up too, but you have gained this right through freedom. This allows you to stand up and to say: bravo!

Polly Greene

WEAVER · SHERBROOKE, NOVA SCOTIA

There's no real tradition of weaving in this area. There have been some weavers, but most of them are fairly recent, since 1940. This village was quite cosmopolitan in its time; a ship came in twice a week from Halifax, so most goods were bought. The country people did some weaving, but I have found little evidence of it. There are looms in some of the old sheds but it certainly wasn't a big part of anybody's life here.

This, where I work, is an attempt to reconstruct what Sherbrooke looked like anywhere from 1860 to 1900. It's not really a pioneer village because the place didn't even exist until 1850, hardly pioneer times. Part of the purpose is to attract tourists, and about forty to fifty thousand come every year. We give them some activity so that they don't simply look at a lot of old buildings. I'm a sort of live exhibit. The other part is to give the local people some means of earning extra money, so I have been teaching them weaving. It has progressed into quite a livelihood for some.

It was mainly an interest in history that got me started. It gave me an interest in how people made things and what they used. I had heard so much about how everyone wove, and I had to know how they did it. Fabric interests me, but only traditional fabrics. I've never become interested in other types.

At first I tried giving workshops for the local people and there was almost no interest at all. They were much more interested in store-bought, ready-made things. Crafts were not part of their idea of a lifestyle. Then I began bringing in people from the outside to do workshops. This had much better results because the few people who were interested saw that other people were too and they got a little more courage.

There seems to be a great renewed interest in the traditional crafts, stemming from the back-to-the-land movement. In the sixties that was fairly superficial, but now I think it's come round to being a lot more serious. Still, the interest around here is only among new-

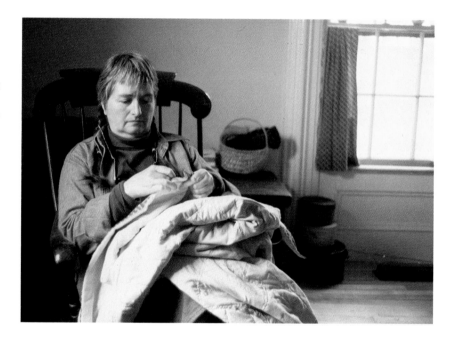

comers, from America and Upper Canada and the West. It's funny, but I'm finding a lot of them are older. Of course they've grown older since the sixties, but there are a lot more middle-aged people.

Some of them are trying to make a living from weaving, but it's a difficult way to do it. Weaving is

slow. The equipment is fairly expensive; it's also very permanent. Few of them really know the market and many of them appeal to other back-to-the-landers who don't have the money to buy. They are ignoring the types of things the consumer is looking for. There is a great market for reproductions of weaving,

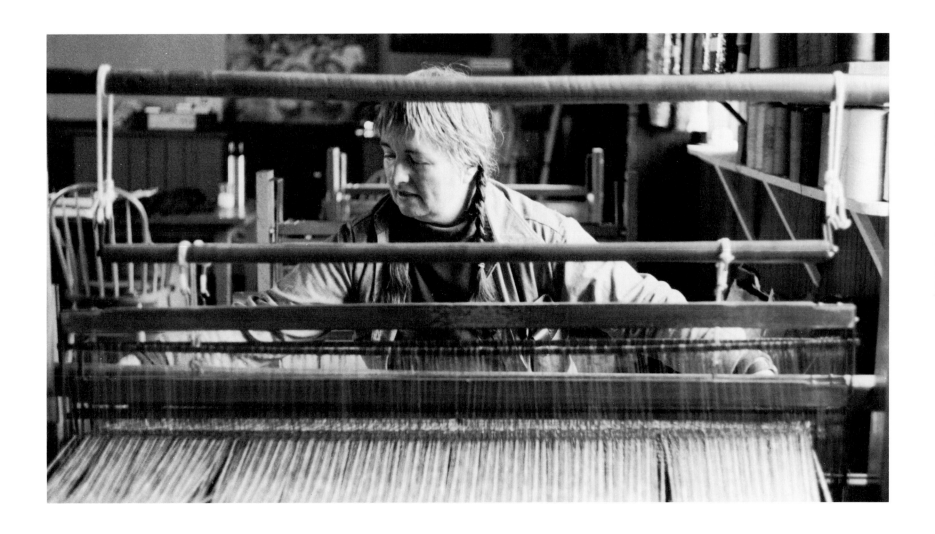

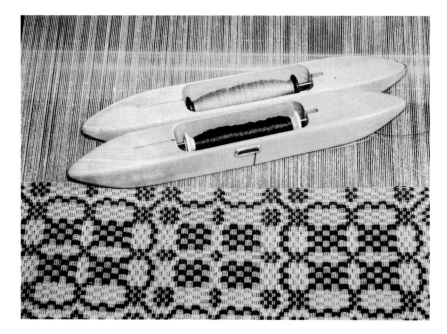

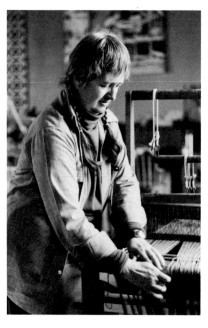

Coverlet 'Weaver's Dream' (detail)
1976
Wool and cotton

because people are restoring houses and buying antique furniture, but they can't buy antique textiles. That's mainly what I do, reproductions.

Of course this has happened before, a number of times. The cycle comes around quite often. But I think we are at the point where machine-made goods are becoming more expensive because labour is costing more and energy is costing more. I think we'll come to the point where hand-made goods will no longer be as expensive as they once were compared to machine-made goods.

My idea of craftsmanship is doing the most perfect work possible on a particular item. It has nothing to do with design or artistry. Craftsmanship is the act of making. The work has to be made by hand, and it has to be nearly perfect. And it has to suit its purpose. That's absolutely the first thing.

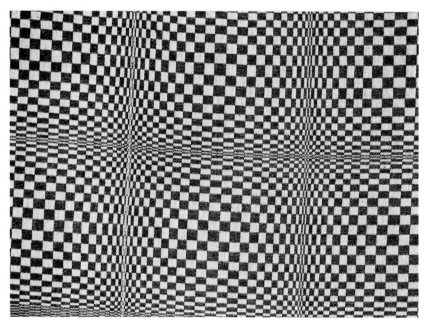

Sampler quilt 1978 (opposite)

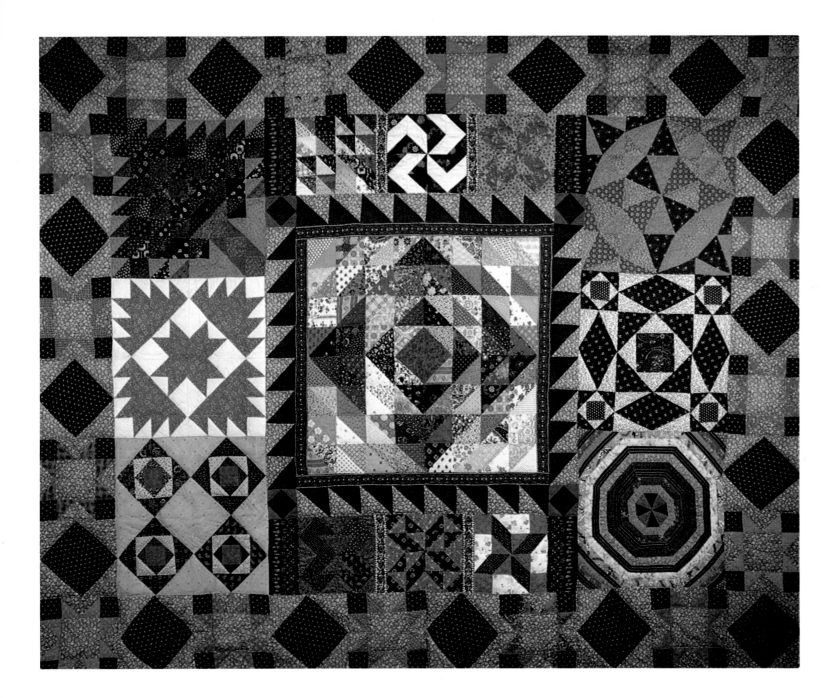

Christine Stanley

WEAVER · PRINCE EDWARD ISLAND

I didn't know weavers existed! Of course, I had always made my own clothes, and done a lot of embroidering, and weaving was along that line. When I took a course, it really held my interest – working with colours, with fibres. Not that I'm that much of a purist about weaving now. For example, some of my placemats are made with a synthetic wool because it's machine washable. If you want to make a living, you have to give a little. If I was to do them, say, all in cotton or whatever, I wouldn't sell as many. The average person wants something washable they can just throw in the machine.

We weren't out to make a lot of money at first. We just wanted to get by and decide what we wanted. But PEI has been pretty good; you can live in the country and still have people come to your shop. In any other province, it'd be hard to live in the country and make a living.

When we first moved to the Island, I couldn't stand to live in the farm house. I had to get into town. We were in town three or four days of the week, just to be around people. Now I'm getting really to enjoy living here. Not exactly being alone – I'd prefer to have more people around – but I love this place. It's so beautiful, and we have some good friends. A lot of young people are starting to settle down here. But the winter!

This winter, especially, there seemed to be a lot of our friends in bad moods, depressed that they weren't going anywhere. It's hard to get a job, except for short periods of time. It's hard on some of them. They'll work for a little while and they have gardens, so they have enough food. And most of them own their own places, so they don't have to pay rent. They can scrape by; they make it.

You're very conscious of the seasons here, especially when you have wood heat. You don't take *anything* for granted. Our hot water is heated by the wood stove. When I was living at home, you'd get up in the morning and take a shower. Nothing like that here! You wash your hair at night after

you have all the hot water. No morning showers. Now when I go home to visit my mother, it's hard to get used to the electric stove: we burn everything. Here, we have a hot plate. Usually that's just for my husband in the morning, because he won't wait for me to light the stove and get his breakfast going. But I like the wood stove. I'm very conscious of wasting electricity. I like to cook meals that take a long time, so if I had an electric stove, it'd be on most of the time. With the wood stove, you don't feel bad about doing a lot of cooking.

We're working towards building our own place, so that we can have a

Wool shawl (detail) 1977
72″ × 24″

lot of the things that we really want.
We'd like to be, not self-sufficient,
but fairly self-sufficient. If we had
our own property, I think I'd be
involved in gardening and farm an-
imals. Maybe I'd be more content.
Right now, life is centred around
the baby and the weaving and the
dogs. But dogs don't really need
that much attention.

It's not that important, the
money-making thing. But there are
plenty of sales for everybody. And
the more competition, the better
your work gets.

Sandra Brownlee

WEAVER · HALIFAX, NOVA SCOTIA

Cotton shirt 1977
36" × 18"

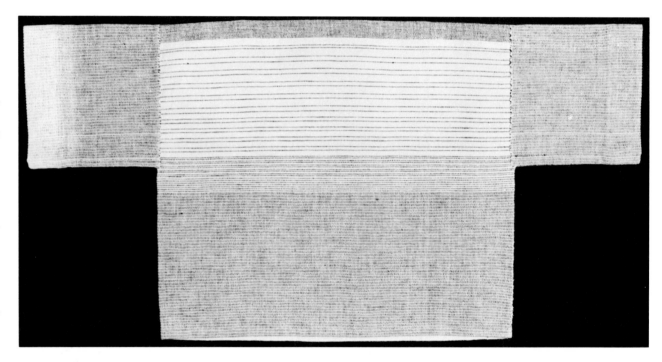

I never allowed myself to think I could do anything on my own. But when I started weaving, I loved it. I loved working with the thread. Even the simple things that some people considered very tedious, like threading the loom, I enjoyed. So I borrowed a loom and I guess I have been weaving ever since.

I was fortunate to meet a person who is a weaver living in this community, although at that point she had been quite isolated. Her name is Charlotte Lindgren, and she is very well known in other parts of the country and the world. We met by chance. She invited me to come to see her studio and then asked me if I would like to bring some of my own work to her. Up to that point I had never had a critique of my work, it was just, 'what are you doing?', or 'that's nice,' or 'that's interesting.' Charlotte and her husband were both kind; they took me seriously, they took time with me. We sat and actually talked – talked about surface, and line, and the idea that I was trying to get across.

I never consciously went into weaving. There was no big thing; it evolved gradually and naturally. I never went into weaving to earn a living – never thought of that at all; I thought I never could. It just grabbed me. It's the creativity, the self-expression, the need; and the more you use it, the more the creativity, and the greater the need.

I love so many things about weaving. I like the handling of the material, I like the *process*. I once took a course in ceramics, and although I love pottery vessels and clay pots – I love to look at them and handle them, I like to see them being made – I didn't like making them. I didn't like going down into the pot shop and putting my hands in all that cold clay; I always got a headache on that day. It's basic: you have to really enjoy the nitty-gritty of what you are doing. Weaving is quite a solitary thing and I like

118

that, and I like the repetition.

I like all the weaver's materials; at one point I really liked things like cellophane, and I still like them for certain things. On some days I've taken out a few little friends, children, and gone out into the woods and made little frames with branches, and woven grass in and out. I like grass. I just like *anything* you can weave.

Tery Pellettier

SILK PAINTER · WARD'S ISLAND, TORONTO, ONTARIO

My interest in art has probably something to do with my parents. My mum worked as a seamstress a lot of her life. My dad was a house painter. I can remember when I was small he painted Cinderella going down the basement stairs, so I wouldn't be so frightened of going down them. His colour sense is very good. I think that is why I've been happy with colours.

What I like about my work is the application, the directness. In etching there are so many processes to go through – waiting, waiting, and waiting – but this is so immediate. You just put the dye on the silk and it almost gets sucked into the fabric. You know right away whether it will work or won't.

I have a bit of a problem deciding whether my work is purely decorative or whether it involves some sort of self-expression. As far as the difference between art and craft, for me it's all in how you approach what you do. I'm not involved in techniques or processes enough to be interested in refining my production line. It doesn't move along very quickly, but to me that's not the important part.

If I don't feel that I'm developing there is no point to my working. You can work and work and work for three or four months and things don't seem to be changing. Your work stays pretty well the same and you can't see anything happening. Then you'll come to one piece and all of a sudden you'll look at it and say, 'well, that has taken me a step beyond what I was doing.' It doesn't necessarily mean that the piece is more complicated, but you can see something new in it. Then, as the years go by, you hope that you can pick out that direction and that it will become more clear.

Handpainted silk scarf 1978
36″ × 35″

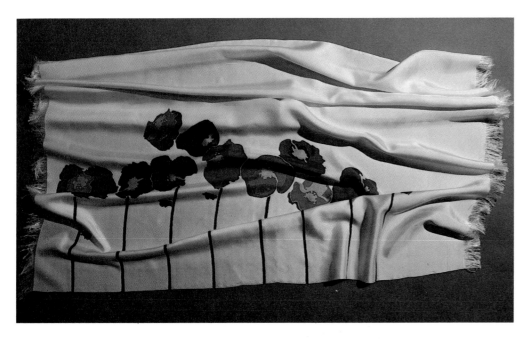

Handpainted silk scarf (detail) 1980
41″ × 35″

Suzanne Swannie

WEAVER · HALIFAX, NOVA SCOTIA

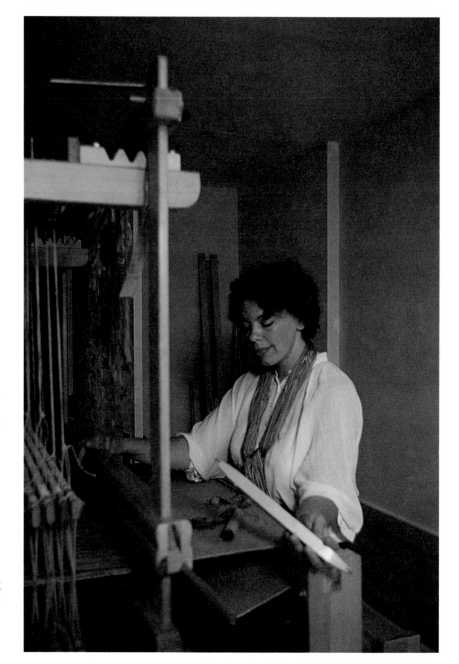

In Copenhagen, where I trained, I apprenticed in a studio which made quite a lot of ecclesiastical textiles. At the time there was much restoration of very old Danish churches, twelfth-century churches in which people found fresco paintings underneath layers of paint and were bringing these back. The churches needed cloth and textiles to complement the restoration, so we were producing altar cloths and robes. They were often made of damask and silks and golds, very beautiful materials to work with.

Eventually, after quite a thorough training and some time in industry, I started out as a full-time designer. But I felt you couldn't be creative and sit there and design things full-time, so I quit my work. I had some commissions, and I also got involved with adult education. Then I replied to an ad from Newfoundland. Their Department of Education was setting up its first handcraft program, and they were advertising for people to come and set up their place. They wanted somebody to do weaving. I applied and got the job. That was how I came to Canada in the first place.

I was teaching hand-weaving, mainly to adults. But I remember one class in which I had students with university degrees and also an Eskimo boy who had gone to school till grade 3. That was in Cornerbrook. Eventually I came here to the Nova Scotia College of Art and Design.

It's very strange to have started and done all your training in one culture, and then to have switched. You have to make parallels and comparisons all the time. The country I come from is very involved in tradition that evolved out of folk art. Craftsmanship in its contemporary form has probably existed longer in Scandinavia than here. I can see in my own work that the effect is different from work in North America, where there has been a real interruption and where there is a tremendous rediscovering process with all the excitement that entails.

I think that weaving is probably one of, if not the, slowest of crafts.

Linen hand towel and back scrubber
(detail) 1978

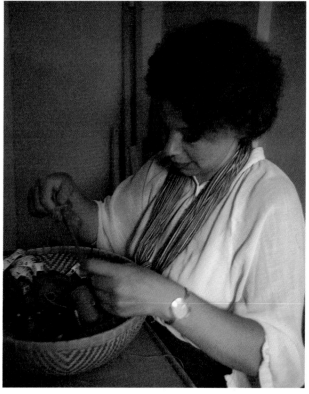

For me, weaving is almost automatic; I have worked so much. I come across this when I teach sometimes: I don't know what I have done. I have to go back and think about demonstrating how I did it. I have to analyse the routine. When I'm working I feel with my hands, and still have something in my mind, without having to connect the two. Maybe that is the stage at which you are a craftsman, when all these things go by themselves and you can concentrate more on the idea of what you are doing.

Marta Dal Farra

SILK PAINTER · MISSISSAUGA, ONTARIO

I started doing embroidery when I was about three. As soon as you could pick up a needle, if you were a girl where I grew up in Italy, you were encouraged to do something like that, and it was really intricate stuff. Looking back on it, I am really amazed at what we did. You always made things, but you didn't see them as art; they were usually functional things, like doilies to put under vases. They were always used. It wasn't anything you framed and put on the wall, and there was no encouragement around my house in that way to make something to hang up. You know, nowadays, when kids come home from school, how their parents stick up the pictures on the refrigerator and all that? Not at my house they didn't.

I have always loved silk, the way it reflects the light. When I find a new type of silk that I haven't seen before, I get so excited I have to think of a way to use it. That will decide what the object is going to be, what the design is going to be on it and everything else. All that

comes from a piece of white silk which maybe just happens to come from a different weave. Otherwise why wouldn't I paint on cotton or canvas?

I didn't discover dyes until I went to work at Sheridan College as a technician, after art college. There I found cupboards and cupboards full of coloured yarns, rows and rows of dye pots. It hit me like a ton of bricks: you can put on any colour that you want and exactly where you want it! Up till then I had only done things like batik. Well, with batik you don't really see what you have got until you finish; you have layers and layers of wax but until you iron it out you're not sure what you are going to have. With dyes you can stretch out the fabric and paint. It's immediate. It is right in front of you.

I usually work on the back of the clothes, more than the front. I design from the back, because that is where there is an unbroken sort of canvas; there is no opening or neck or anything back there, and when I hang my work in galleries or shows,

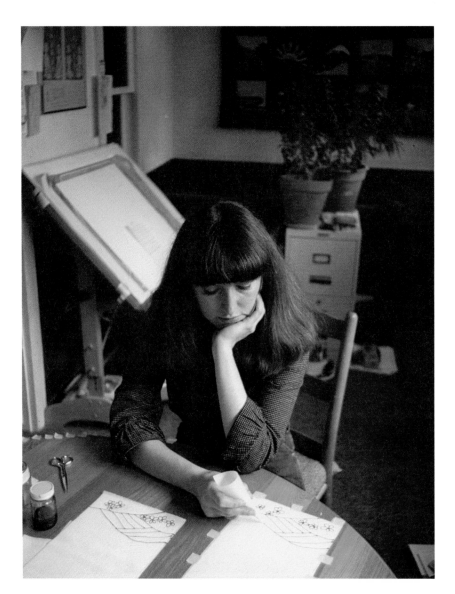

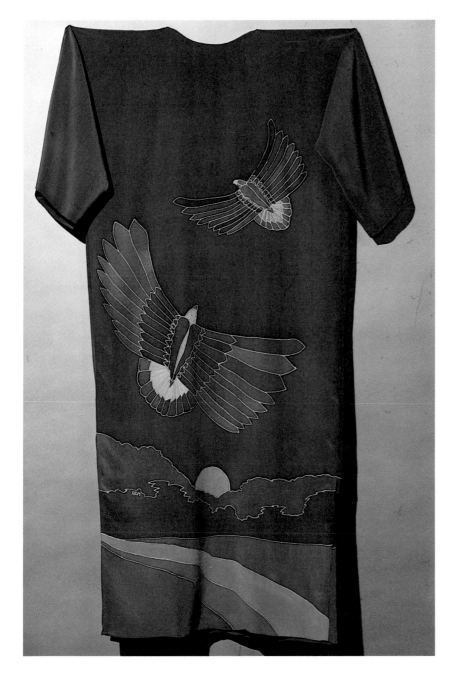

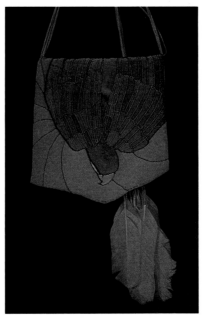

Handpainted kimono 1978
Crêpe de chine

Handpainted and quilted purse 1979
Silk and feathers
8 1/2″ × 8 1/2″

I always hang it with the back showing. I am aware of the body to the extent that when a person puts on one of my things, something could disappear under the arms or in the folds of the sleeves, so I am careful where I place the design. It has to work flat, two-dimensionally. But the garments fit anybody, because they are based on an Oriental rectangle cut – a man can wear them, a woman can wear them, it doesn't matter.

People are so vain, you know, about what they wear. I wouldn't think it was art if I had to make a garment for somebody and it had to flatter them or something like that. That is definitely not art. I don't want to be a dressmaker. I make my garments, and people buy them if they like them.

There are certain craft areas where you can make money, a lot of money. I think pottery is one and glassblowing is another, and of course in textiles, once you get to be a commission artist, or mass-produce, you can make a lot of money, too; but that is not my point of view. I do not necessarily enjoy doing commissions. If you approach things the way I do, you get used to not having an awful lot of money.

1 UNKNOWN INUIT CRAFTSMAN,
Baker Lake, NWT
Stuffed Dog 1974
Stroud and embroidery

2 ANN NEWDIGATE MILLS
Rug 1979
Wool and linen
42″ × 38″

3 MAX ROUX
Short kimono, batik 1977
Silk

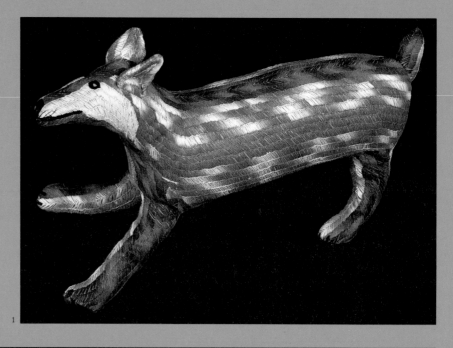

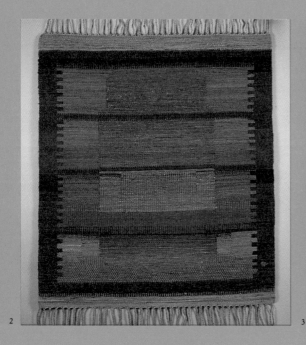

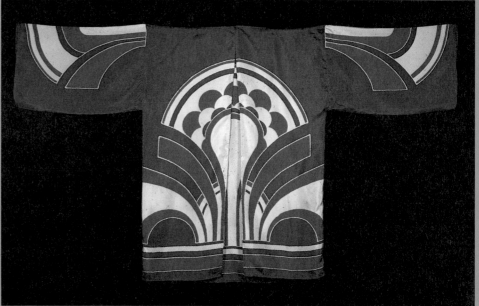

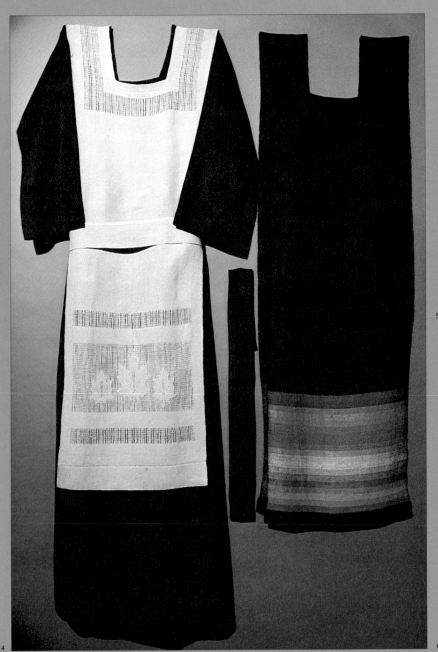

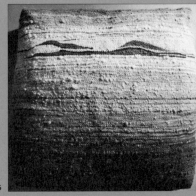

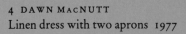

4 DAWN MacNUTT
Linen dress with two aprons 1977

5 MIENEKE MIES
Cushion 1979
Wool 28″ × 28″

6 JUDITH DINGLE
Quilt 1980
Cotton 85″ × 67″

DAWN MacNUTT, MIENEKE MIES, JUDITH DINGLE 127

7 DINI MOES
Evening raincoat 1980
Saran

8 BETTY MacGREGOR
Evening coat 1980
Quilted and stitched

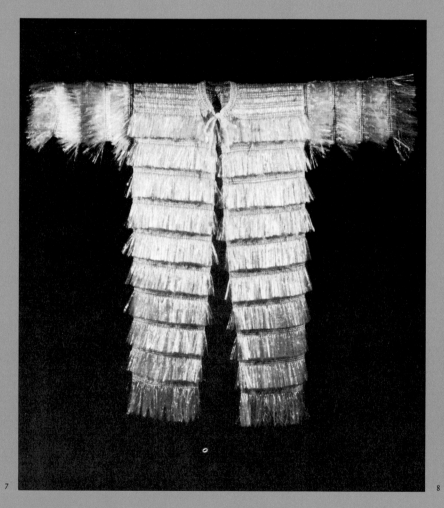

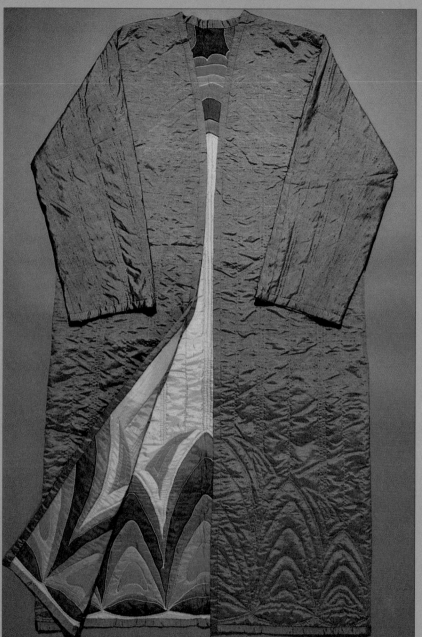

9 YVETTE HÉLIE
Quilt 1978
105" × 89"

10 EMELY DESJARDINS
Ceinture flechée 1978
Wool 120" × 8 1/2"

9

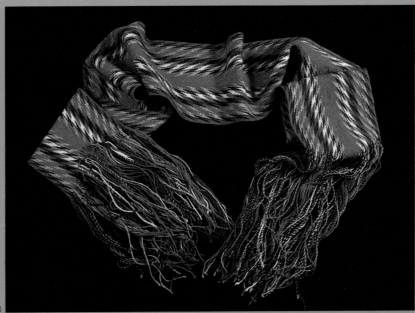

10

11 GINA SCHORSCHER WATSON
Handpainted cushion 1978
Silk 16″ × 16″

12 SETSUKO PIROCHE
Dolls 1978
21″ and 22″ h.

13 NICOLE POUSSART
Hammock 1978
Cotton and wood
76″ × 40″

11

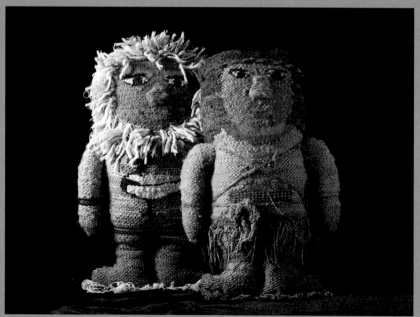

12

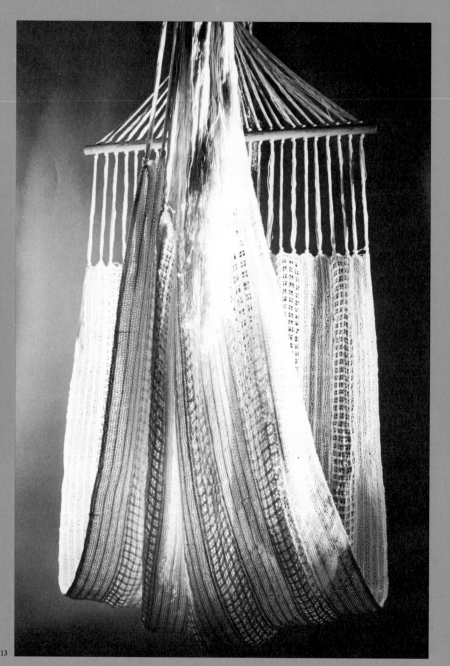

13

130 GINA SCHORSCHER WATSON, SETSUKO PIROCHE, NICOLE POUSSART

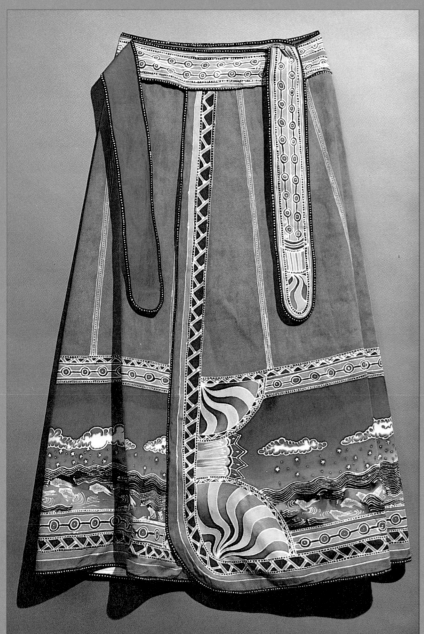

14

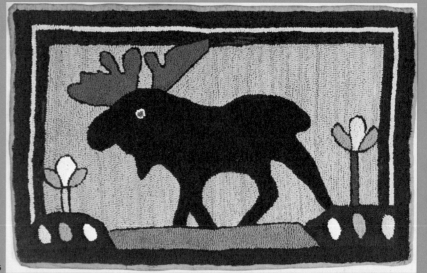

15

14 DOROTHY CALDWELL
Handpainted wraparound skirt 1979
Cotton

15 LOUISE BELBIN
Hooked mat
'Moose'

16 KOONOAK, Baker Lake, NWT
Collar
Stroud and beadwork
15″ d.

17 'Blazing Star' quilt 1978
Cotton, Polyester fill
96″ l. × 96″ w.
VICKI LYNN BARDON, design;
NETTIE ZINCK, piecework;
CAROLYN AND GLENNIS DAUPHINÉE,
quilting

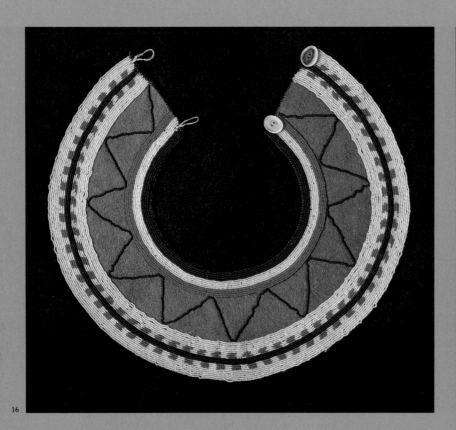

16

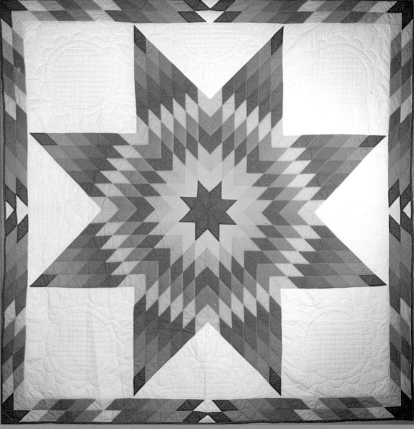

17

Basketry, Brooms, Paper, Leather

Rose Mary Plet Chapman

BASKETMAKER AND WEAVER · OTTAWA, ONTARIO

I consider myself a craftsman; I don't consider myself an artist. Not because I don't deal with rather abstract shapes or abstract concepts, because some of my designs are elusive even to me – you work at them for a while and they grow; you have added, you have taken away – but just because I don't like to get caught up in that question. If someone thinks my work can stand on its aesthetic value solely I am very happy, because that is basically what I am aiming for, for it to stand on its aesthetic value with a built-in level of craftsmanship. It has to be well made; it has to have characteristics of construction which conform to the methods being used; but the ultimate effect must be aesthetic.

A craftsman is a person who has mastered the techniques necessary to produce a usable, functional item. A lot of designers are not craftsmen and a lot of craftsmen are not designers. You will see some items that are beautifully designed and you know they were meant to be used but they cannot be used. In fact they are poorly designed. A craftsman is very pragmatic. 'Will this cup hold water? Can you drink out of it comfortably? How do you hold it?' – those are the primary things you have to look at as a craftsman. From there you go on to 'how can it be attractive? can it be different?'

This is basically an industrial age: most of the things that I can do can be done by a machine. So if a craftsman really wants to be successful, he has to add that extra element of personality to all the other elements. The value of hand-made objects lies in the personality of the maker. It is the quirks, the irregularities, the distinction given by the maker. It is not a calculated thing. A manufacturer has to make sure that his product is going to sell; he cannot afford to produce ten thousand sheets without testing the design, the colour, so that they are pretty safe. But a craftsman is usually working by himself. He can afford to experiment. He can afford to put his personality into his work, and that is where the value comes.

An item has to be well designed, and not only from the point of view of structure. It has to do what it sets out to and then it has to be pleasing, and if you don't have a marriage of the two things, it's going to be terrible. I have seen baskets that are magnificent. They are really beautiful, then after two or three months they fall over. They should have been designed differently. That goes for all crafts. The designing is the most important thing.

That's why I am moving away from one-of-a-kind. When you put all that effort and energy into the perfection of a particular shape, there is no way you can move on. Also, you know you are not going to have limitless ideas. They come, they are few and far between, and often they are take-offs from the same idea. It is important that they be maximized.

I find my inspiration in natural shapes. I like gourds, because they are an enclosed shape. Most of the baskets I make are like closed containers. My basketry in that sense almost falls into the non-functional. It is almost a sculptural form.

It is very very hard to sell something that falls closer to an art form than to functional craft. You can get more money for a piece that is considered artistic than you can for one that is strictly considered practical, but there is a much smaller market. And crafts are labour intensive. You work very, very hard to make very little, and in order to live at a minimal standard you have to charge a certain amount. I think craftsmen are grossly underpaid. But then you chose to do what you are doing. I could be making more money if I were to pursue my original profession as a sociologist. But now I consider this my profession.

There are several appealing things about working in crafts. One is independence. Another is the satisfaction when you have made something, when you think it is quite nice and it is appreciated – even though you know that in six months you may not like it as much, because hopefully you will have moved on. Then, craftsmen

interrelate with the public more than artists. They are pragmatic basically because they are making functional articles. You know there is a process. You do not isolate yourself. You know what you make is to be used. You can't keep three hundred mugs, so you build up a relationship, a rapport. That for me is the most exciting part.

One of the major reasons why people are getting into crafts is that community colleges have started to offer good courses. There is somewhere to go where you can get the technical information that you need. Canadians haven't traditionally had an apprenticeship system, and as well a lot of our goods were not manufactured in Canada, so it has only been in maybe the last fifteen, twenty years that there has been a place to go and learn. There is a difference also in that the consumer has shifted back towards hand-made articles. When I think back to my parents' home, there was very little in it that was hand-made in North America. There were a few things that were made in other countries, but very little.

Craft today seems to fall into two very distinct areas. There are folk craftsmen, who have grown up with techniques and are carrying them on in the more traditional manner; in many lower income areas there is a large proportion of this passing on of techniques. But a lot of the new craftsmen are urban people; in fact they are very middle class; they are the product of the sixties. Most of them lived in big cities. I am constantly surprised at the educational level of craftsmen. It is not unusual to find in a group of craftsmen at least one PH D.

There are a lot of reasons for this trend, which is not an abandoning but a shift in emphasis. What is happening is not necessarily less intellectual. In fact, what I'm doing now is more satisfying intellectually, it's strange to say, than my time at university, because what I'm doing now is making something from my own concept. I set my

own standards. They may be too high and they may be too low, but I'm achieving something I have set for myself.

Also there is a self-sufficiency to craftwork. You have to survive by your own means. You have to present yourself to the public. You have to be your own accountant, your own public relations, your researcher, your technician; you have to do the whole thing. You are not at the mercy of any one other person; you succeed or fail on your own merit.

To succeed you have to be flexible. You have to decide, for one thing, what your standard of living is going to be and then you have to decide how it can be achieved. Some craftsmen can't compromise their work; therefore they have to be flexible enough to make their income in another manner. You also have to be pretty resilient. In a lot of situations ego is involved in the article you make. You have put a lot of time, a lot of effort, a lot of yourself into it, and if someone comes along and says something negative, it can be very painful.

And, oh, goodness, you have got to work. As far as I am concerned, you have to be able to work at least twelve hours a day. There may be periods when you don't work at all for two or three weeks – some people even don't work for a couple of months – but when you are working you have to be able to work long, hard hours. It is not the kind of work you can just pick up. It doesn't come between tea-time and dinner. Most craftsmen I know clear large areas of time and maybe work all through the night. Once you get going, you keep working. You have to be prepared to work more than other people.

Basket 1978
Raffia, brushed sisal top
3 1/2″ d. × 6 1/2″ h.

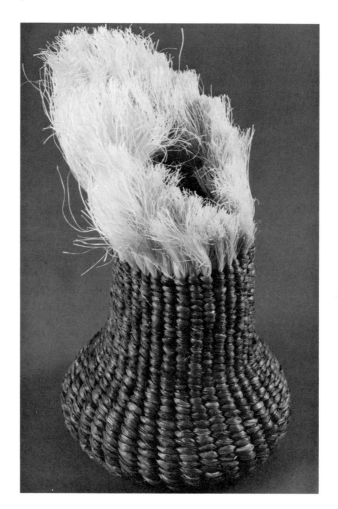

Peter Honeywell

BASKETMAKER AND WEAVER · OTTAWA, ONTARIO

I'm very conscious of the primitive tradition that I like to go back to, the African roots of basketry, or South American basketry. I find that Canadian Indian basketry is a quite specialized form, very graceful and well developed. I lean more towards the primitive forms.

A lot of my ideas come from the materials that I'm working with. If I'm working with a banana fibre, which has a lot of highlights and dark tones and ridging, the piece will take on a similar look and the whole piece will develop from the materials. It is the same with a material that has a shiny finish – the piece will shine and sometimes the form will come from that.

Basketry can take any form. It can take a square shape, it can take a cylindrical shape, it can take any form that you want, but the round form is probably the most prevalent. Basketry works in a circular fashion, takes on that circular form. Often if I am creating, for example, a bottle or a small jar, a pot or a piece of glass will influence the shape I am trying to get – a flare at

the top, or a very quiet ending.

My interest in basketry started with an appreciation of painting and drawing. I worked with a teacher I had in high school, in his studio, and my leaning in the beginning was towards clay. I enjoyed that but I wasn't comfortable with the medium. I tried working with some fibre, very simple knotting techniques, and I enjoyed that – the flexibility of the materials, and being able to make from them a solid form or a fluid form, either way. I grew from there into basketry and weaving. Now I weave, cloth and scarves and ponchos, in order to make a living. Weaving is the bread and butter. The baskets are the relaxation and the reward for doing the weaving.

The satisfaction in basketweaving is seeing something that you have visualized in your mind. You see a shape, or you see a selection of two colours joining together in a certain way. You visualize it, and then you begin to work, slowly, and sometimes at the beginning you are fighting to keep

the basket under control. Finally you do impose that control. That's when the satisfaction starts to come, when you feel the shape moving into what you visualized, until it's completed and you can stand back from it and see it made tangible.

Basket 1978
Jute and palm
2 1/4″ d. × 6 1/2″ h.

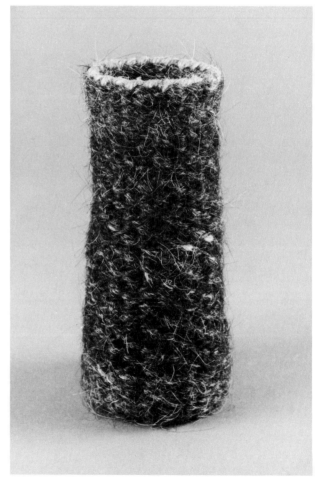

Robert Lyons

BROOMMAKER · ANNAN, ONTARIO

Once I saw an old broom machine which, just one day a year, was brought out as part of a celebration. I was one of the people looking after it, and I think I made two brooms on it that day. That was the spark of my interest. Then one morning about 6 AM I woke up from a dream. In this dream, a very clear voice told me, 'you can make a living making brooms.' That was it. I woke up and decided to take the dream at its face value. Although there were other factors leading me to the decision, that was the thing which shoved me over the cliff.

I have to admit that when I first started I hadn't thought a lot about the symbolism of brooms, but as I got involved I realized the broom is an exceptionally important symbol. Broom-making is a very old craft. The broom sweeping the dust out is a symbol of purification.

The first brooms I made were very simple. I was using dowel handles, and broom corn without stalk. They were very simple utilitarian articles that had not much to them and nothing of me in them.

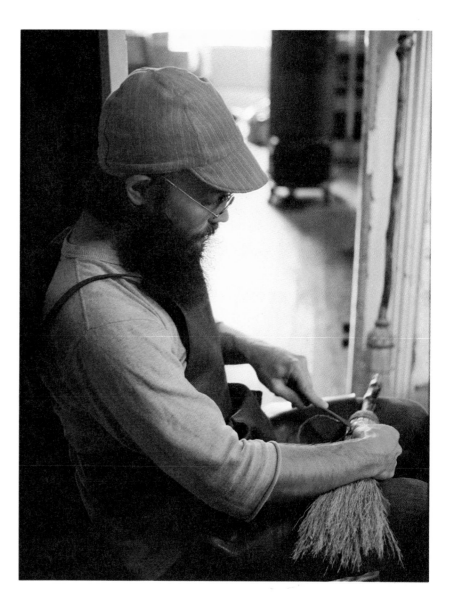

But after a while I began experimenting with bush handles – in other words, handles that were not straight, that had knobs and natural curves in them. I thought that here were brooms which were very different indeed. People liked them. I also realized that Nature was putting its own skill into the handles. I was basically using a bit of found art, if you want; if Nature could make a very beautifully curved handle, then I was just borrowing it for the broom.

I also started developing a way of making a broom that would last, that would be a good working reliable tool. I realized from the beginning that I was recreating an old tradition, using techniques of one hundred, two hundred years ago. Some people bought my brooms purely for decorative value, but as far as I was concerned I wanted to make useful brooms, and I wanted to make useful brooms that were beautiful. What I make are useful, good-looking objects meant to sweep floors and fireplaces and the backs of the hands and doorsteps

and garages. I know that people will take them differently. Some say 'this is a decoration,' but there always are a number that say 'now, this is a very fine-looking broom and it looks as if it is meant to be used,' and buy them for that. People come up and say 'oh, this is a curling broom' and another says, 'oh, this is a hearth broom' and another says, 'oh, this is a besom,' which is the old European type of round broom.

I do make round brooms, rather than flat ones. That is an old tradition. I am interested in the circle and the symbolism of the circle as unity, as infinity, as life itself. All brooms basically were round up until the last two hundred years; they have become flat since, for the sake of sweeping more floor. That to me is symbolic of the whole modern culture and its emphasis on quantity.

I have two broom machines. One is a recreation of an 1850-model broom machine; the other one uses the principles of the 1700s. It goes back to an English tradition of

making brooms, where they sat astride a broom horse, almost like a leather working horse. There are not a lot of other broommakers around to fraternize with in Canada, but I have run into two broommakers in the States who use traditional techniques. They make very different brooms from the basic braided style I make.

I can duplicate a broom that is made in the factory, make it slower but make it exactly the same. Physically, to look at the two, there would be no difference. But here another thing comes up. I believe that the emotional quality of the builder of something stays with the article, so that even if two articles look identical, and one was built by someone in a good mood, and the other by a fellow who was angry, both qualities would be there too. A craftsman who is not in a good mood and a factory hand who is not in a good mood will make identical objects. But if a human being who has love in his heart is making something, that is very good. It can happen in the factory or it can

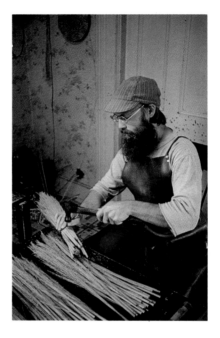

happen in a small individual craft enterprise. I have a feeling that today love can more easily happen in a small craft enterprise, because the craftsman has more freedom in his life.

I call myself a craftsman because I am making something that can be used every day and admired for its

appearance. The crossover point to art is when I can reach the level where I can impart some universal truth in my brooms. I don't feel that I have achieved that although I definitely feel I am headed in that direction. I feel quite strongly about the difference between my brooms and factory brooms. I have no doubt in my mind that my brooms have more warmth in them and more humanity, in the sense that people quite obviously know that these were made by somebody, rather than stamped out by a machine. I don't want to deride machines. They have their place and many things should be stamped out by machines and used. Yet we cannot lose touch with the quality of humanity in the making of things, and if we are not constantly reminded of our humanity in our surroundings, we might lose touch with these things that we need to have close to us.

I have definitely reacted against a materialism that has been prevalent during the last two hundred years. If I wished to live in Toronto I

would find it difficult to live by this belief. But we live in the country, in a rented farmhouse that is in rather poor condition. We live below the poverty line, as the government defines it, and yet we are still able to save money every year so that by our standards we are rich. We have extra time, we can do most everything that we want to do, but we don't have a lot of income that could be spent on what a lot of people consider important.

I have made thousands of brooms. I would say in a year I make between one and two thousand brooms. That includes small whisks as well as big brooms. It is not something that I could enjoy if I had to do it every week of the year. It is an economic existence, but I would not want to be bored to death by it. I want enough time to pursue other matters that feed themselves back into the broom-making, other avenues that may lead to various truths about broom-making. My ambition is to create the archetypal broom. I want to make a broom that has love in it, and has harmony in it, and can be perceived consciously or unconsciously by others as such. That's a tall order.

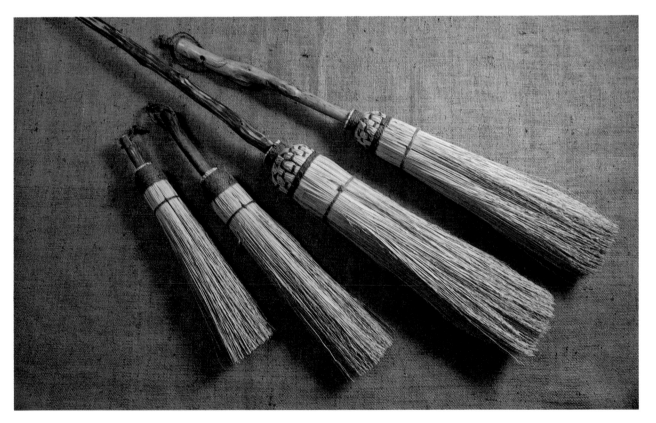

Sweeping broom, ironwood handle 1978
Broom, corn straw and cord binding 54" l.
Besom, ironwood handle 30" l. 1978
Whisks, 22" and 15" l. 1978

Annegret Hunter-Elsenbach

BOOKBINDER AND BOXMAKER · TORONTO, ONTARIO

In bookbinding there is an easy distinction between craft and art. There are bookbinders who are only really restorers; they take old books and get them to look the same as they looked from the day when the original binder made them. They specialize in repeating designs that have been done and they are very good at it. That is the pure craft side of bookbinding. Then there is the other side, where people try to find new possibilities for design. A book, after all, is a square thing, so you are somewhat limited. You can't make a round thing out of a square book, but some binders, some artists, try to break through this square a little bit. I'm interested in that part, the design part, the art part.

I enjoy the challenge. In painting, you have a huge surface which you can make any size you like – thin colour, thick colour, whatever you like – but with a book you have only the two covers with something inside. The challenge is somehow to make the whole thing more like a painting. Although you have limits, you push some of the limits to make something really new with the means you have there. You bring lines in a strange way across the spine, or you use both covers, or you cover the whole thing completely or decorate just the one, the front cover. There are many challenges in breaking through that rigid form of a book.

It is very important too that there be a connection with the inside – the story and the printing and the illustrations. You have to know the book, and the cover has to relate to the book.

I also make boxes. This began because for a year after I studied bookbinding I was in an area where there was no bookbinder. I didn't have that many books to work on, but I had to practise. The boxes, I thought, would be a good compromise. All the techniques were the same as in bookbinding. So I started to draw all kinds of different boxes with leather, and without leather – with velvet lining and silk lining and things like that. Afterwards, when I did books for cus-

tomers, that experience really came in handy.

Every bookbinder is conscious of being part of a very long tradition. After all, the techniques are all the old techniques. The gold tooling is done exactly the same way as they used to do it in the fifteenth century. And one way to learn still is to try to reproduce someone else's work that you admire: only the better binder has a better grasp of the technique, and to learn it, I think, you should just reproduce what he did.

I'm sure I want to stay in bookbinding for a very long time, because I'm not near the stage I want

142

to be. Every time I do something new for myself I see the next five hundred steps towards the next kind of perfection, and that just goes on and on and on. I doubt that there will ever be an end to that.

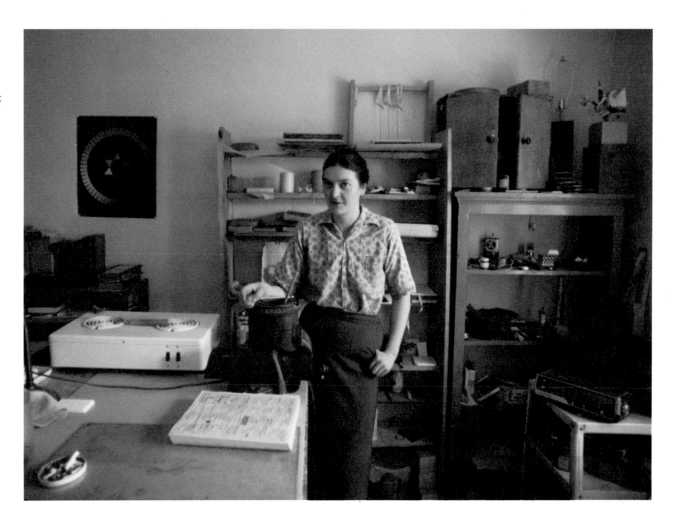

Box 1979
Binder board, paper, black goatskin
(crinkled relief)
10 1/4″ × 6 1/4″ × 3″ h.

Box 1979
Goatskin, handpainted silk top (by
Marta Dal Farra), silk lining, binder
board
12″ × 12″ × 5 5/8″ h.

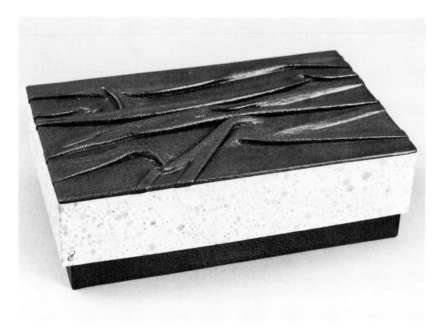

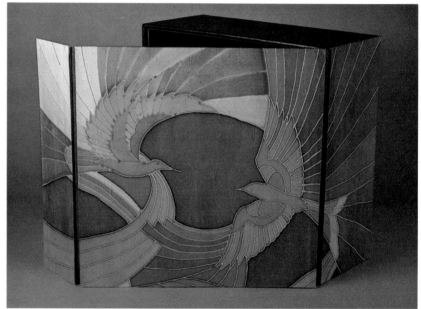

Gerard Brender à Brandis

BOOKWRIGHT · CARLISLE, ONTARIO

When you look at a book you are in a very private space. When you talk to someone who is reading you know you are intruding, so in making books one is creating a little nook for someone to crawl into by himself. You make a book for yourself, to a certain extent, but you are also making it with the idea that someone is going to use or consume your book. You are making this little secret surprise-filled space for somebody to come into. That is one of the reasons why it's so wonderful to have a book in a box; you have to open the box and then you open the book, going layer by layer into that space.

I had a delightful Australian teacher in grades 3 and 4, a retired army man. Nobody now would regard him as a good professional teacher, but he had been to Baffin Island and to Africa, and he made the world very, very interesting. He taught bookbinding, so I started bookbinding as a noon-hour activity. Mind you, in 1949 or 1950 school budgets were low; we *had* to mend the books and do things

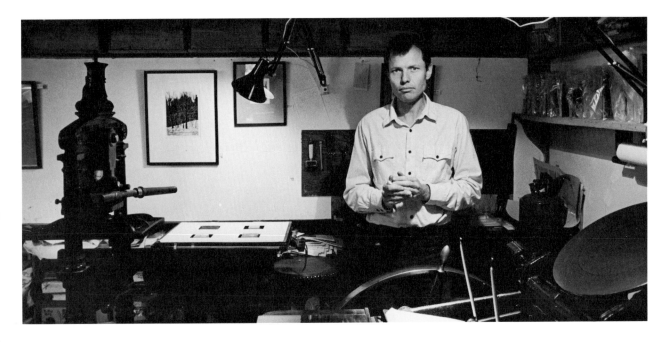

like that at school. Later I had some small prints, and I thought, 'what beautiful books they would make!' I made some one-of-a-kind books as wedding presents for friends. I didn't have the equipment to turn out editions at the time; I was making one-of-a-kind books, which I still do occasionally.

I call myself a bookwright, because to say I'm a bookbinder would suggest that I only assemble the books. To say, for example, that I'm a printer is wrong too. Again it's an aspect, but not the total. So the bookwright is someone who can presumably do most of the stages of production of the book. A play-

wright, a cartwright, a millwright, a wheelwright, they are all people who make something and so it seems the best word. It is not commonly used but it's not coined by me. It's the best I can come up with. Bookmaker resounds of the racetrack and betting, and it somehow doesn't seem to be right for what

145

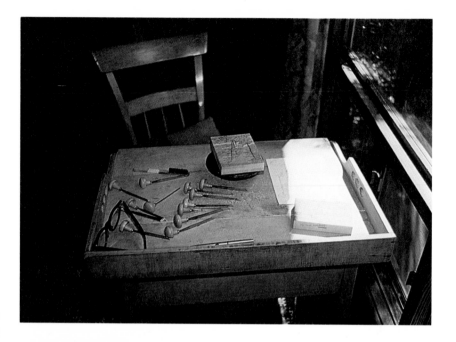

I'm doing.

I make the paper for some of my books. I make it out of rag which is, of course, cotton, and is traditionally one of the fibres of the West, in contrast to those of the Orient. I make some papers out of iris leaves and goldenrod and other plants, more in the eastern tradition; sometimes I blend both types together. I design the illustrations, which means I go out sketching and collect the materials and transfer my drawings to wooden blocks. Then I engrave the blocks: that's the pictorial part of the content. Only in a couple of cases have I written the text. Usually the text is prepared by someone else for me, but I can set the type and combine the type and the blocks in the press, and then print the sheets. The bindings entail spinning and dyeing and weaving flax, which I do for a number of bindings. What I have done in the past is usually a number of copies in one binding; and then I'll do other bindings. I like the fact that the copies in one edition don't have to be identical. There should be va-

riety. Each book, I like to hope, might become an individual. When I weave the covers I make sure that no two covers are the same. I don't weave a length of cloth which then gets cut up so that each part looks the same; I weave so that they all look different. Then I think people will have the joy of feeling they have something no one else has, although the contents of the book may be the same.

I think tactility is very important and highly individual. There are people who feel that the hand-made book is something gorgeous and elaborate. I have had a couple of my books bound by another binder in gold-stamped morocco leather; that's the image most people have of the hand-made book. I quite enjoy that, but because I think I relate more happily to fibre's tactile experience I enjoy the linen-bound book more.

If you talk to artists, they will tell you that the most important act in their work is the thinking, the conceptualization of the work. I think that for the craftsman the most

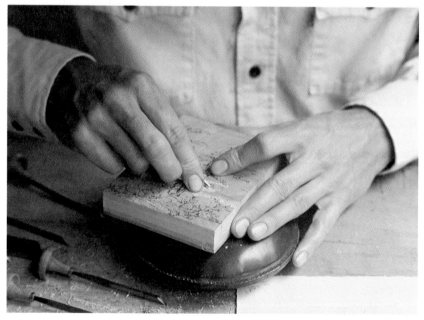

Handmade books 1978
Wood engravings, binding, printing,
and paper by the craftsman

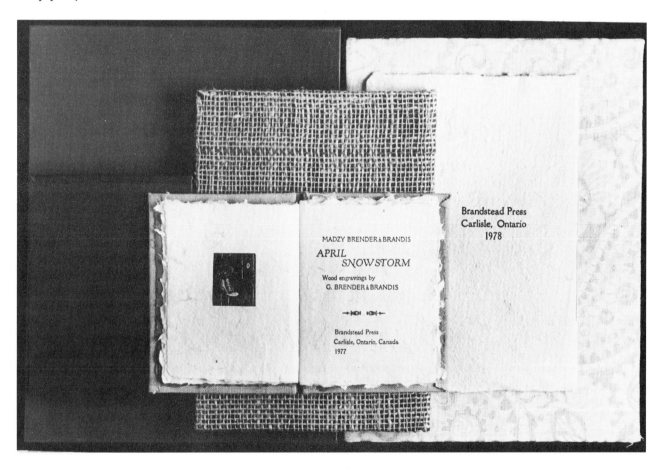

important act is the making, not the conception, not the thinking up of the thing, but the actual making, the working with materials. The craftsman is at his peak when he's got the clay in his hands, or the paper in his hands, or the wood in his hands, making and shaping the object.

I can't really draw the line between when am I working and when am I not working. My work place and my living place are close together. I like having everything bundled together. If what I really need is some fresh bread I'll go downstairs and do something on the books until they all need to dry for half an hour and then come upstairs and mix a batch of dough and let it stand to rise. Then I can go back to the books. Later on I can come upstairs and punch the dough down and then go back to the books and so on. I like having things integrated like that and not saying 'now, I'm at work and now I can't do anything else.' I like the muddle of what might be called non-work and work.

David Trotter

LEATHERWORKER · BEETON, ONTARIO

I'm not sure what I call myself, perhaps a leather craftsman. I tend more towards designer craftsman at this point, because I feel that what I do is designing as much as crafting.

When I was a teenager, I lived about two miles from Daphne Lingwood's leathercraft studio at Caledon East, outside Toronto. I started doing a few things with leather in the summer when I was going to high school, cutting out leather blanks. I did that for about two summers, and immediately after high school I worked there full-time for a year. At that point I decided I needed to find out whether I was interested in other media – I had worked with wood, I had worked some with metal – and whether my designing ability was such that I could use it to make a living in craft work or something in that line. So I took an art fundamentals course – a little bit of everything, a little bit of photography, a little bit of 3D design, a little bit of painting, and I found I was using leather for the basis of most of my things. I was taking pictures of

leather scraps in a collage, and I was designing sculptures in leather, and I was painting on leather. I realized at that point that I should probably stay with leather.

I went back to Daphne's for more apprenticing. In all I was there for five years, and from her I learned that leather had unlimited possibilities as a material for any kind of art or craft. She inspired me to keep trying and to keep experimenting.

I was probably fifteen or sixteen when I really decided I was going to make my living doing leather work and that I was going to change the image that leather had. I was going to give it a new image: I was going to try and bring it out of the Dark Ages, try and bring it to a point where I think other materials have gotten to. Now I'm spending a lot of time strictly with the artistic and the sculptural and the ability of the leather to take colour and texture.

Leather is very responsive to anything that you do with it. Any kind of a mark that you make on it, any way that you shape it when it's wet, it will respond immediately. Yet it

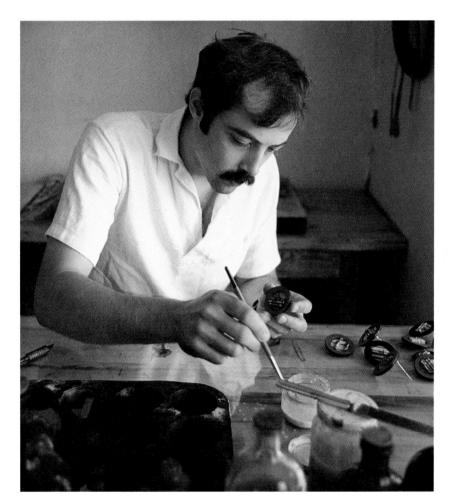

will retain what you have done indefinitely. Leather was probably the first material that man worked with. As soon as he started eating meat he had leather to do something with. It's only recently that I've started to read and to realize that that is part of what I'm doing. When I first started working with leather that part had nothing to do with me. I started with the leather after it had been processed up to a certain point: it was simply a material that could be worked with. Most of the work that was being done with it was still the type that had been done for centuries. I approached it as a completely new medium. I didn't use any of the traditional methods. I never have. Most of my influence comes from inside me, not from tradition – from what I see, from abstract ideas that I get from looking at textures and colours and forms.

When I'm working with my hands and thinking about what I'm doing I block out everything else. It's an escape. I think it's basic to human nature to be doing some-

thing with your hands. It's the tactile thing. It goes right back to infancy – touching and feeling things. If you are not doing something with your hands you have to find some other outlet that will soothe that urge.

Leathercraft has been somewhat neglected for as long as I have been working at it. During the sixties, all sorts of things were being done to leather that were inferior workmanship. I think it is important to bring the image back up, to let people know that leather is not just belts and shoes and purses. There is a lot more to it than that. It's a medium that has been with us for a long time, and people should recognize its history and importance.

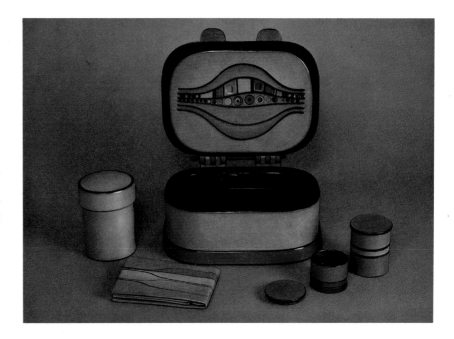

Leather wallet with incised design 1978
Cowhide box with incised design and
hinged lid 1978
7 1/2″ × 5 1/2″ × 2 3/4″ h.
Round leather boxes with lids 1978
2 1/2″ d. × 3 1/2″ h.; 1 7/8″ d. ×
2 1/8″ h.; 1 3/4″ d. × 1 3/8″ h.

David Orban

SHOEMAKER · REGINA, SASKATCHEWAN

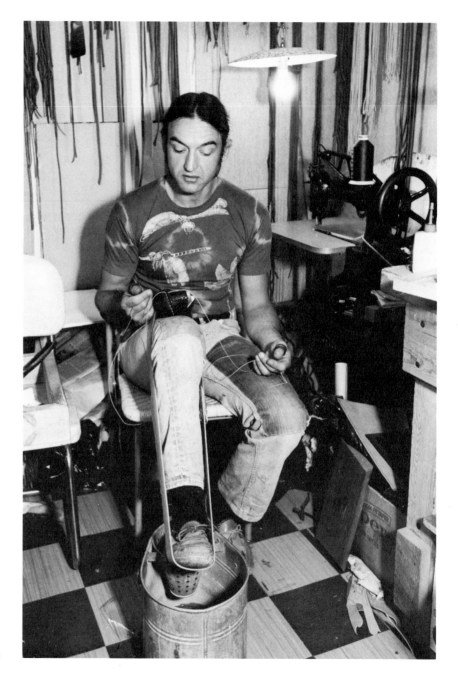

In 1972 I was travelling in Colorado and ran into a pair of very unusual shoes in a custom-leather store in Boulder. I tried to put them on but they were way too small for me. Fortunately, the fellow who made them only lived a couple of hundred miles to the south. I went there to get him to make me a pair and ended up, after our first meeting, wanting him to teach me everything he knew. It took about a week of discussion before he accepted me as his first apprentice. He had been making shoes for about forty years.

It was an honour to be working under this man. He had me doing practically everything in his shop for about four months. He didn't know exactly how to set up an apprenticeship. He made me pay him $10 the first week that I worked with him and $5 for the next week and I did nothing but sew for a month after that. Then he taught me how to cut and make patterns. He taught me everything in reverse: the last processes he taught me first because they take the most time and skill to get down pat.

My teacher had been taught by a family in Maine how to make moccasins, and that was where he had originally set up. There are, I believe, only three people in the States who build hand-lasted moccasins: one in Maine, where he learned, somebody in Massachusetts, and my teacher in Colorado. They are the only ones who build totally hand-lasted, hand-stitched moccasins. There are lots of partially hand-stitched, partially hand-lasted makers. There is even a factory in Saskatchewan that makes lasted moccasins, except most of the operations are done by machine.

A last is a form in the shape of a foot. You stretch the water-saturated leather over the last and shape it to that form and tack it onto it and sew it up and let it dry there. The result is a moulded type of footwear.

It all began with the Indians. Some tribes had a crudely shaped block of wood that they would build their moccasins over. There are essentially two ways of making moccasins, with a last and without a

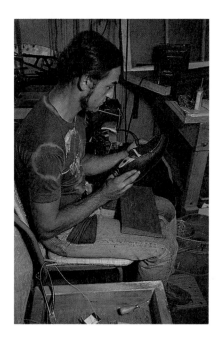

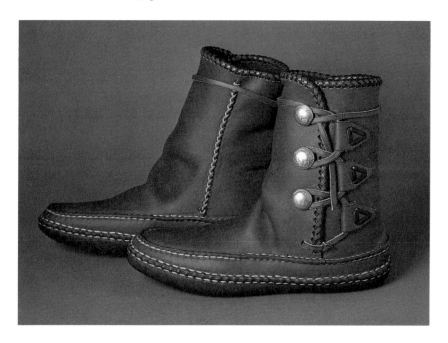

last. The more primitive method is without a last. I build moccasins that way, too: I was taught by an Indian in northern Saskatchewan.

Traditionally, the European hard-sole and raised-heel shoe is constructed from the top downward; the moccasin is constructed from the bottom up. That's true whether it's lasted or not. It always starts with the sole and works itself up.

I think every culture began with a simple single piece of leather that was wrapped or sewn around the foot. Essentially the ethnic dancing slippers are moccasins. I have made Roumanian and Polish dancing slippers, and I found they easily adapted to my technique of making.

I feel I could be lost in leather for the rest of my life and not really scratch the surface of it. But I would rather wrestle a bear than do an afternoon's paperwork.

I do not consider myself an artist. I don't even consider myself a craftsman. I consider myself a tradesman. I feel put off when anyone calls me an artist. I feel strange when my footwear is behind glass cases in a gallery, for I feel that footwear is about the most animate of objects. When I see my slippers on a group of thirty dancers on a stage, that gives me a big thrill.

The fact that things are created with love and care is what craft is all about. The moccasins I make are deeply rooted in Mother Nature. They grow when being built the way everything above the ground grows – upwards – which is a contradiction of the European method of building shoes. All the processes – the sewing, the shaping of the seams, everything – are done in unison with nature. It's a very organic process. It's a spiritual thing. My religion, my philosophy, my trade, and my craft are all wrapped up in one bundle.

Victor Bennett

SADDLEMAKER · EDMONTON, ALBERTA

I started working on saddles in a small way when I was thirteen or fourteen years old. I spent most of my high school years drawing pictures of chaps and what-have-you, trying to figure out how to make things. That was when I became involved with Roy McCaughy, who became my partner later on. He had a place in the country where he was building and repairing saddles. I used to go and stay with him. My father always told me not to fool around with those stupid horses and saddles, I'd never make money at that. He wanted me to go into the construction business.

I did go to university and took business administration. But I used to skip a lot and spend my time at Roy's, learning how to build chaps and how to carve leather, and starting to build saddles. He was in partnership with his father, and when the father decided to sell his interest I bought it and dropped out of university.

Roy and I built saddles together. I would do the carving and certain pieces and he would do most of the construction, and we used to agree on everything. But when I started making them on my own we both developed our own styles. It was interesting. We worked side by side for years, and it got so we could hardly agree on anything as far as saddle construction went. We both appreciated what the other made, but we developed our own little idiosyncracies about how we did it.

We always ran the business so that we sat in the back and made saddles. It got to the point where people thought the manager owned the store. In fact, we were once sitting at a horse show and there were a couple of guys in front of us and one said to the other: 'Have you been over to Clover Bar Saddlery?' The other said he hadn't, and the first said: 'You should go. That Dwayne [the manager] sure has a good store there, but those dumb buggers in the back, I don't know why he keeps them on.' We knew we had arrived at the proper balance of things then.

Saddlemaking has a rich heritage. It came up through Mexico and the

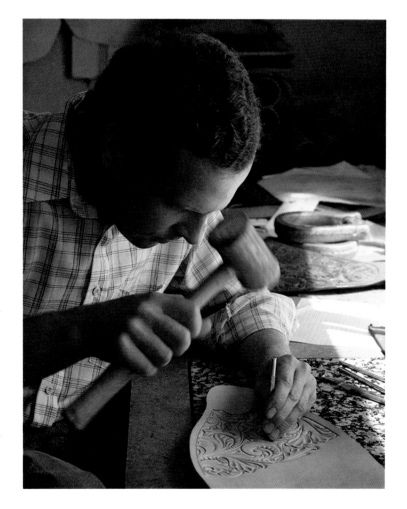

southern United States. Certain areas developed certain styles, and you can identify with certain patterns that you like. I'm interested in the West and its heritage. That's different from someone who's interested in cowboys and Indians.

I make saddles for what I call modern-day working cowboys, people who do things with horses – team ropers or calf ropers. Some of these fellows do actually work full-time or part-time looking after stock. I also build a lot of saddles for people who ride cutting horses in competition. The other people I make saddles for are horse-show people. They want something fancy, something that will help them look good on their horses so the judge will like the way they ride.

With some saddles it's hard to ride properly. Saddles can help a lot in the way you look on a horse. You can build a seat that will put you in the right position and give you the right posture and so enhance your riding, or you can build a saddle that will throw you in the wrong position, which makes it hard for

you to ride properly. To build one properly, you have to spend time.

I really enjoy working with leather. There's the smell of it, and the texture, and what you can do with it, and once you've learned to work it, it's a fairly forgiving substance. If you cut something a little too short you can stretch it. It's also possible to shrink it. If I was working with 2×4s I'd have an awful scrap pile. But if you don't know how to work leather you can wreck a lot of it.

I rope steers, myself. I go to a few amateur rodeos, and I also go to quite a few jackpots. We have an active roping club in this area and I go to all their events. I also keep horses for my kids, and rope horses for myself, and usually in the summer I'll have a couple of horses in training. That's kind of hard because if you get too involved with the horses you forget the saddles. But it's also good because you learn more about what a saddle has got to do. Some saddlemakers have learned how to build a pretty decent saddle but have never learned to

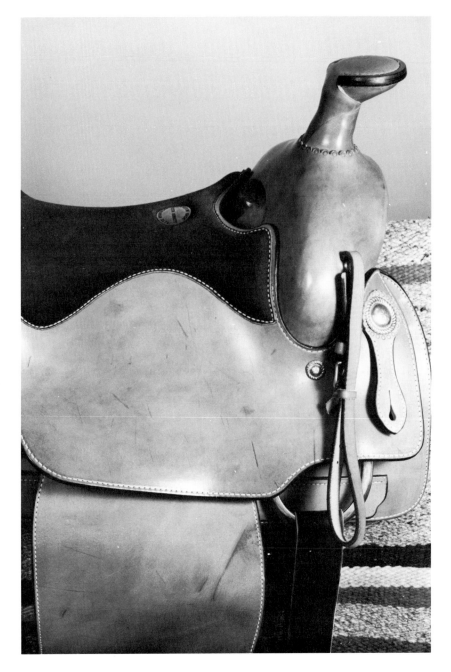

ride a horse, and it does hold them back because they don't have a working knowledge of what the saddle has to do.

Anyone who's thinking of getting into a craft has to *want* to do it, because it's not easy. Where in the world are you going to learn how to do something really well? A lot of the people who are good at it don't want you around. If you're lucky enough to find somebody who is good at it, he probably can't afford to pay you all that much because you can't produce the quality stuff that he's known for. You have to spend the time, pay your dues, finding out what you can where you can. Roy and I learned a lot together and by ourselves from all kinds of sources, like reading horse magazines. Maybe they would have an article about some saddle shop some place. I once noticed a picture of a shop in the States where a bunch of guys were lined up sewing Cheyenne rolls with the saddles in a position I'd never seen before. I used to sew Cheyenne rolls – that's the roll at the back of the seat of the saddle – but I had no idea you could put it in such an easy position: obviously these fellows had been working in that factory for years and years. But a lot of craftsmen are pretty close-mouthed. They don't want you to get to the same level as they are, so they don't tell you anything. They might talk to you though, and while you are there you have to look around the walls and see what they are doing – look at what kind of glues they've got, what kind of dyes they use, what kind of tools they have, and just try and learn. It takes a long time.

I'll introduce myself to people as a saddlemaker just to see the reaction. A lot of people think that's the same thing as being a cobbler – not that I'm running down cobblers, but they think of you sitting in a dark, dingy backroom somewhere eking out a living, a very small living. I always tell them that there are fewer saddlemakers than there are brain surgeons.

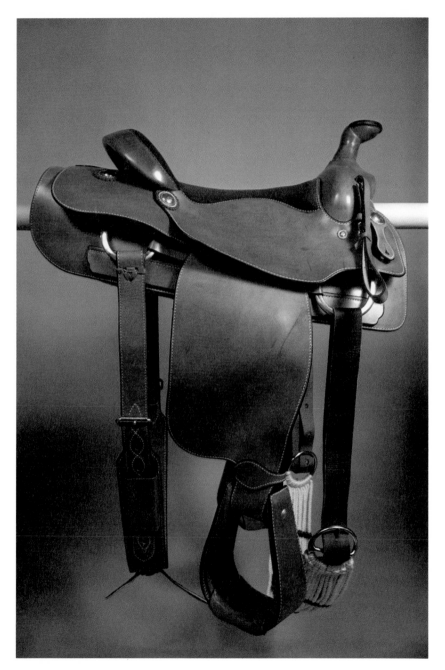

Roping saddle 1979
Bull hide; 'Chuck Shepherd' tree

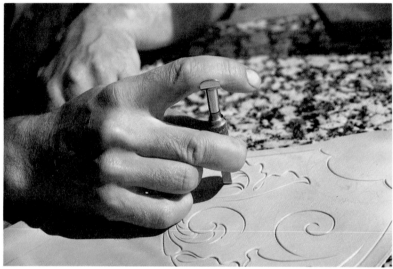

1 EDWARD YOUNG
Baskets 1978
Spruce root
Various sizes 16″ × 13″ to 3″ × 3″

2 UNKNOWN INDIAN CRAFTSMAN
Northern Quebec
Bear paw snowshoes
27″ × 20″

3 EDWIN BURKE KOE
Leather belt and pouch 1978
Beadwork decoration, Blackfoot design
Pouch 12″ l. × 6 1/2″ w.

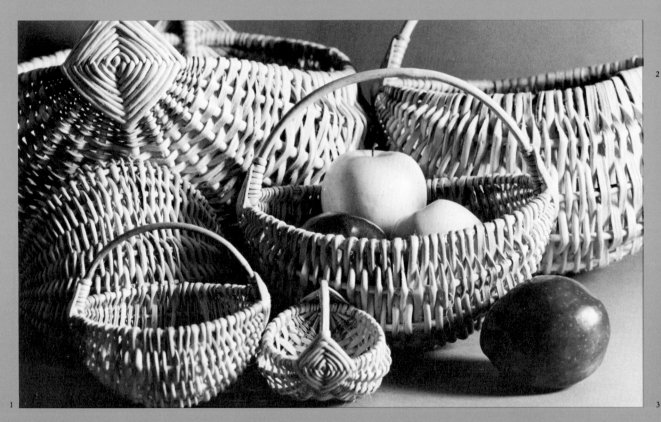

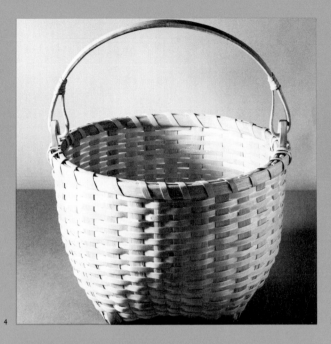

4 UNKNOWN MICMAC CRAFTSMAN
Nova Scotia
Basket 1975
Split black ash
20″ d. × 24″

5 UNKNOWN INUIT CRAFTSMAN
Cape Dorset, Baffin Island
Man's camiks 1978
Sealskin, urine-tanned, waterproof

6 PAUL WILLIAMS
Leather briefcase 1979
Cowhide, lined with English kip leather
18″ × 14″ × 4″

7 HEBER HEFFERN
Birch broom 1980
Cut from one piece of wood

8 CECILIA WILLIAMS
Four small baskets. Nootka design
Grass, cherry and cedar
Three – 3″ d. × 3″ h., one – 4″ d. × 5″ h.

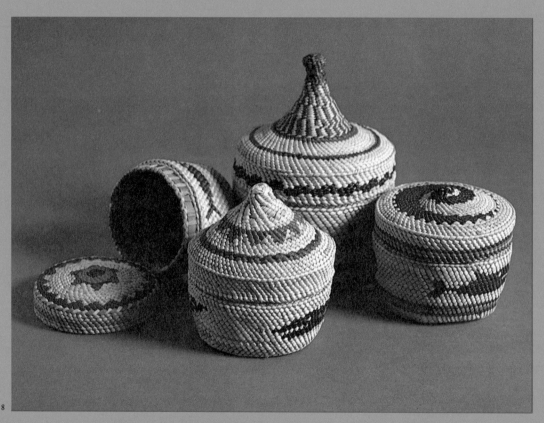

8

9

10

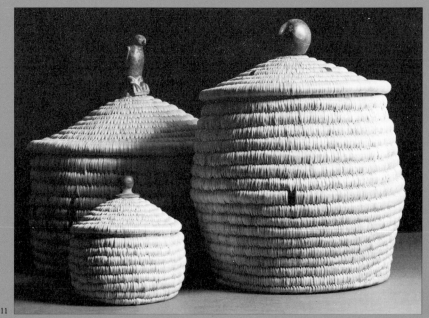

11

9 MARGARET HORN
Choker 1978
Bone, brass, leather, abalone

10 DORA FAVEL
Leather moccasins 1979
Beadwork decoration

11 MINA WETTAGAK, Povungnituk
Lidded basket
9″ d. × 10 h.
Lime grass, soapstone, sealskin
decoration

LUCIE NARLIK, Great Whale River
Lidded basket 1974
4″ d. × 4 1/2″ h.
Lime grass, soapstone

MARY COOKIE, Great Whale River
Lidded basket 1975
9″ d. × 10 3/4″ h.
Lime grass, soapstone, sealskin
decoration

12 MADELEINE CHISHOLM
Basket with lid 1977
Sisal rope, crocheted
18″ d. × 12″ h.

13 EVELYN JEBB
Leather mukluks 1977/8
Smoked hide, otter fur trim, bead
decoration

12

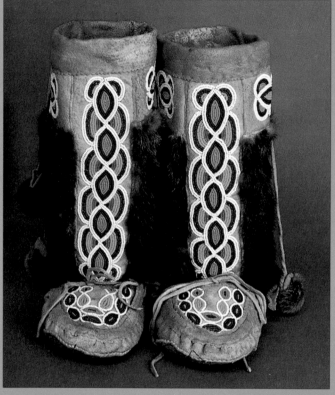

13

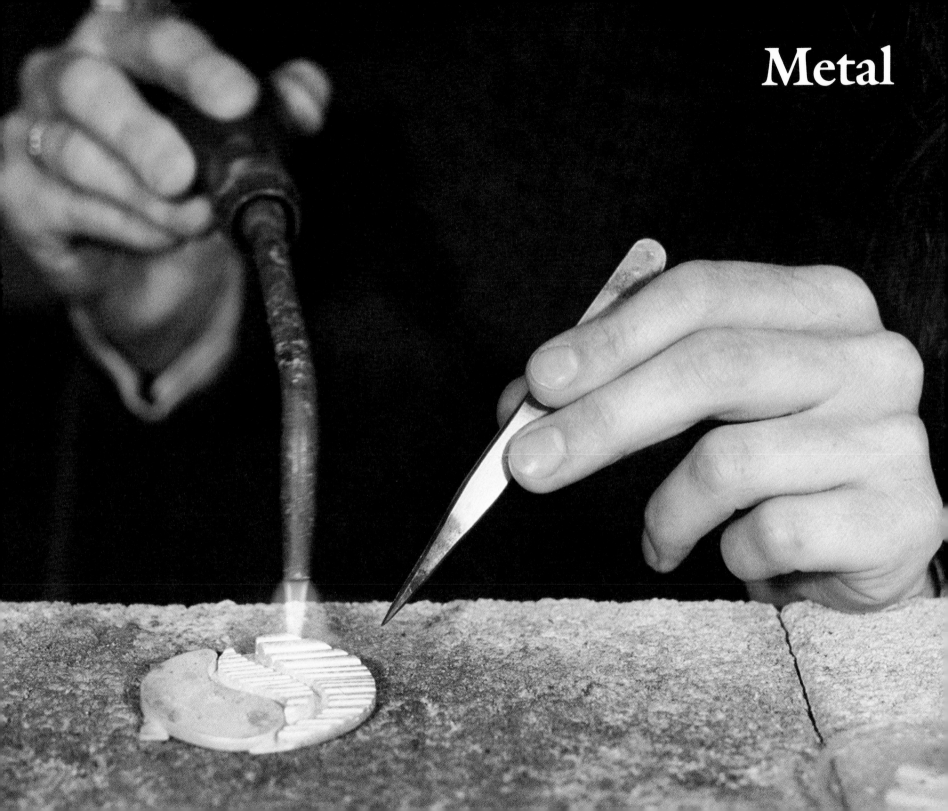

Pierre Lemieux

JEWELLER · VAL DAVID, QUÉBEC

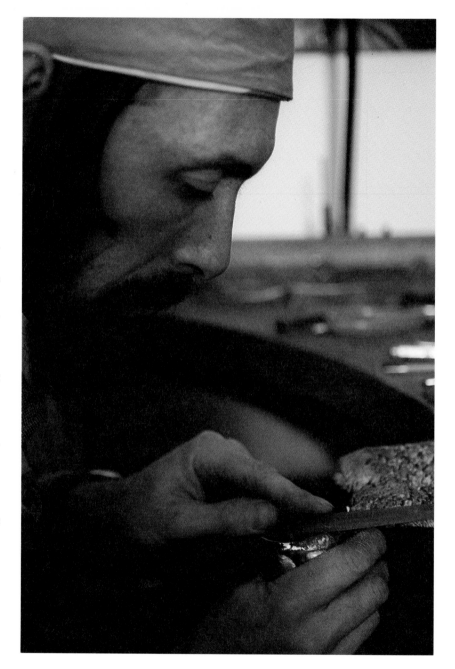

A French philosopher once said that any art form is done out of frustration, a need to be able to get what you feel across to others. Jewellery is a way I get close to women. I make jewellery to enhance the body, to belong to and be a part of the body. When I make a piece of jewellery for somebody, she usually ends up wearing that piece most of the time; it's not a piece of jewellery to wear with that suit or this dress – it belongs to the person. So much so that (and this I've seen to be true) I'll make a piece of jewellery for somebody and when somebody else wears it it doesn't look good.

I once made a necklace which was sort of like a snake; it went around the neck and came down and terminated in two pieces of gold. I made it for a specific woman some years back and it was perfect on her. But no other woman has been able to wear it so well. You might think it luck, but I think of it almost as a sixth sense. The jewellery has to match the owner's bone structure very well. Now, I had seen this

woman, but not long enough that I could match her bone structure with what I was doing maybe two or three weeks later. Yet it worked and that piece was exactly, precisely right on her body.

If I'm doing a piece for somebody in particular, one way or another I have to be influenced by that person or personality. I will look at the strength in the person, something that might not come out readily. I know of a piece that I did for a girl at one point who said, 'I love this piece. I can't wear it now but I feel as I grow I will be able to wear it.' Somehow I had perceived a strength in her that was not yet there but that she felt was coming about.

Steel is a very strong material. A person who would buy clunky jewellery-store jewellery would not be attracted to the kind of work that I do. It's not pretty. I would rather it be ugly or beautiful: the word pretty doesn't come in. My work can be worn by either a man or a woman; it just depends on the strength of that person.

The fact that I use steel, for

instance, would stop most people right there. Jewellery is something you buy with the intention eventually of fleeing from a country or a war and selling it. This is the traditional value of jewellery: it has been traditional to keep gold in a nice form for use as a passport. With my jewellery you get very little monetary content. The value of it is as is.

I'm not trying to create something that is pretty but something that is beautiful and something that touches a strong emotion. But I can't really define that emotion until the piece is finished. Some pieces are violent, some pieces are very calm, some pieces are sensuous, and some pieces are cold. But it's only when the piece is done that I realize how it came out because, basically, when I start, there is just a very strong, undefined urge. The metal tells me what to do. The piece makes itself. It's just a case of being sensitive enough to the matter. It dictates how it should go, what curve it should take, how thin or how thick it should be, how it should feel, what should be put

with it. Too often an object is made pretty by the addition of little things on it: I try to keep away from that. I try to keep the line simple and as basic as possible. Whatever material I put in I feel is needed by the material itself.

A piece of steel to me is security. I have a strong emotional tie with steel. Other metals, too, but steel is the metal that most fascinates me. Because of its mechanical abilities, you find it in tractors and things like that – knives, guns, tools, forgings. Steel has been used mainly for weaponry, very rarely in jewellery, but I try to bring out its aesthetic qualities. The strength is there, obviously, and when you colour steel the variations, all the way from yellow to green, blue, browns, purples, are wonderful. It can be a very soft material and also a very strong one. You have to feel precisely how it's going to go. It's always a wonder to see a piece of steel, which is very hard, move so fluidly and with almost no effort.

One of the very first pieces I made is a steel ring lined on the

Bracelet 1978
Gold, silver, wrought steel
Riveted construction
Neckpiece 1967
14 kt gold, mild steel,
blued and polished 9″ × 5″

inside with a gold band; on the
outside it has dots of gold and you
can see the contrast of the two
metals. The concept itself is fasci-
nating: steel, which is probably the
cheapest and one of the hardest
metals around, and gold, which is
the most expensive and softest. Put
together, they complement each
other. The gold brings out the
strength of the steel and the steel,
because of its strength, shows the
softness, the ductility, the power,
and the fascination of gold.

Bob Davidson

JEWELLER · VANCOUVER, BRITISH COLUMBIA

My grandfather was an incredible craftsman, an argillite carver. He also built boats, thirty-foot trawlers. He was the last person to carve a large Haida dug-out canoe, in 1937. I come from a long line of experience in creating things. He taught me a lot about crafts – no, not crafts, but perfection, putting everything into it. You do a good job *now*, not next time. That rubbed off on me. I was very conscious of doing a good job, but I would have to be reminded quite a few times.

I grew up at Masset, on the north end of the Queen Charlotte Islands. It's one of the three remaining villages of the Haida tribe. My dad encouraged me to start carving. I had a great interest in making things with my hands at a very early age. A lot of my friends were doing the same thing. We didn't have very much money in those days, so most toys were made by us or our parents. We made a lot of boats. I carved my first totem pole when I was just turning thirteen. From there I went to argillite and learned from my dad, who was also an argillite carver, and my grandfather and I carved till I was eighteen or nineteen in the local Masset style.

Then in 1966 I was demonstrating carving at Eaton's, in Vancouver. A lot of people asked questions, and some people placed orders. There was a quiet time, the first or second day, when I was really getting into my carving and I could feel the presence of someone. I was too shy to look up; I just carried on carving. After about five minutes of silence this voice said, 'hi, I'm Bill Reid.' I just wanted to crawl under the table. That was the first time we met.

He invited me over to his workshop, and I did a lot of practising in copper, copying his designs. Finally, one day, he said: 'Now it's time for you to design your own.' So I designed my first bracelet in October 1966. It took me four days. He took all his designs away, everything, and told me I had to do it on my own. I'd show him something and he'd say it wouldn't do. Finally, after four days, I had a design he approved. I did it, engraved

Bracelet 1979
Killer whale motif
Silver, repoussé

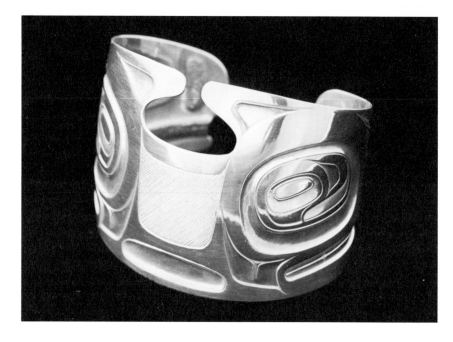

it, and gave it to my girl-friend.

He always said you had to be daring. That always stuck out in my approach to things, but I have a different understanding of being daring now. I feel once you gain understanding and confidence you don't have to be daring, you just do it. I worked with Bill for a year and a half. I feel he saved me a lot of time and effort. It took him I don't know how many years to arrive at the level he was at at the time of our meeting; I was down in the beginning, and I remember accelerating and learning through him. From that point on I was able to start creating my own work.

I started off learning how to copy the traditional art. I went through that with Bill, my dad, my grandfather, and many other people. This is how you carve the eye, this is how you do the ovoid, and you copy how it's shown to you. It's like music, which is very structured. You have to work within a structure: you have to have boundaries. I have a very strong understanding of the tradition, how the art works.

From that I can't stay within the tradition. I have to start working within the tradition on a personal level. I can't make eagles look like eagles any more. I can't because there are only so many ways you can make an eagle look like an eagle. It becomes very abstract and personal in my creating. It becomes a very personal thing. Anybody who progresses as an artist or as a person starts to become an individual. You are no longer part of the masses; you emerge as a person.

My ambition right now is to take every day and deal with it. I have future dreams or ideas but I have to live out my bracelet phase, and every once in a while I get scared as to what will happen when I exhaust the ideas for bracelets. But the ideas just keep coming. The more you progress there is no void in problems – just more problems and more ideas.

I'm very aware of my surroundings. I'm very conscious of things happening around me, the understanding or creativity that we, as people, have. Once you've gained

that awareness, the thing is to play with it. That's creativity: you play with the ingredients.

A lot of my inspiration comes from nature now, whereas, before, a lot of my inspiration came from other people. It's pretty powerful. I like to go fishing once a year, and when I go up I take my work and I assess what I've done for the year. It's like a cleaning-out period. Nature is a balance. If we take too much fish, we won't have any fish the following year. The eagles, the crows, the ravens – everything lives in harmony, everything lives in a balance. Everything is in cycles. There is no electricity there so you work with the light: you work with

the day. You set the net when the tide comes up: you work with the tide. Everything has a power there, a life. My work has to have a life. You try to create the balance. Yesterday I was watching a musician. He was singing. He jumped, and one sandal fell off, so his feet weren't balanced and he had to kick the other one off. We are always striving for balance.

Elma Johnston McKay

JEWELLER · SAINT JOHN, NEW BRUNSWICK

I was born in Saint John in 1951, a local girl, born and bred, and went to the New Brunswick Craft School in Fredericton. I had no idea what I wanted to do: I just thought I had always worked with my hands even as a very small child. But by Christmas of my first year I knew that jewellery was what I wanted to do.

I liked the mystique of it, I guess, and the properties the metal has to offer. You can do so much with it. Metal has the quality of being able to be stretched, hammered, shaped, formed. You can melt it, and pour it into moulds. It's lasting. Pottery you can break, a piece of fabric you can burn, but something in metal you are bound to have around for a long time. That's important to me, to have something that I can say that I've made with my own two hands that might be around for a lot longer than I'll be around.

I make jewellery that pleases my eye, or that I think is wearable, but I like to make jewellery that is based on a certain technique, mechanical or otherwise. Whether or not a person tries to buy that piece of

jewellery and wear it really doesn't concern me at all. The fact that I have made it and it pleases me is more important than having somebody buy it.

Most of my work is of the construction method, meaning that I saw into the metal to cut out shapes, then solder them together to achieve a three-dimensional look. This is as opposed to casting, which is sculpturing a piece of wax, making a mould around that wax, and then burning out the wax and filling the cavity with molten metal, resulting in a finished piece of jewellery. The construction method takes a lot longer but I can get a completely different type of look.

When I design a piece of jewellery I've got something specific in mind. I've experienced something new or I've seen something new in nature, or I've read a story in a book which has made an impression on me. My jewellery says something to me that I hope I pass along to whoever buys it. It may not necessarily mean the same thing to them, but they wouldn't buy a piece of jewel-

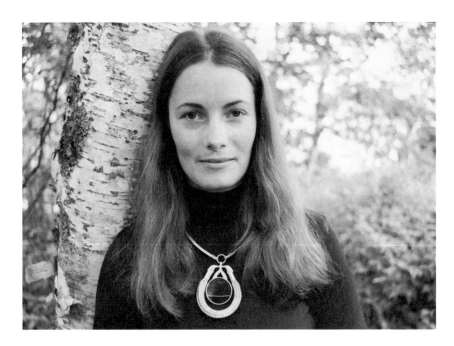

lery if they didn't like it for some reason and I hope that reason is close to my reason for making it.

I think all Canadian crafts people are trying continually to upgrade skills and standards, to be the best that we can possibly be. We are trying to open our eyes, so to speak, to be not just as good as we think we

can be but to be even better than that – to look a little further.

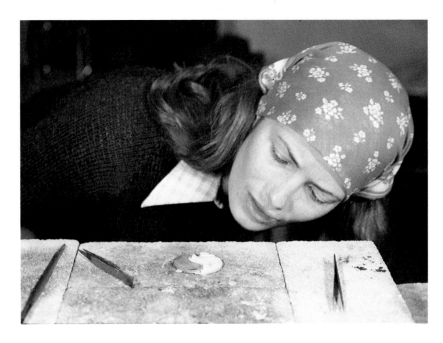

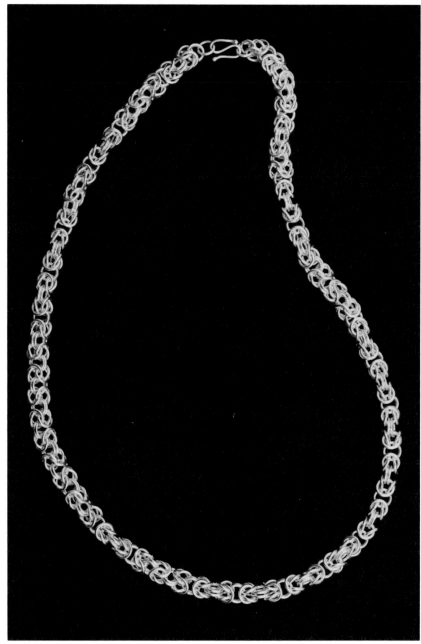

Chain (idiot's chain) 1978
Silver 24" l.

Jacques Troalen

JEWELLER AND SILVERSMITH · MONTRÉAL, QUÉBEC

What attracts me to making jewel-
lery is the metal itself. I started to
make jewellery before I even thought
of being a jeweller. We lived near a
railway and I used to put pennies
and dimes on the tracks, then after
the train had flattened them I would
cut them and make rings from them.
I used to glue them around pieces of
ham bone.

About the end of grade school
my father asked me if I wanted to go
back to school or do something
with my life. I hated school. He said
to choose now. So I became an ap-
prentice in jewellery, working in
traditional ways, always by hand
with metal, no wax, no casting. I
learned all the methods: how to
draw wires, how to roll, how to
melt, how to prepare everything,
how to make tubes. Today you can
buy everything ready-made. You
can't get that kind of training in
Canada any more.

I never do any jewellery for a
woman unless I know her. You
can't make a ring without knowing
who is going to wear it. When I
have pieces in an exhibition, with

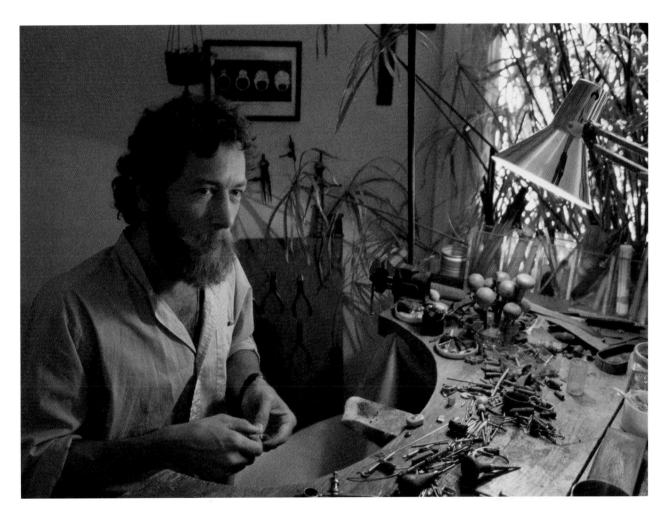

Covered box 1977
Silver, top surface of lid 18 kt gold
1 7/8″ sq. × 3 1/2″ h.

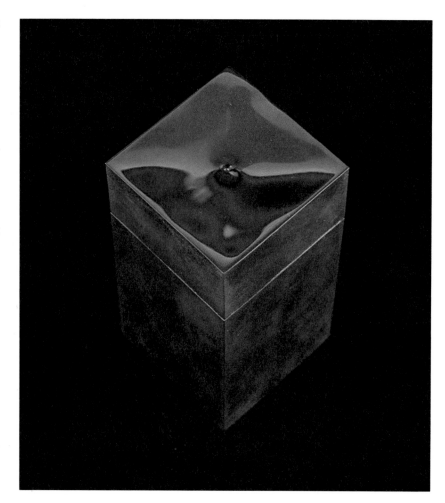

people buying them, sometimes I'm afraid. If I make a ring and I love it I just imagine who might wear it – somebody ugly, or somebody it doesn't fit with.

There are rules. People who are short or chubby have different hands from very tall people; they won't wear the same jewellery. The colour of stones, and the person's own choice in colour, are important. Some people hate blue, or hate certain kinds of stones. For instance, a lot of people don't like transparent stones.

That is why I sometimes have to make pieces I really don't like, but I have to make them for my living. I wouldn't call them ugly pieces, but ordinary. It's not a question of money; some people have a lot of money and will ask you to do what I would call stupid things. Other people will be almost poor, such as teachers, but they will come to my place and ask me to make rings. They won't have the money to pay, but I would do anything to make the best design for them. Some of those are my best pieces.

Donald Stuart

SILVERSMITH AND WEAVER · BARRIE, ONTARIO

A lot of people ask me how I can weave as well as work in metal, and get honours in both. But both are forms of expression for me, and close examination of the styles of design in my metalwork and my tapestry will show that the same person is doing them. I find one serves as relaxation from the other, although I must admit that recently most of my efforts have been put into the metals, especially into hollow-ware.

There's a fascination in metal in that it is such a hard material and yet so plastic. You can do so much with it. It still amazes me to start with a flat sheet and be able to form it and raise it up by hand, or with hammers, into even a vase form, a tall cylinder. It's incredible that you can manipulate material that way. Also there's the innate fascination of silver and gold. People talk about gold in hushed terms, and some people pooh-pooh it, saying it's all false, but gold is an incredible material. It's nice to work with, it's beautiful to look at, and it's one of the purest of metals.

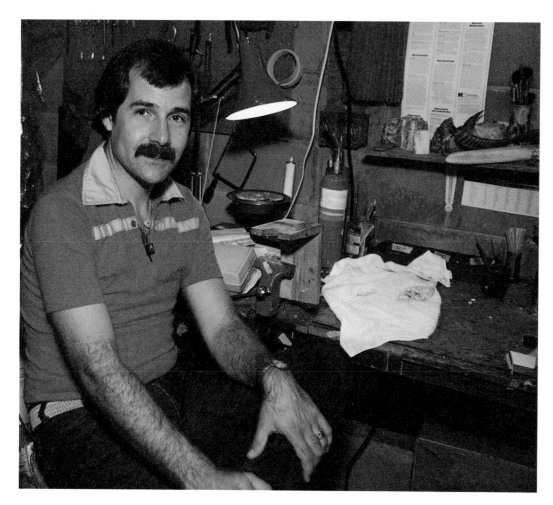

I use some stones in my work. In the last little while I've been working in a technique called inlay – taking pieces of stone, and exotic woods, and ivory, and embedding them into the surface of the metal. It's another form of design, this combining of materials, and it's sort of tricky. It's not just pure metal. It's the combining of a hard metal, a soft wood, hard stone, colours, and the designs within those materials, and having them all come together as a pleasing combination of form.

I believe that it is important to keep the crafts alive because we are in a computer age. Everything is programmed for us. We are not names, we are numbers: you can't go anywhere without giving your social security number. You go into a store to find this or that item which has been mass-produced. Working with the crafts you are coming back to reality, the human factor. The hand-made means that you can have something that is slightly different if you need to. I don't think we need everything in our house hand-made. That would

be like living in a museum. But the hand-made is very important in the variations, the work, the sweat that went into it. It wasn't churned out.

Lidded bowl 1979
Silver, handle of lid inlaid
6 1/2″ d. × 4 3/4″ h.

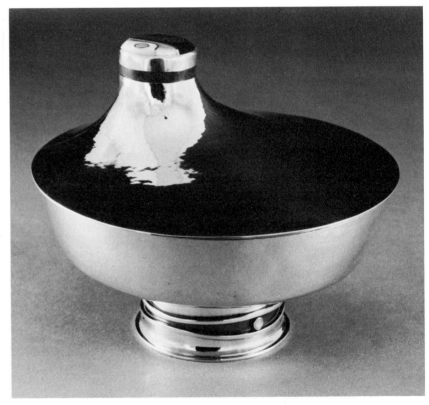

Raymond Landry

PEWTER SPINNER · ST ÉDOUARD, QUÉBEC

I was born to be an intellectual. My father was a surgeon who wanted all his children to be professionals. I did want to be an architect but wasn't admitted to that course at the university. I decided to study the mechanics of cars for a year and then take architecture. But car repair – the manual work – was interesting and I started welding for the body shop. Then I saw some steel sculptures and decided to try making some myself. I made thousands of pieces.

After four years of welding I became tired of doing that. It was dangerous because of the vapours of the zinc, which are very harmful. Twice I became sick with zinc fever. Then I came across a book explaining all the procedures of metal-working for an artisan. I read a chapter about metal spinning, and bought a lathe. I paid $2000 for that lathe and I didn't know what to do with it the first day I had it. But I said to a boutique owner, 'I think I can spin pewter,' and I bought some pieces of the metal and set to work. Fortunately I met another pewter worker and learned much from him.

The first time I showed my work I was sure I would sell all my pieces: I came back with all of them. Maybe it was because they looked like industrial work. But like an intellectual guy I decided to complete my apprenticeship step by step. I still had problems of production, and I wanted to eliminate them completely.

Pewter is soft, an easy working metal. Now I also use copper and brass because I can't stay on the same metal for a long time. With three metals I can improve in all the steps of metal-working. If I work in one metal, I don't progress.

Working with my hands isn't easy. I thought it would be when I started my studies in mechanical repairs. I was five years older than the others, and I'd had a good education, but it was not easier for me. It was the same with the welding. I was sure I would do it very easily, and it wasn't easy. I was disappointed to find that manual work was not easy. I thought intellectual work would be harder than

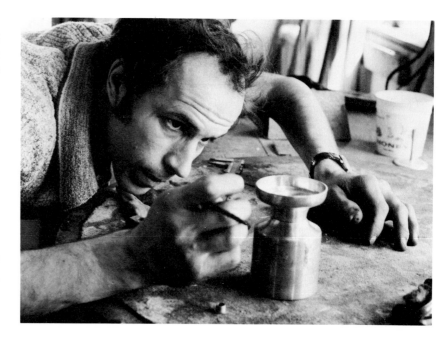

manual work but they are different. I am still an 'intellectual,' because I feel that books will give me the answer, but they don't.

I work from nine to six every day. I don't have a boss above me and I work alone, and if there was a boss I probably wouldn't work as well. Because I am my own boss I work at my own speed. I'm very tired at the end of the day.

Working so many hours every day in a very dirty shop, I don't see my pieces on a nice wall; I only see them on the shelf. I don't see, myself, what I make. When I put the pieces away from me and don't look at them for a few weeks, I can

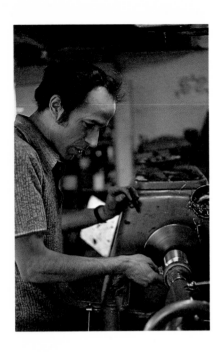

Spun pewter 1978
Covered boxes 4 1/4″ d. × 2 1/2″ h.;
3 1/2″ d. × 2 1/2″ h.
Bowl 3″ d. × 1 3/4″ h.
Various cups 3″ to 2″ d. × 4 1/2″–
2 5/8″ h.

see – a little bit – whether this is nice
or not. But right after it is done – no.

My major clientele are well edu-
cated though. They know about
pewter, they know about brass,
before they buy the pieces. Pewter
people are different from copper
people. The pewter people are intel-
lectual; they know about the metal.

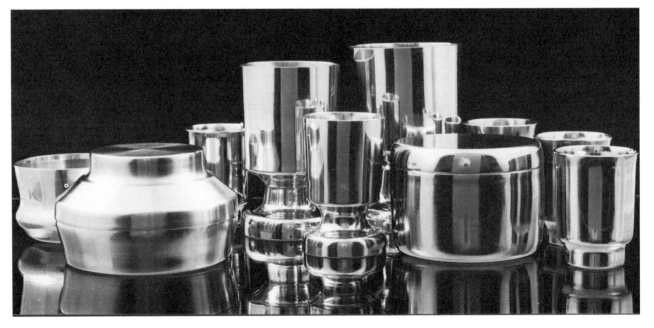

Raymond Cox

PEWTERSMITH · ST JOHN'S, NEWFOUNDLAND

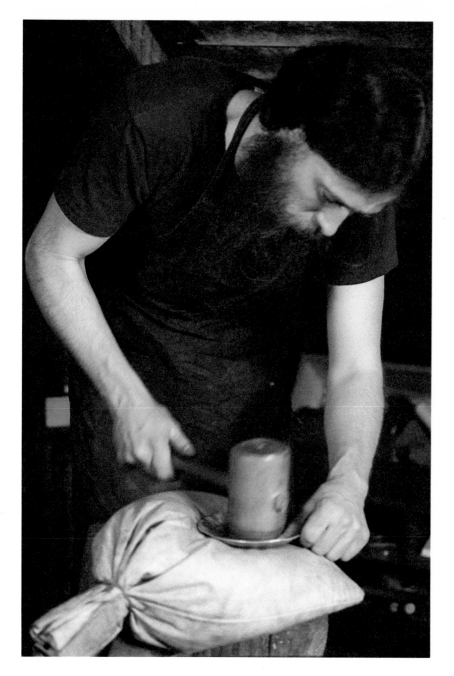

Pewter changes a lot. It's shiny when I get it. Then I work it and it changes to grey, dirty, and messy, and then I clean it up again. And then, as it's used, it becomes grey and dirty and changes again. There's a seasonal, cyclical process involved in the metal itself.

I never found pewter very difficult to work in, but I've been lucky, because I took to it. It's easy for me to work in compared to the hard metals – silver and copper, say. But it's very limited: you can't use it with high heat, you can't use it on a stove. It works up easily, but there are difficulties. You're soldering and working with flame very close to its melting point. You don't have the tolerance that you may have with some of the harder metals.

I've done an awful lot of work in kitchens. A kitchen table is as much a work bench to me as anything else, and kind of fun. All of a sudden suspend cooking and baking and take over the place for a day or two, working on a project. Or just come home and work in the evening for a couple of hours.

I'm not very meticulous about drafting plans for something that I'm going to make. I will have an idea of what I want to make, and then, through my mind's eye, I make changes through the process. Or I do something over and over again. But I tend to have a certain confidence that, in setting out to do something, in trying to work in a controlled fashion, I'll get what I want.

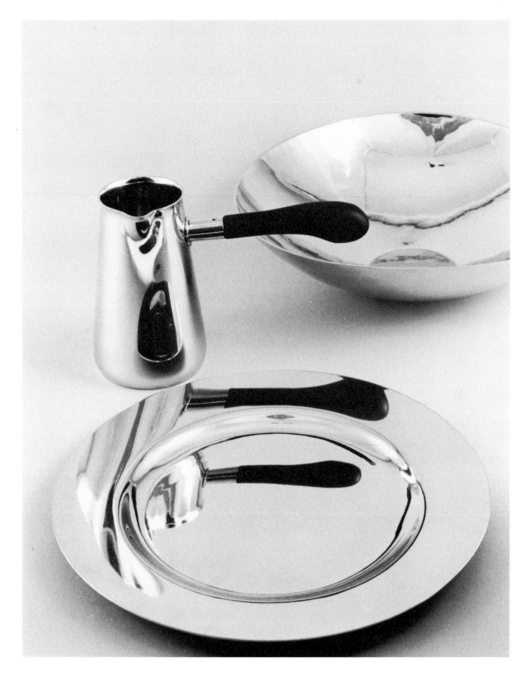

Handmade pewter 1978
Bowl 9 1/4" d. × 2 1/2" h.
Plate 9" d.
Side-pouring jug with walnut handle
2 3/4" d. × 4 1/4" h.

John Little

BLACKSMITH · EAST DOVER, NOVA SCOTIA

I'm glad that I got started in this business because I *like* it. I like the drama of it. I like the intensity of it. I like the physical effort involved. It really feels good at the end of a long, hard day when I'm making anchors or something – the heavy stuff. It's a very pleasant sort of exhaustion. That's the high point of my day, when I'm all finished, and I'm soaking wet, and there's a pile of stuff on the floor that I made.

My business has changed a lot in the last couple of years because I've gotten into making a lot of marine hardware. One of my neighbours advised me to do that. He's a young fellow who came in here when I was making a big fancy set of hinges, or something like that. And he said: 'Ah, it's all well and good, John, but you just remember, you can buy anything with anchors. You can only buy *some* things with that fancy stuff.' I laughed a little bit. But I started thinking about it. I live in a fishing community. And it's not very nice of me to have a blacksmith shop here and not take care of my neighbours.

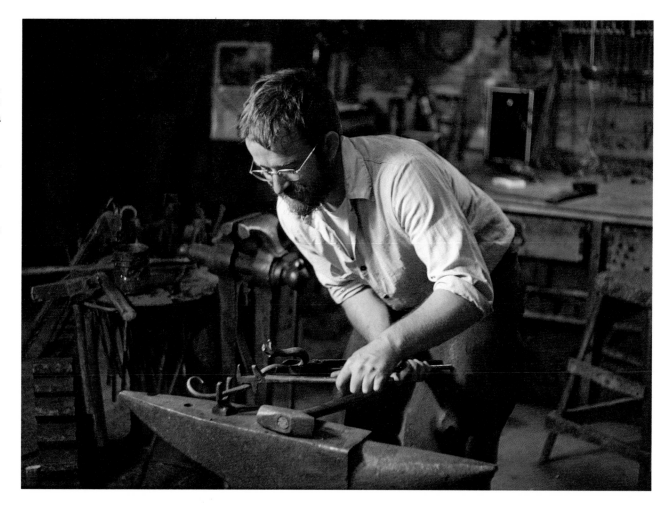

I do for my neighbours. One of the things I like especially about making anchors is that people round here treat me so well. They always pay the bills; it's always cash up front. They don't ever ask me to give them credit or anything like that. They understand. On top of that they always bring fish. This time of year we get mackerel – boxes of mackerel and the odd salmon and lobster. They take real good care of us.

When we first moved here, after I gave up graduate work in psychology, I thought I might go fishing, just lead a subsistence-level life. I'd be content with that. We didn't have any expenses. We had a garden. We raised chickens and goats. There was no electricity for the first seven years we were here. There was no telephone. We heated with wood. There was no plumbing. There were *no* expenses, you see. So we didn't have to make much. You won't believe this, but it's true: we lived on $500 a year. That was our budget for about four years. And we lived reasonably well.

I had an anvil. I ordered it from a company called Brown's in England. It cost me, I think, $135 or $140, and I had to wait six months to get it. Now I must have had some damn good reason for doing that. But I can't remember any reason. That thing was sitting out there, in my way. And I was tripping over it, so I set it up. It sounds corny as hell, but that's literally how this started. One thing led to another, and it gave me something to do out here that would allow me to stay home, which is what I wanted.

Then I met an old Austrian fellow near Digby, Paul Geier. I was delivering some ironwork to a neighbour of his and somebody told me there was this old fellow down the road and I should go see him. I drove down, through really poor country, and there was this one immaculate little farm, the stereotype of thorough, methodical, careful, disciplined working. I have a beard and all that, and I was a young kid at the time. I pulled into their driveway unannounced and Leah Geier came out with her apron on, wip-

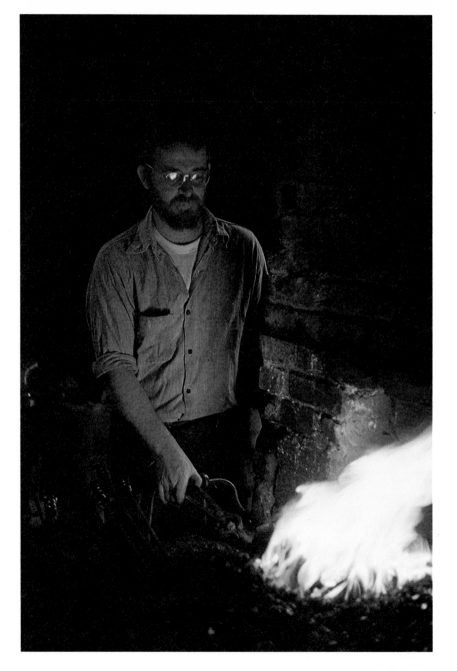

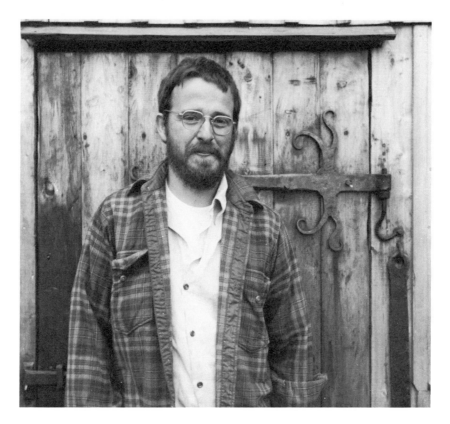

ing flour off her hands. 'Yes, can I help you?' And I said, 'I'm starting out in blacksmithing.' 'Well!' she said, and pretty well dragged me into the house for tea, cookies, cakes. 'Wait here, wait here, Paul will be back pretty soon. Don't go away.' And she brought out books and books and books. That visit turned my whole life around. He was my base inspiration. Not so much for his work, which is different from mine, as for his excitement. I hadn't known what good ironwork was. He showed me.

I learned mostly from books. There are a lot of good books. There's an especially good set from England. Black and white photographs. Step by step. It's just like watching a man work.

The first thing you have to learn as a blacksmith is to control the hammer. You probably don't stop learning that for thirty years. All your muscles have to be working just right. You usually have to hit hard. But you can't be thinking about what you're doing: 'Should I hit it over here?' You can't.

Steel knife 1977
Damascus steel blade with mild steel handle
8″ l.

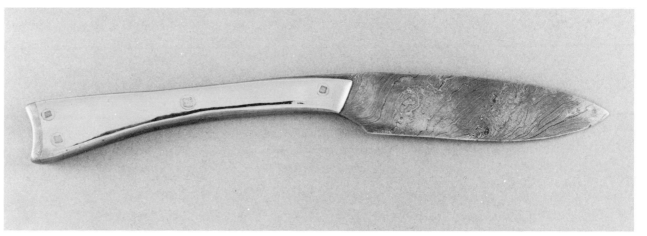

Then forge-welding is very difficult to learn. Almost anybody can go in and make two pieces stick together, but to do a really good job, or to do it in steel – that takes a long time and it's hard to get a feel for it. But it's worth it. I know that medieval smiths would have given their first-born sons to have an electric welder: it's just like a bolt of lightning in your hand. It's what blacksmiths have wanted since about 4000 years ago. But it can compromise the work. For example, if you make a monster-head and you want horns coming out of the skull, if you arc-weld them on it doesn't look right. It looks like they're stuck on. If you forge-weld them, they grow out of the parent stock. You've pushed one iron into the other, and your hammer blows finish the work.

And running a fire. It took me three or four years before I could run a fire.

In the beginning I went to craft shows. This was around 1969, 1970. They were just beginning. I made these atrocious, horrible knick-knacks and went to the craft shows and peddled them. I'd love to get that stuff back now: it was pretty awful. Now marine blacksmithing really fascinates me. You can't muck about. It has to be right. I'm also interested in sculptural work. I'd like to do some very nice hand-iron things, or fire tools. I look at my future and say, 'when I get older, I'm not going to be able to handle this anchor work.' It gets harder. That's the trouble with blacksmithing. You're just getting good when you're physically worn out. If I can amass a reputation as a fine blacksmith in the next ten, fifteen years, it'll make my life a lot easier. I'll be able to carry on and do elegant, lighter stuff.

I know I'm going to survive. I know I'm going to be able to carry on and do this as long as I want to, as long as my health holds out. I'll probably be doing this until I die, which is a nice feeling.

Just lately, too, I've had a burning ambition: what I really wanted was fame and glory! It was a real ego trip. I think all craftsmen have that

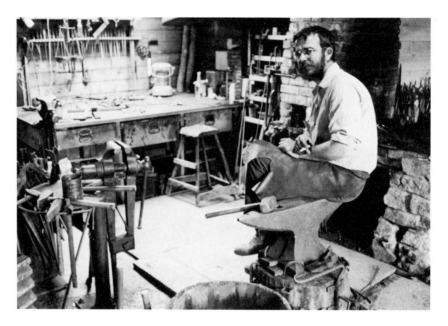

to a certain degree. There's a lot of ego involved in this sort of stuff. Recognition. I've worked awfully hard. I'm not trying to toot my own horn, but I had a lot of really rough years getting started and it was very frustrating. I can remember times when I was in tears in this shop. I was working out here by kerosene lamp – and the cold in the winter time! – trying to get some work done in the evening before going to work in the morning. Once I threw the hammer at the wall, I was so frustrated. And it stuck! Right in the wall. Because of that, I really like it when somebody comes down and says, 'Jeez, man, you're really coming along.' That feels good. That's a real shot in the arm.

Adam Smith

KNIFEMAKER · WOODBRIDGE, ONTARIO

Making knives is different from being interested in knives as things. I first got interested in knives as a very young child. I was given my first knife at the age of four by my grandfather, whereupon I promptly cut my hand wide open and had the knife pulled. There was a whole feud between my mother and my grandfather over that one.

I've been interested in knives ever since. Philosophically, what you have is a device to produce an infinitely thin edge which is capable of dividing particles. It's a device for creating a physical distinction, and the way it goes about it is a good model for the intellectual means of creating a distinction. It is a fascinating process, building an edge that will cut.

Apart from that I find designing for use, designing a tool, a restriction that's very rewarding. As soon as I heard that people were custom-making knives I thought, 'oh, of course, one could do that' and immediately started to scrounge around for materials to try it myself. Material procurement was a

huge problem; I first heard of custom knives when I was thirteen and I was eighteen when I started to make my first one. The reason for the interregnum is that materials are incredibly difficult to procure. You have to buy high carbon steel, and, in Toronto, the suppliers of high carbon steel really want to sell you a ton. They will sell you a hundred pounds, and they might sell you ten feet, but selling you enough for one knife is something else. When I was eighteen I bumped into a supply house in the States that catered to custom knife-making. It stocks basically everything that you need to make a knife and will sell you tiny quantities. They will sell you one pair of bolts to rivet on the handle, one pair of scales to actually form the handle, one foot of steel to grind the blade out of. I started making knives then, because I finally found a source of supply.

The tools are different. They are difficult but they are get-aroundable. It is possible to make first-grade knives with nothing but files and sandpaper, and I still routinely make

some of my smaller folding knives strictly by hand. Not so much as a discipline, but because there is so little material it's hardly worth using the machine.

Steel is not a congenial material in the sense that wood is, or leather, but it's fascinating. It will do things no matter how precise the manufacture, and we now are getting involved with double-milled steels, oxygen lancing, vacuum furnaces, and all sorts of things to make the steel as precise as possible. Even so, it's unpredictable. When you heat-treat a blade, you never really know what's going to happen. It's a mysterious process, nearly as mysterious now as it was a thousand years ago, I guess, when it was first discovered. The blade may warp. You can do everything you can to avoid it but if the steel starts to warp, it's going to warp, and you can't really anthropomorphize the way you can with some material. You can put it down to the steel having it in for you: well, the steel has got it in for you at times, and that's that.

But the other materials are a relief, because they offer work with congenial materials. You can work with a piece of wood and it will smell good, and feel good in your hands, and it has a warm gloss to it, and the same thing is true of leather. You can make leather do virtually anything you want, once you really know how. A decent piece of stiff ten-ounce welt neck or something like that – when you first pick it up it feels like plywood but you drop it in a dish of soapy warm water for two minutes and it'll do anything for you. It also smells good and feels good.

As a knifemaker, I don't try to mystify the process; I don't try to make it seem more complicated than it is. Too many others are doing that. It's hard enough without making it seem harder. But I am very aware of the mystique in the sense that knife-making partakes of magic and glamour. It's part of the reason why I'm a knifemaker. I try to let my customer know how I feel, and I find that most of my customers are already in tune with it and that is

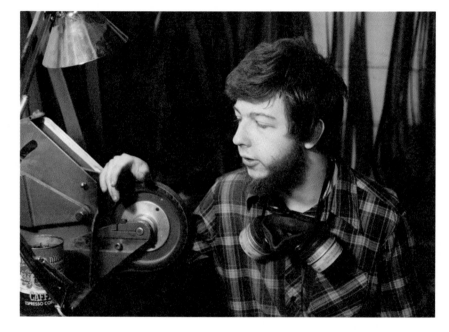

part of the reason they are my customers.

To me the quality of the product is everything and I use the best method, modern or traditional. I feel that that is the tradition. I think that the person who was chipping the flint of the chert knife was using the best material that he had. He had

found out that flamed hardwood didn't do the job that chert did and so he threw the wood away and decided he wouldn't be bound to wood. The same transition happened from chert to bronze and from bronze to iron and from iron to steel, from low carbon steel to high carbon steel and from high carbon

Sporting knives 1978
A.2 steel with rosewood, hobio, and
cocobolo handles
9 3/4″, 7 3/4″, and 6 1/8″ l.

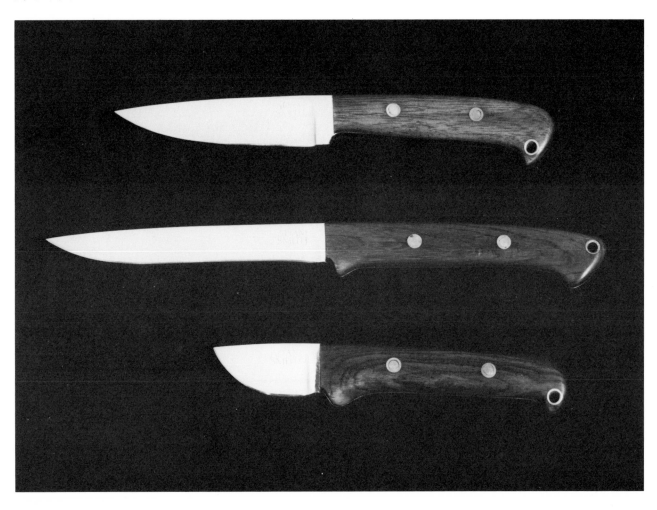

low alloy steel to high carbon high alloy steel. The tradition is devotion to the quality in use of the final product.

There's another thing: the knife is not a knife until it's in steel. Each step closer to steel the closer you are to finding out the validity of your design. Paper will show you bugs in a design, especially when it's no longer a drawing but a blueprint, but making a three-dimensional template out of perspex will show up defects that the drawing missed and then it's in steel and even in rough profile steel shows the difference. Then the bevels are in, and they show an incredible number of flaws that may not have been visible in the perspex of the profile. From that point you don't find all that much difference until the handle's on. But it's only when you've made and used a prototype that you really know for sure that your design has validity.

When I first started I was influenced to the point of being inundated by work of other designers. I couldn't even form thoughts of my own much

less get them down, much less clarify them to the point where I could actually make a knife. That went on to the point where I actually had to forget what everybody else was doing. I had to stop looking at other people's designs, I had to stop reading trade journals, stop reading books, and especially stop looking at the photographs in books. Now I find I do get valuable ideas and information from other people because I've done it so long I know very well from which frame of reference I approach the problem.

A craftsman is someone who designs with an intuitive relationship towards his material or towards its use. The intuitive aspect is very important. When I first started designing I designed coldly and with my brain, but now after probably a thousand, or several thousand, designs I design much more by eye and by feel.

Mechanical ingenuity is very handy for a knifemaker. In general, anyone going into crafts also needs persistance, because it is not going to be fast getting the recognition or,

in fact, picking up the hand skills. Curiosity is desirable. An obsessive nature doesn't hurt. But the only basic requisite that is absolutely necessary for a decent craftsman is an absolute fascination with the craft that he is pursuing. If you are not all that interested in what you are doing I don't see that there is much hope for you; but if you're fascinated I think there probably is. I am a craftsman, not an artist, and I feel very adamant about that. There are lots of things that are half-way in between, but what I do is a craft, not an art. It is not one of the things that sits on the line.

I draw the line thus: if it has use, if it is designed for use, then it is craft; if it is designed primarily to please the soul and not for functional use, then it is art. I work with my discipline: I am a craftsman. I work for that use, and that makes me very strongly a craftsman. I am appalled by the influence that art is exercising over craft. You find people with very good design sense, good training, good craftsmanship, being seduced into sculptural values

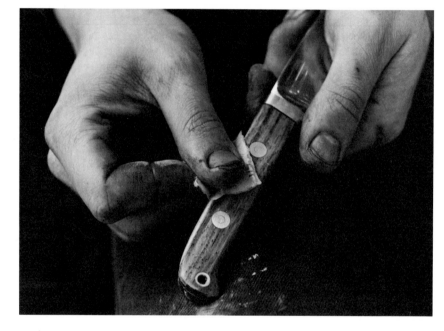

which don't work in the article's own terms. When I look at a piece and it's getting sculptural for no reason to me, it's being ashamed of itself. It's denying its own craft. It's saying, 'I'm not craft; I'm art.' To me, if anything, craft is the superior of the two.

1 REEVA PERKINS
Neckpiece 1977
Silver; brushed 14 kt gold
12″ top to bottom

2 ANDREW JACKSON MOERS
Crooked knives 1977
9 1/2″ l.
Similar to Micmac knives with blade set
at angle to handle

3 LOIS BETTERIDGE
Rosebowl 1977
Silver. Repoussé, butternut base
10 3/4″ sq. × 3 7/8″ h.

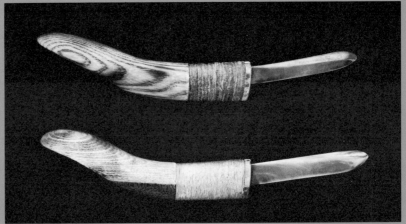

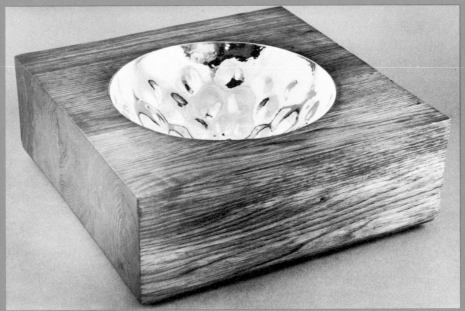

4 DAVID McALEESE and
ALISON WIGGINS
Ring 1979
Gold, silver, anodized titanium

5 ZOE LUCAS
Necklace 1977
Double row silver bead
Neckpiece 1977
Silver, ivory, plastic

6 THEO JANSON
Choker 1978
Silver, glass African trade beads
5 1/2″ d.

7 LOIS BETTERIDGE
Bracelet 1977
Silver. Repoussé

4

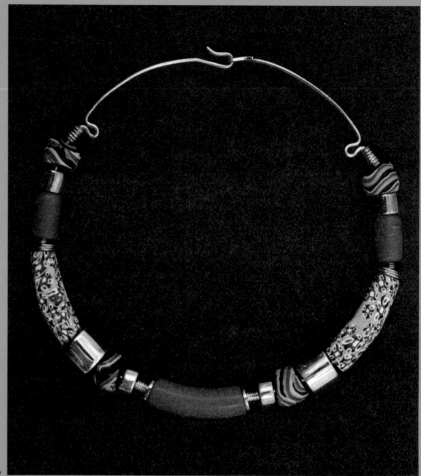

6

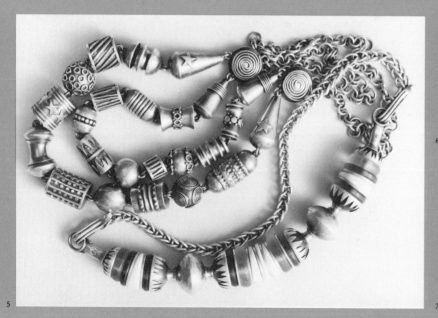

5

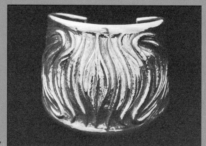

7

186 DAVID McALEESE AND ALISON WIGGINS, ZOE LUCAS, THEO JANSON, LOIS BETTERIDGE

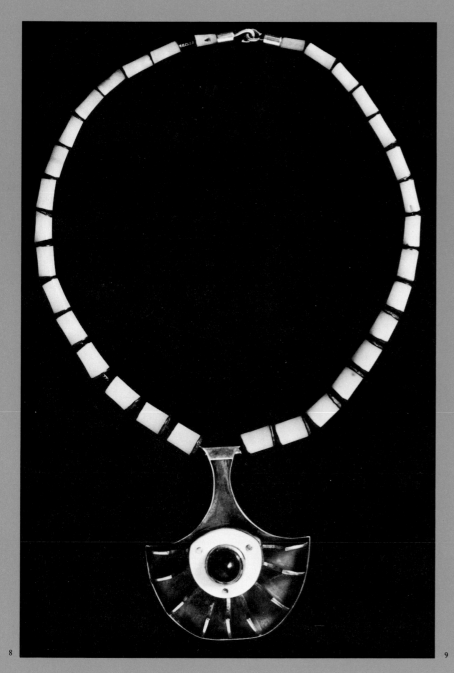

8 GLEN FAWCETT
Neckpiece 1977
Silver, ivory, lapis lazuli, buri wood

9 BILL KOOCHIN
Candlestick 1977
Wrought and welded steel
15" × 9" × 15 1/2" h.

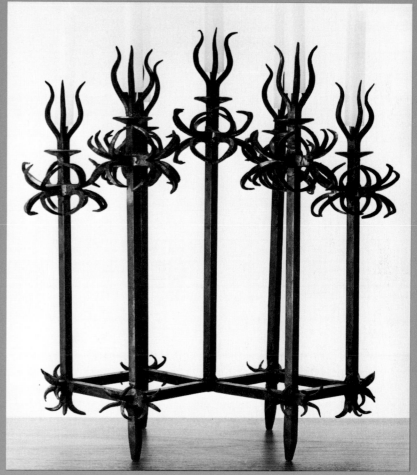

10 MONICA HARHAY
Hinged bracelet 1979
Silver; cast and assembled

11 DAVID DIDUR
Small box on cord 1979
Silver, silk cord, shibuichi, and gold
bead
Box 1 1/2″ × 3/4″ × 2″ h.

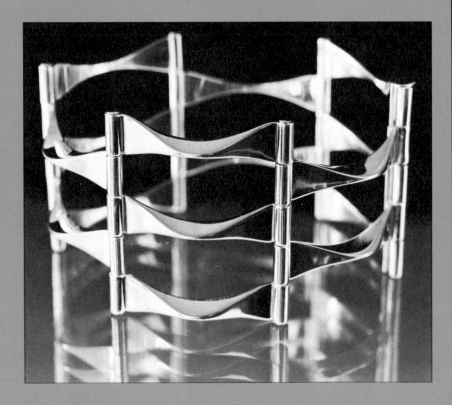

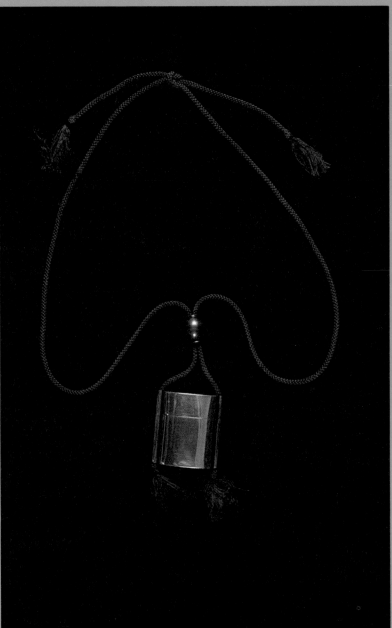

11

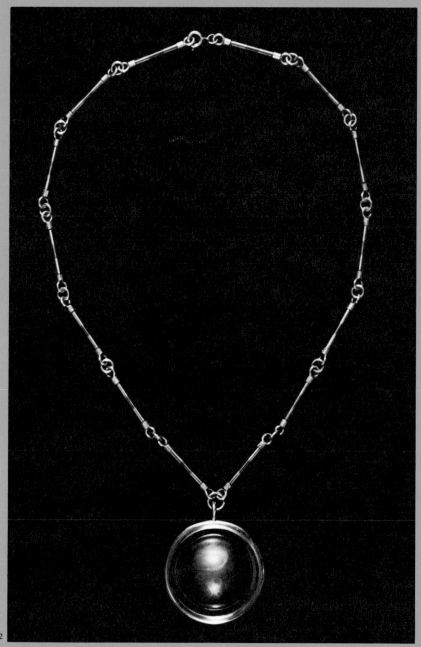

12 DAVID McALEESE and
ALISON WIGGINS
Pendant and chain 1979
Silver and anodized titanium
Pendant 1 3/4" d.

13 VANESSA COMPTON
Dragon ring 1979
Silver; lost wax casting

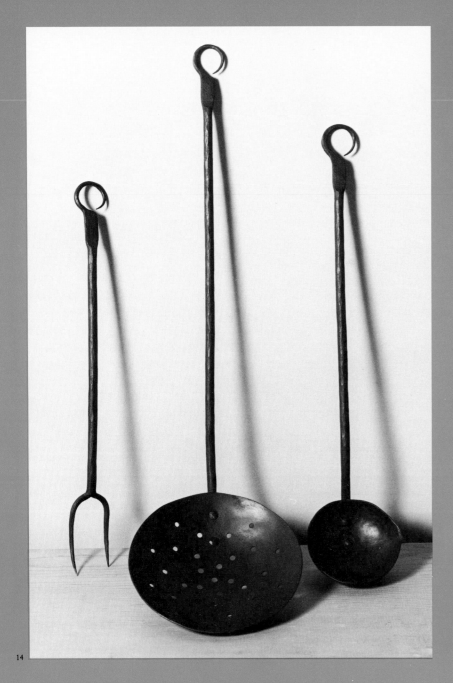

14

14 MICHAEL SPENCER
Wrought steel implements 1977
Skimmer 20″ l., ladle 18″ l., carving
fork 15″ l.

Biographies

VICKI LYNN BARDON
quilter (p 132)
Born Halifax, Nova Scotia 1947

Acadia University, Wolfville, Nova
Scotia, BA 1968
New York School of Interior Design
1968–9
Self-taught

Design Canada Award 1974
American Printed Fabrics Council
Tommy Award 1978

———————————————

VICTOR BENNETT
saddlemaker (pp 152–5)
Born Vancouver, British Columbia
1944

University of Alberta, business admin-
istration 1963–6

Self-employed

———————————————

LOIS ETHERINGTON
BETTERIDGE
goldsmith and silversmith (pp 185, 186)
Born Drummondville, Quebec 1928

Ontario College of Art
University of Kansas, BFA 1948–51
Cranbrook Academy of Art, MFA
1955–7

Citation, University of Kansas 1975
Member, Royal Canadian Academy
Saidye Bronfman Award 1978

Self-employed since 1952

———————————————

ELSIE BLASCHKE
embroiderer (pp 100–3)
Born Vienna, Austria 1932
Canadian resident since 1952

Academy of Fine Arts, Vienna

Best of Show Award (Ontario),
Ontario/Quebec Crafts 1979

Self-employed

———————————————

TONY BLOOM potter
(pp 33–4)
Born Tokyo, Japan 1947
Canadian resident since 1970

University of South Carolina,
physics 1965–6

University of Virginia, physics 1966–8
University of Maryland, physics
graduated 1970

Self-employed

———————————————

DEMPSEY BOB woodcarver
(p 79)
Born Telegraph Creek, British
Columbia 1948

Studied with Freda Diesing

———————————————

GERARD BRENDER
À BRANDIS bookwright
(pp 145–7)
Born The Netherlands 1942
Canadian resident since 1947

McMaster University, fine arts history,
BA

Self-employed since 1965

———————————————

WENDY BROOKS potter (p 49)
Born 1953

Sheridan College 1971–4
University of British Columbia, part-
time studies

University of Toronto, part-time
studies
Simon Fraser University, part-time
studies

———————————————

SANDRA BROWNLEE weaver
(pp 118–19)
Born Fredericton, New Brunswick
1948

Nova Scotia College of Art and Design,
BFA and Diploma in Art Education 1971
Studied with Fredrika Wetterhoff,
Finland 1974–5
Cranbrook Academy of Art, MFA 1981

Nova Scotia government grants 1974,
1978

Self-employed

———————————————

DOROTHY CALDWELL
stitcher and fabric painter (p 131)
Born Bethesda, Maryland, 1948
Canadian resident since 1971

Temple University, Tyler School of Art
BFA 1966–70

Canada Council Explorations Grant
1979

Ontario Arts Council grants 1974–80
Ontario Crafts Council travel bursaries
1978, 1980

Board of Directors, Peterborough Art
Gallery

Self-employed

JOHN CHALKE potter (p 50)
Born Gloucestershire, England 1940
Canadian resident since 1968

Bath Academy of Art 1959–61

Canada Council grants 1972, 1978

Self-employed

ROSE MARY PLET
CHAPMAN
basketmaker and weaver (pp 134–6)
Born Isernia, Italy, 1947
Canadian resident since 1952

Carleton University, Ottawa, sociol-
ogy, 1968–72
Self-taught

Canada Council Grant (shared) 1981

Self-employed since 1975 (with Peter
Honeywell)

MADELEINE CHISHOLM
weaver (p 160)
Born Halifax, Nova Scotia, 1934

Dalhousie University, mathematics,
B SC
Handcraft House Textile School, Van-
couver, textiles
Nova Scotia Government Handcraft
Centre, pewter
Vancouver Vocational School, jewel-
lery and metal
California College of Arts and Crafts,
jewellery and metal
Oregon School of Arts and Crafts,
jewellery and metal
Western Washington University,
jewellery and metal

EDITH CLAYTON
basketmaker (p 158)
Born Cherry Brook, Nova Scotia 1920

VANESSA COMPTON jeweller
(p 189)
Born Montreal, Quebec, 1952

Sir George Williams University 1969–
71
Sheridan College 1971–3

Nova Scotia College of Art and Design,
jewellery workshop 1973
Mohawk College, enamelling work-
shop 1974

Self-employed

RAYMOND COX pewtersmith
(pp 175–6)
Born Bridgeport, Connecticut 1949
Canadian resident since 1973

Saint Mary's University, Halifax, an-
thropology, BA 1971
Memorial University of Newfound-
land, MA program
Studied with Frances Felton

DANIEL CRICHTON
glassblower (pp 84–6)
Born New York City, New York 1946
Canadian resident since 1968

Ithaca College, BA
University of Guelph, MA program
Sheridan College

Ontario Crafts Council awards
1977–80

Glass master, Sheridan College

MARTA DAL FARRA
silk painter (pp 124–5)
Born Belluno, Italy 1948
Canadian resident since 1955

Ontario College of Art, AOCA 1972
One-year post-graduate study 1974–5
Canadian Guild of Crafts Scholarship
for travel 1974

Instructor, Sheridan College and On-
tario College of Art
Self-employed

ROBERT DAVIDSON jeweller
(pp 165–6)
Born Haidaberg, Alaska 1946

Apprenticeship with Bill Reid 1966–7
Vancouver Art School 1967–8

Self-employed

EMELY DESJARDINS weaver
(p 129)
Born Montreal, Quebec 1915

University of Montreal 1976–9

TED DIAKIW potter (p 50)
Born High Prairie, Alberta 1938

Alberta College of Art 1957–62,
1968–9

Visual Arts Scholarship 1961
Memorial Award, Toronto 1962
Pool Award, Alberta 1963

Self-employed

DAVID DIDUR jeweller (p 188)
Born Saskatoon, Saskatchewan 1953

Nova Scotia College of Art and Design
1971
Study in Japan

Saskatchewan Arts Board awards 1972,
1974

Self-employed

JUDITH DINGLE
textiles (piece work) (p 127)
Born Montreal, Quebec 1947

Sir George Williams University, fine
arts 1965–73
McGill University, teaching diploma
1968

Ontario Crafts Council awards 1978,
1979

Self-employed

ANGELO DI PETTA potter
(p 51)
Born Colle d'Anchise, Italy 1948
Canadian resident since 1956

Ontario College of Art 1968–72
L'Instituto d'Arte per la Ceramica,
Italy 1973, 1975
Ontario Crafts Council Travelling
Scholarship 1975

Acting Head of Ceramics Department,
Ontario College of Art 1979–80

LOUISE DOUCET-SAITO
potter (pp 40–1)
Born Montreal, Quebec 1938

L'Ecole du Musée des Beaux-Arts
1957–60
Studied oriental ceramics, Japan 1965–7
Canada Council grant 1965
Saidye Bronfman Award 1980

Self-employed since 1968 (with Satoshi
Saito)

WALTER DROHAN potter
(p 49)
Born Calgary, Alberta 1932

Alberta College of Art 1952–6
Cranbrook Academy of Art 1956–7

Canada Council senior grant 1968
Member, Royal Canadian Academy
1976

Instructor supervisor, Alberta College
of Art

PAUL EPP woodworker (pp 54–7)
Born Sexsmith, Alberta 1949

Sheridan College, honours 1972
Studied with James Krenov, Sweden
1972

Design Canada Bursary 1972
Canadian Guild of Crafts (Ontario)
Bursary 1972
Ontario Arts Council grants 1976, 1978

Self-employed

GLENN FAWCETT goldsmith
(p 187)
Born Saskatchewan 1952

Apprenticeship, Saskatoon 1973–5
Nova Scotia College of Art and Design
1975
Study in Europe

Self-employed

MICHAEL FORTUNE
woodworker (p 79)
Born Toronto, Ontario 1951

Sheridan College 1971–4
Ryerson Polytechnical Institute (part-
time) 1972–4

Ontario Crafts Council Travel Bursary
1974
Design Canada Travel Scholarship
1974–5

Part-time instructor, Sheridan College
Self-employed

DORIS FRASER glassblower
(p 94)
Born Winnipeg, Manitoba 1946

University of Manitoba, interior design
1964–8

Georgian College of Applied Arts and Technology, summer school and part-time, glass studies 1974–6
Sheridan College, summer school 1975

Glass consultant to Ontario College of Art 1980
Self-employed, Sirius Glassworks (with Peter Gudrunas)

————————————————

POLLY GREENE weaver
(pp 112–15)
Born Springfield, Massachusetts 1929
Canadian resident since 1969

Business college 1959–60
Nova Scotia College of Art and Design 1970

Craft Co-ordinator, Sherbrooke Village Restoration (Nova Scotia Museum)

————————————————

SUSAN GROFF potter (p 51)
Born Winnipeg, Manitoba 1952

University of Manitoba 1971–3
School of Art, University of Manitoba, BFA (honours) 1974–8
Banff Centre 1977

Nova Scotia College of Art and Design 1978

Self-employed

————————————————

PETER GUDRUNAS
glassblower (p 94)
Born Sudbury, Ontario 1949

Georgian College of Applied Arts and Technology 1973–6
Sheridan College, summer school 1973

Assistant to Roman Bartkiw 1975

Glass consultant to Ontario College of Art 1980
Self-employed, Sirius Glassworks (with Doris Fraser)

————————————————

CLARK GUETTEL glassblower
(p 96)
Born East Orange, New Jersey 1949
Canadian resident since 1969

Newark State College 1967–9
Ontario College of Art 1969–70
Sheridan College, graduated 1972

Self-employed

MONICA HARHAY jeweller
(p 188)
Born Toronto, Ontario 1949

Ryerson Polytechnical Institute 1969–71
Sheridan College 1971–4
Workshops with Arline Fisch, Lois Betteridge, and Barry Merritt

Ontario Crafts Council awards 1977, 1979

Visual arts instructor, Seneca College of Applied Arts and Technology

————————————————

STEPHEN HARRIS
woodworker (pp 58–9)
Born Toronto, Ontario, 1939

University of New Brunswick (one year)

Ontario Crafts Council grants 1975, 1976
Canada Council Grant for travel 1976
Design Canada Craft Award 1974

Part-time instructor, Sheridan College

Self-employed

HERBERT HATT woodturner
(pp 66–7)
Born Tancook Island, Nova Scotia 1894

Acadia University, BA 1924
Colgate Rochester Divinity School, BD 1927
Croger Theological Seminary, MTH 1928
University of Chicago 1929–31
Mount Allison University, applied arts

————————————————

HEBER HEFFERN
broommaker (p 157)
Born Wild Cove (Salvage), Bonavista Bay, Newfoundland 1927

————————————————

ROBERT HELD glassblower
(p 96)
Born USA 1943
Canadian resident since 1967

San Fernando State University, education, BA 1963–5
University of Southern California MFA 1967
Penland School of Crafts 1968

Teaching master, Sheridan College
1967–77
Manager, Canadian Art Glass, Calgary
1977–9

Self-employed since 1979

YVETTE HÉLIE quilter (p 129)
Born Daveluyville, Quebec 1916

Self-taught

MARTHA HENRY glassblower
(p 96)
Born Montreal, Quebec, 1953

Sheridan College (honours), 1971–4

Self-employed

STEPHEN HOGBIN
woodworker (pp 63–5)
Born Tolworth, England 1942
Canadian resident since 1968

Kingston College of Art, NDD 1961
Royal College of Art, Des. RCA 1965
Travelling scholarship 1968

Instructor, Sheridan College 1968–73
Artist-in-residence, Melbourne State
College, Australia 1975–6

Self-employed

PETER HONEYWELL
basketmaker and weaver (pp 137–8)
Born Ottawa, Ontario 1953

Self-taught

Canada Council Grant (shared) 1981

Self-employed

MARGARET HORN
Indian jewellery (p 159)
Born Caughnawaga, Quebec, 1948

Dawson College, Montreal, social
work 1973–7

Self-taught

FRANÇOIS HOUDÉ
glassblower (p 97)
Born Quebec City, Quebec 1950

Collège de Limoilou and Séminaire
de Québec Diploma in Social Sciences
1969–71

CIDOC Cuerna Vaca, Mexico, Spanish
and Latin American studies with Ivan
Illich 1975
Laval University, anthropology, BA
1972–6
Apprenticeship, Atelier La Mailloche,
Quebec 1977–8
Sheridan College 1978–80
Workship, Pilchuk Glass Center,
Stanwood, Washington 1980
Illinois State University, working to-
wards MFA

Government of Quebec grant 1980
Ontario Crafts Council grant 1980

HARLAN HOUSE potter (p 50)
Born Vancouver, British Columbia
1943

Alberta College of Art 1964–9

Self-employed

ANNEGRET HUNTER-
ELSENBACH bookbinder
(pp 142–4)
Born Hagen/Westfalen, West Germany
1948
Canadian resident since 1976

Wilhemshaven, Abitur (baccalaureate)
1968
School of Fine Arts, Bremen 1968–9
University of Fine Arts, Hamburg
1970–5
Bookbinding courses, Toronto 1976–7

Instructor, Board of Education, To-
ronto, and Sheridan College

TAM IRVING potter (pp 42–5)
Born Bilbao, Spain 1933
Canadian resident since 1956

Edinburgh University, BSC 1956
Winnipeg School of Art 1963–4
Haystack Mountain School of Crafts
1964
Vancouver School of Art 1964–5

Instructor since 1973, Emily Carr Col-
lege of Art

THEODORA JANSON
jeweller (p 186)
Born New Brunswick, New Jersey
1946
Canadian resident since 1971

University of Florida, BFA 1969
Sheridan College 1972

Workshops in jewellery and enamelling

Ontario Arts Council grants 1976, 1977
Wintario travel grant 1978

Self-employed

ROBERT JEKYLL
stained glass artist (p 97)
Born Montreal, Quebec 1933

York University, BA
Studied with Patrick Reyntiens, England 1972-4

Professional engineer (Ontario)
Member, Royal Aeronautical Society
(UK)

Crafts Advisory Committee (UK) Apprenticeship Grant 1974
Ontario Arts Council grants 1975, 1979

Self-employed

EDWIN BURKE KOE
leather- and beadworker (p 156)
Born Northwest Territories 1952, Fort
McPherson Band (Cree)

BILL KOOCHIN
woodcarver and metal worker
(pp 60-2, 187)
Born Brilliant, British Columbia 1927

Vancouver School of Art 1949-51
Ceramic studies, France

Instructor, Emily Carr College of Art

JOSEPH KUN
violin- and bowmaker (pp 71-3)
Born Kosice, Czechoslovakia 1930
Canadian resident since 1969

Czechoslovakian State Conservatory as
student and later professor of music
Apprenticeship with J. Prybyl

Self-employed

RICKEY LAIR
woodworker and instrumentmaker
(pp 68-70)
Born Niagara Falls, Ontario 1953

Sheridan College 1972-4

Part-time instructor, Sackville
Community Arts Centre 1975-80
Self-employed 1975-80

Presently employed at Sherbrooke Village Restoration (Nova Scotia
Museum)

RAYMOND LANDRY
metal spinner (pp 173-4)
Born Montreal, Quebec 1949

Collège Ste Croix, Montreal 1960-8
School for Mechanics and Automobile
Repairs 1969
School of Architecture, Quebec City,
1970

Self-employed

SUZANNE LANTHIER weaver
(pp 108-11)
Born Hull, Quebec 1953

CEGEP du Vieux-Montréal

Self-employed since 1974, Zannélop
(with Paul Marineau)

RENÉE LAVAILLANTE
potter (pp 27-8)
Born Montreal, Quebec 1947

University, France, art of the Middle
Ages 1969-72

Apprenticeship with potters, France
1972-3
Ecole des Beaux-Arts, Bourges 1974
Centre des Arts Visuels, Montreal
1977
Studied with Pierre Legault and Viviane
Prost 1979-80

Self-employed

ENID LEGROS potter (pp 38-9)
Born Gaspé Peninsula, Quebec 1943

Ecole des Beaux-Arts, Montreal
1961-4
Institut des Arts Appliqués, Montréal
1964-6
Atelier Francine Del Pierre, Paris
1966-9

Canada Council grants 1970, 1978

Self-employed since 1969

PIERRE LEMIEUX jeweller
(pp 162-4)
Born Montreal, Quebec 1945

Atelier Bernard Chaudron 1964-7

Haystack Mountain School of Crafts
1967
Cranbrook Academy of Art 1968–9

Self-employed

JOHN LITTLE blacksmith
(pp 177–80)
Born Newark, New Jersey 1943
Canadian resident since 1968

Brown University, Providence, RI, BA
1965
Dalhousie University, Halifax, MA pro-
gram, psychology 1966–8
Self-taught

Canada Council Explorations Grant
1978–81

Self-employed

ZOE LUCAS jeweller (p 186)
Born Halifax, Nova Scotia 1950

Nova Scotia College of Art and Design,
BFA 1968–72; MFA 1973–7

Self-employed

ROBERT LYONS broommaker
(pp 139–41)
Born Georgetown, Ontario 1947

University of Guelph, sociology, BA
1970
Self-taught

Self-employed

DAVID McALEESE jeweller
(pp 186, 189)
Born Toronto, Ontario 1947

Self-taught
Fellow of the Gemmological Associa-
tion of Great Britain

Self-employed since 1974 (with Alison
Wiggins)

BETTY MacDONALD quilter
(pp 106–7)
Born Shinimicas, Nova Scotia 1935

President, Mayflower Hand Quilters
Society of Nova Scotia

BETTY MacGREGOR
embroiderer (p 128)

Born Buckingham, Quebec 1932
Sheridan College Arts and Crafts
Teaching Certificate 1976

ELMA JOHNSTON McKAY
jeweller (pp 167–8)
Born Saint John, New Brunswick 1951

University of St Thomas, Fredericton,
NB 1971–2
New Brunswick Craft School 1973–5

Self-employed

DONALD McKINLEY
woodworker (p 79)
Born Bartlesville, Oklahoma, 1932
Canadian resident since 1967

Wichita University 1950–2
State University of New York, College
of Ceramics, Alfred, NY, BFA 1952–5
Fulbright Scholarship, Finland 1962–3
Syracuse University, MID 1963–5

Director, School of Design, Sheridan
College 1967–72
Master of furniture design studio since
1967

RUTH GOWDY McKINLEY
potter (pp 46–8)
Born Brooklyn, New York 1931
Died 1981

State University of New York, College
of Ceramics, Alfred, NY, BFA 1953; MFA
1955
IDAP Ceramic Design grant, Design
Canada 1973

Ceramics International Award 1973
National Ceramics Award 1976
Ontario Crafts Council Award 1978

DAWN MacNUTT weaver
(p 127)
Born New Glasgow, Nova Scotia 1937

Mount Allison University, BA 1957
Dalhousie University, MSW 1970
Part-time instructor, Nova Scotia Col-
lege of Art and Design and Haystack
Mountain School of Crafts

BRENDA MALKINSON-
POWELL stained glass artist
(pp 82–3)
Born Calgary, Alberta 1952

Alberta College of Art 1971–5

Wimbledon School of Art and
Design, England, summer 1973

Self-employed

PAUL MARINEAU weaver
(pp 108–11)
Born Port Menier, Anticosti Island,
Quebec 1950

CEGEP de Hull

Self-employed since 1974, Zannélop
(with Suzanne Lanthier)

MIENEKE MIES weaver (p 127)
Born The Netherlands 1926
Canadian resident since 1954

University of Amsterdam
Private studies in Sweden and Germany
Capilano College, Vancouver
University of British Columbia
Emily Carr College of Art
Self-taught

DAVID MILLER
luthier (instrumentmaker) (pp 74–8)
Born Dysart, Saskatchewan 1948

National Theatre School, Montreal,
graduated 1969

Workshop courses 1975, 1979
Studied with Northern Renaissance In-
struments, England 1978
Self-taught

Saskatchewan Arts Board travel grant
1975
Canada Council awards 1976, 1978

Self-employed

ANN NEWDIGATE MILLS
weaver (p 126)
Born Grahamstown, South Africa
Canadian resident since 1966

University of Cape Town, BA 1964
University of Saskatchewan, BFA 1975
Travel abroad and numerous work-
shops

ANDREW JACKSON MOERS
knifemaker (p 185)
Born Nova Scotia 1900
Died 1977

Woodsman, guide, maker of crooked
knives

DINI MOES weaver (p 128)
Born The Netherlands 1920
Canadian resident since 1948

Amsterdam, textile diploma
The Netherlands, degree in general and
psychiatric nursing
Weaver's Guild of Boston, Master
Weaver Certificate 1977
Guild of Canadian Weavers, Master
Weaver Certificate 1977
Handweaver's Guild of America, Cer-
tificate of Excellence 1978

Ontario Crafts Council awards 1977,
1978

Self-employed

WAYNE NGAN potter
(pp 29–32)
Born Canton, China 1937
Canadian resident since 1951

Vancouver School of Art, graduated
1963
Travel and study outside Canada 1965,
1968, 1978

Canada Council Arts Grant
Vancouver Art Gallery Purchase
Award 1962

Canadian Ceramics Award 1969
BC Ceramics Award 1976

Self-employed

DAVID ORBAN shoemaker
(pp 150–1)
Born Regina, Saskatchewan 1946

University of Saskatchewan, School of
Education 1965–6
School of Fine Arts, Regina 1968–9
Apprenticeship with Herb Perry, Col-
orado Springs 1972

Self-employed

SANDRA ORR
weaver and embroiderer (pp 104–5)
Born Toronto, Ontario 1949

York University, Toronto, BSC
1967–70
Galasso School of Design, Toronto
Studied with Marie Aiken, Gravenhurst
Georgian College of Applied Arts and
Technology

Self-employed

TERY PELLETTIER
silk painter (pp 120–1)
Born Toronto, Ontario 1950

Ontario College of Art, AOCA 1973

Ontario Crafts Council Certificate of
Merit 1976

Self-employed

DUANE PERKINS potter (p 51)
Born Chicago, Illinois, 1947
Canadian resident since 1970

Bethel College, St Paul 1965–70
University of Minnesota 1970–1
Canada Council Grant 1974
Manitoba Arts Council Grant 1977

Self-employed since 1971

REEVA PERKINS jeweller
(p 185)
Born Toronto, Ontario 1917

George Brown College of Applied Arts
and Technology, Toronto
Mohawk College, Hamilton

Ontario Crafts Foundation Design
Award 1968
Steel Trophy, Metal Arts Guild of On-
tario

SETSUKO PIROCHE
textile artist (p 130)
Born Tokyo, Japan 1932
Canadian resident since 1968

Studied with Setsu Asakura 1947–58
Travel in India 1959
Studied textile art, Handcraft House,
Vancouver

NICOLE POUSSART weaver
(p 130)
Born Quebec City, Quebec 1940

University of Laval, languages 1960–2
Studied with Margareta Grandin
Nettles, New York

Handweavers Guild of America, Cer-
tificate of Excellence 1980

Self-employed

DAVID QUIMBY
woodworker, loommaker (p 80)
Born Exeter, New Hampshire 1947
Canadian resident since 1973

Studied with Carl Zimmerman, 3 years

JOHN REEVE potter (pp 24–6)
Born Barrie, Ontario 1929

Vancouver School of Art 1954–6
Studied with Colin Pearson and Harry
Davis, England 1957–8
Student apprentice to Bernard Leach
1958–61

Visiting professor of ceramics, Univer-
sity of Minnesota 1966
Senior lecturer, West Surrey College of
Art and Design, Farnham, England
1967–72
Visiting artist, Vancouver School of
Art 1972–3
Manager, Leach Pottery, England
1973–4
Associate professor, chairman of
ceramics, Nova Scotia College of Art
and Design 1977–9

Canada Council Senior Arts Grant
1961, Arts Award 1972
Member Royal Canadian Academy

Self-employed

HAN REIJERSE
woodworker, toymaker (p 79)
Born Rotterdam, The Netherlands
1937
Canadian resident since 1974

Art School, photography, Breda, 3
years
Self-taught

Ontario Crafts Council Grant 1977

Self-employed

ED ROMAN glassblower (p 94)
Born London, Ontario 1941

University of Toronto, history, hon-
ours BA 1964
University of Paris 1964–5
Sheridan College 1970–2

Ontario Arts Council Grant 1976
Ontario Crafts Council awards 1977,
1978

Ontario Potters Association Purchase Award 1980

Self-employed

MAX ROUX batik artist (p 126)
Born Pretoria, South Africa 1946
Canadian resident since 1968

University of Pretoria, architecture 1964–7
Self-taught

SATOSHI SAITO potter
(pp 40–1)
Born Tokyo, Japan 1935
Canadian resident since 1961

Keio University, Japan, BEC 1961
McGill University, economics, post-graduate program 1961–4
Self-taught
Studied oriental ceramics in Japan 1965–7

Canada Council Grant 1965

Self-employed since 1968
(with Louise Doucet-Saito)

KARL SCHANTZ glassblower
(pp 90–3)
Born New York State
Canadian resident since 1974

Rochester Institute of Technology, BFA 1967; MFA 1969
University of California (Los Angeles)
Los Angeles City College, summer 1965

Studio master, Glass Department, Sheridan College 1975–80
Art and Design Consultant, Ontario College of Art Glass Studio 1978–80

Ontario Arts Council grants 1976, 1977
Wintario Grant, sponsored by Ontario Crafts Council
Art Gallery of Ontario Grant 1978

Self-employed

ADAM SMITH knifemaker
(pp 181–4)
Born Toronto, Ontario 1956

York University, Japanese, one year
Self-taught

Award of Merit, Ontario Crafts Council 1980
Only Canadian member of the Knife-maker's Guild

Knife-making instructor (part-time), Sheridan College
Self-employed

MICHAEL SPENCER
blacksmith (p 190)
Born Los Angeles, California 1942
Canadian resident since 1969

University of Massachusetts, BSC (chemistry) 1964
Various workshops
Self-taught

Nova Scotia Government grants 1975, 1980
Canada Council Grant for travel 1980

Self-employed

CHRISTINE STANLEY
weaver (pp 116–17)
Born Middleton, Nova Scotia 1954

New Brunswick Handcraft School

Several Prince Edward Island handcraft awards

Instructor, New Brunswick Craft School 1974–5
Self-employed

DONALD STUART jeweller
(pp 171–2)
Born Toronto, Ontario 1945

Ontario College of Art 1963–7
Travel to Scandinavia 1967–8
Rochester Institute of Technology, MFA 1981

Designer, Karen Bulow Ltd, Montreal 1969–70
Master weaver, Pangnirtung, NWT 1970–2

Ontario Crafts Council awards 1976, 1979, 1980

Teaching master, Georgian College of Applied Arts and Technology, Barrie, since 1972

JACK SURES potter (p 50)
Born Manitoba 1934

University of Manitoba, BFA 1957
Michigan State University, MA 1959

Studio potter 1962–5
Many workshops

Canada Council grants 1966, 1969, 1971, 1972

Professor of ceramics, University of Regina since 1965

SUZANNE SWANNIE weaver
(pp 122–3)
Born Copenhagen, Denmark 1942
Canadian resident since 1967

Studied with Kirsten and John Becker, Copenhagen 1960–3
Textilinstitutet, Boraas, Sweden 1963–5
Haystack Mountain School of Crafts, Maine 1979

Has taught in Nova Scotia, Newfoundland, and Prince Edward Island
Many workshops

Award, Nova Scotia Designer/Craftsmen 1978

Self-employed

DAVID TAYLOR potter
(pp 35–7)
Born Middleton, Nova Scotia 1944

Nova Scotia College of Art and Design 1963–5
Coventry College of Art and Design, England 1965–6
Ecole des Beaux-Arts, Paris 1969

Nova Scotia government grants 1976, 1980

Award, Nova Scotia Designer/Craftsmen 1978

Self-employed since 1974

IONE THORKELSSON
glassblower (pp 87–9)
Born Ashern, Manitoba 1947

University of Manitoba, architecture 1965–9
Sheridan College, summers 1973, 1976

Manitoba Arts Council Grant 1976
Canada Council Grant 1978

Self-employed since 1974

JACQUES TROALEN
jeweller and silversmith (pp 169–70)
Born Montreal, Quebec 1949

Apprenticeship, Montreal, London, Stockholm, Brussels 1965–8

Canada Council grants 1969, 1976, 1978

Self-employed since 1970

DAVID TROTTER
leatherworker (pp 148–9)
Born Toronto, Ontario 1951

Sheridan College 1972–3
Apprenticeship with Daphne Lingwood

Ontario Craft Foundation Award 1974
Ontario Crafts Council Award 1975

Self-employed since 1976

JEAN VALLIÈRES glassblower
(p 95)
Born Charney, Quebec 1947

Collège de Ste-Foy
Apprenticeship with Robert Gervais 1967, Claude Morin 1976

Ceramics instructor, Arts Visuels, Laval University, 1970–3
President-director, Corporation des Artisans de Québec, Salon des Artisans de Québec 1973–6

Self-employed since 1976

GINA SCHORSCHER WATSON
silk painter (p 130)
Born Scotland 1930
Canadian resident since 1976

Glasgow College of Art
Studied silk painting in France

ALISON WIGGINS jeweller
(pp 186, 189)
Born Toronto, Ontario 1955

DeBeers Diamonds Today Award 1979
Ontario Crafts Council Award of Merit 1979

Self-employed since 1974 (with David McAleese)

CECILIA WILLIAMS
basketmaker (p 158)
Born Nitnat, British Columbia 1890

PAUL WILLIAMS
leatherworker (p 157)
Born Toronto, Ontario 1949

Seneca College, cartography 1970
Workshops with Robert Muma 1971,
Stephen Hogbin 1975, Rex Lingwood
1979
Self-taught

Ontario Arts Council grants 1975,
1977, 1978, 1979, 1981

Self-employed

DARRELL WILSON
glassblower (p 95)
Born Victoria, British Columbia 1952

Georgian College of Applied Arts and
Technology, Barrie 1970–3
State University of New York, School
of Fine Arts, Alfred, NY, BFA
1973–5

Instructor, Georgian College of Applied Arts and Technology 1976–9
Resident artist, Harbourfront Studios,
Toronto

Self-employed

EDWARD YOUNG
basketmaker (p 156)
Born Newfoundland early 1920s
Died 1980

TYPESETTING
University of Toronto Press and
Mono Lino Typesetting Limited

COLOUR SEPARATION AND PRINTING
Herzig Somerville Limited

PAPER
Warren Patina, 200M
Strathmore Grandee, Cordoba Brown

BINDING MATERIAL
Columbia Bradford Linen BL889

BINDING
The Hunter Rose Company Limited

DESIGN
William Rueter RCA